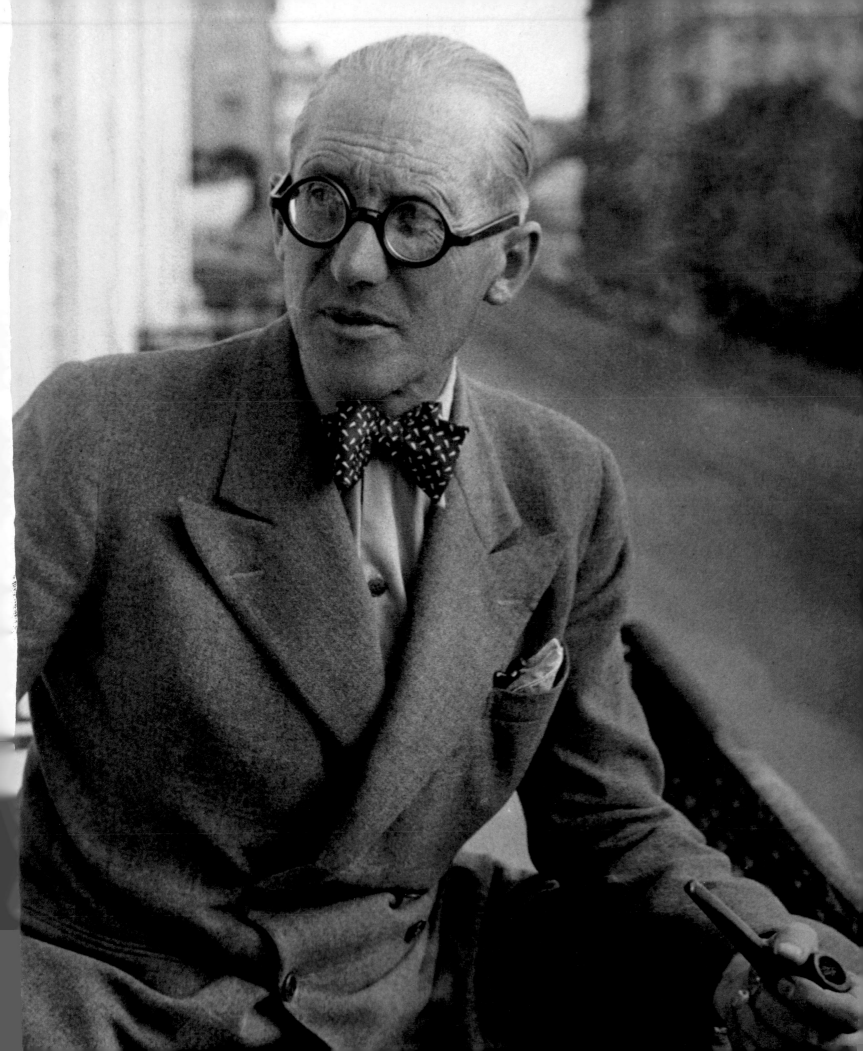

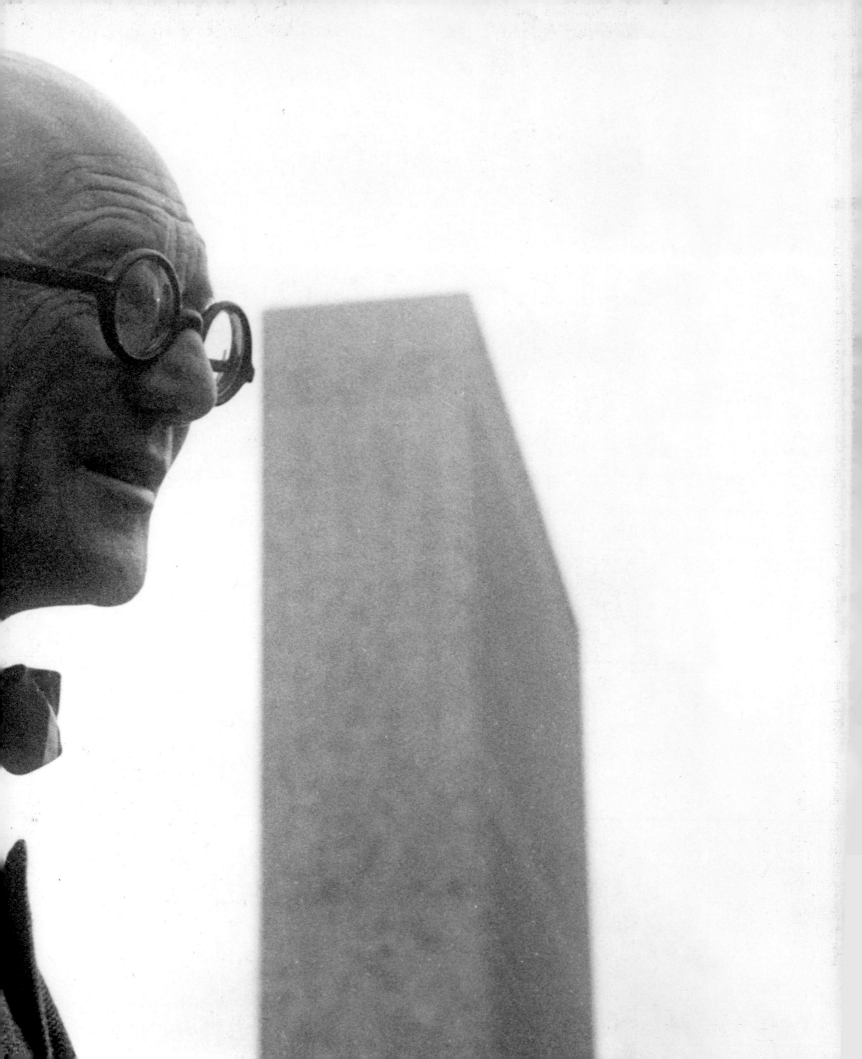

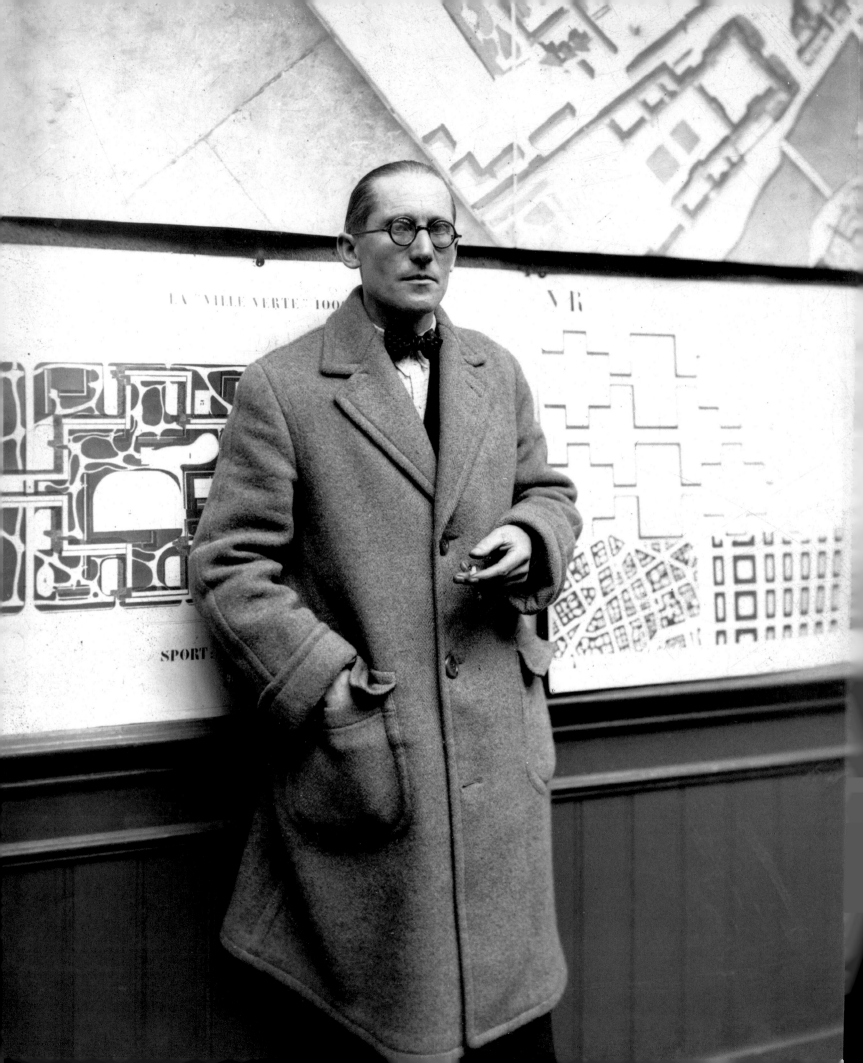

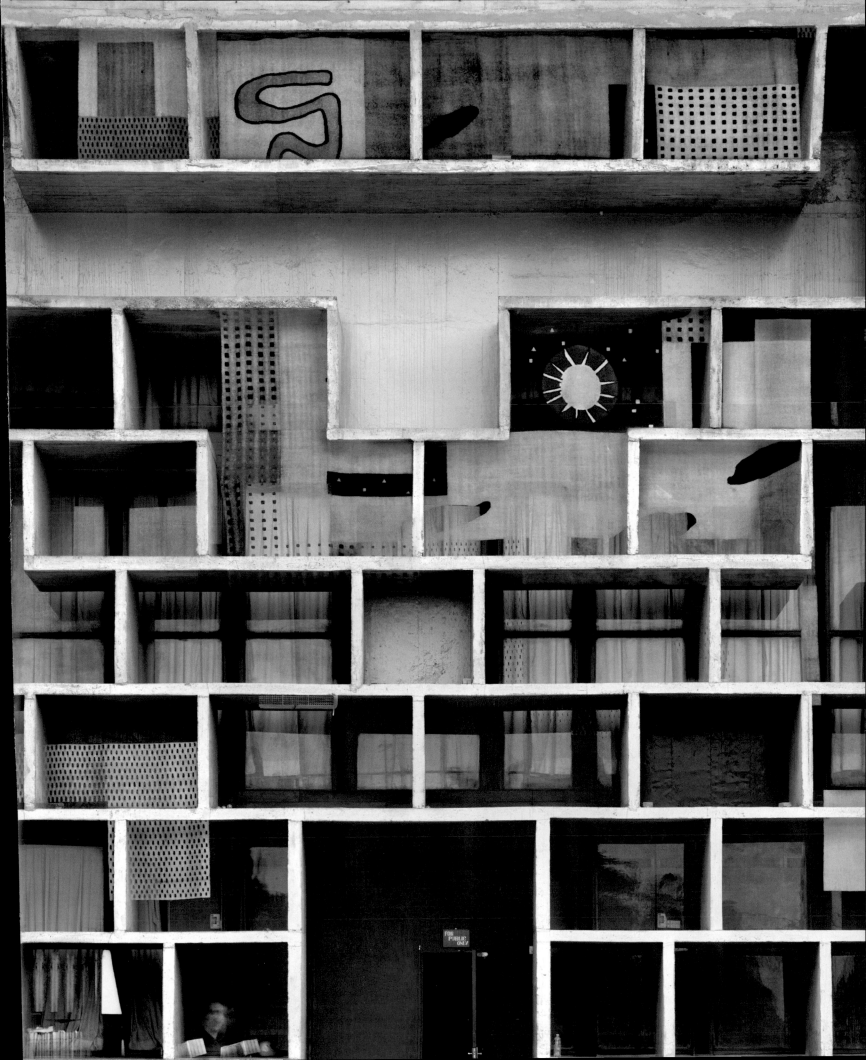

LE CORBUSIER AND THE POWER OF PHOTOGRAPHY

EDITED BY NATHALIE HERSCHDORFER & LADA UMSTÄTTER

CONTRIBUTIONS BY TIM BENTON, JEAN-CHRISTOPHE BLASER, VERONIQUE BOONE, CATHERINE DE SMET, ARTHUR RÜEGG, KLAUS SPECHTENHAUSER

Thames & Hudson

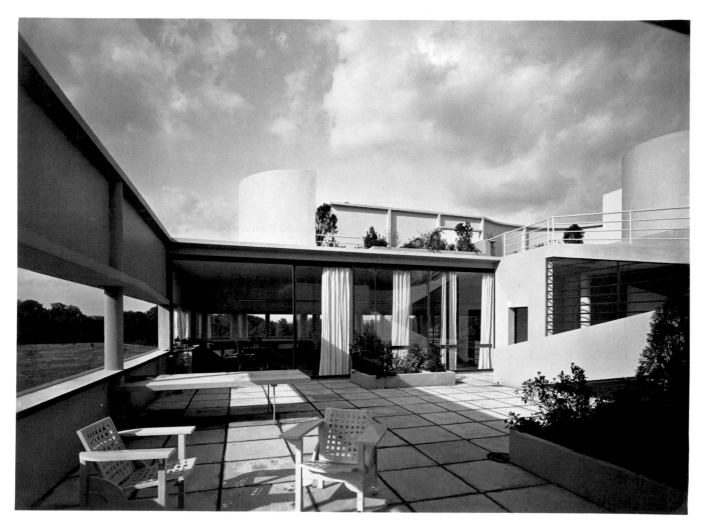

Villa Savoye, Poissy, France, 1931.
Photograph by Marius Gravot.

PREFACE

I can remember clearly my first encounter with the work of Le Corbusier.
As a teenager, growing up in Manchester, I discovered *Vers une architecture*
(1923; published in English as *Towards a New Architecture*, 1927) on the shelves
of the Free Library in Levenshulme. Leafing through it was a revelation – as much
an escape from everyday reality as the pages of the *Eagle* comic or the Saturday
morning cinema.

I was enthralled as much by Le Corbusier's bold of use of imagery, and the way
he found inspiration in engineering and classical archetypes, as I was by his vision
of a brave new world. Where else would one find a photograph of a humble grain
elevator opposite the Baptistry at Pisa; or the cockpit of a Caproni hydroplane
juxtaposed with the entablature of the Parthenon? The images are well chosen,
the captions pithy – virtually mini manifestos in themselves. Taken together,
they communicate a powerful message with an incredible economy of means.

Le Corbusier shows us how compositional discipline can be found in purely
functional forms (aircraft, motor cars, bridges and ocean liners), just as it is in
architecture. 'If houses were constructed by industrial mass-production, like
chassis, unexpected but sane and defensible forms would soon appear, and
a new aesthetic would be formulated with astonishing precision', he declares.
For a young student with an awakening interest in architecture, this was
a heady introduction.

Later, through the photographs in *Oeuvre complète* (Complete Works, 1930–
1970), I discovered another side to Le Corbusier: the scene-setter. Here he
uses photography as much more than a documentary record – he takes care
to show patterns of use. Turn to the images of the Immeuble Clarté (Clarity building),
for example, and you find the building full of life. Even in the unpopulated photographs
there are telltale signs of habitation: a visitor's hat on the hall table in the Villa
Savoye, or a pot of coffee on a kitchen counter. Occasionally, here too he uses
juxtaposition to reinforce a point. Look at the Cité de Refuge (City of Refuge)
and you see Le Corbusier's favourite Voisin motor car parked in the street
outside – the refined, functionalist aesthetic common to both.

Picking one building and its accompanying image that for me summarizes
Le Corbusier is impossible. He is richly complex. Like a coin, there are two
sides to his architectural personality. On one side is the Unité d'Habitation
in Marseille – rational, prototypical, incorporating all the rich ingredients of urban
life in a single high-density block. Its spirit is captured perfectly in a charming image
of children playing on the roof terrace. On the other is the chapel of Notre-Dame-
du-Haut at Ronchamp – a spectacular one-off, almost a piece of inhabited
sculpture, which offers a deeply moving spiritual experience. It is summarized
in a wonderfully evocative image of the building under construction, rising almost
literally from the rubble of the historic chapel, which had been destroyed in the war.

Le Corbusier was perhaps the first architect to understand that image, idea
and message are wholly interdependent. In that, as in so many other ways,
he was far ahead of his time.

Norman Foster

INTRODUCTION:
MAKING IMAGES

NATHALIE HERSCHDORFER & LADA UMSTÄTTER

MAKING IMAGES

I spend the day taking photographs. Oh, the miracle of photography!
Brave lens, what a precious, extra eye. I treated myself to quite a camera.
Working with it isn't easy. But the results are perfect and I haven't missed
a single plate since April.
Le Corbusier, Letter to Charles L'Eplattenier, 18 July 1911[1]

Le Corbusier is one of the major figures of the 20th century. His architectural
work and thinking deeply influenced several generations of architects and urban
planners, and his legacy continues to contribute to the shaping of our contemporary
environment. His work also extended to painting, tapestry and sculpture. If his
influence has been so significant, it is also because Le Corbusier was a tireless
and effective propagandist for his own ideas, through countless lectures, articles,
books and manifestos, for which he also developed his own media, such as the
journal *L'Esprit nouveau* (The New Spirit), founded in 1920 with Amédée Ozenfant
and poet Paul Dermée. Drawing on his wide-ranging culture, Le Corbusier
continuously participated in the artistic debates of his time. Curious about
the world and willing to participate in its modernization, he created all of his
work using a knowledge accumulated from reading and travelling, two perpetual
sources of new observations. Le Corbusier wanted to offer his contemporaries
a new approach to the living space, urbanism and art; in short, to offer new living
conditions for a new humankind.

Many books have been devoted to the multi-faceted career of Le Corbusier. There
is, however, one aspect of his work that is seldom addressed and has not yet been
the subject of a comprehensive book: the artist's relationship to photography. This
medium was of course a major tool for the promotion of his architectural work. But
this book is not limited to a photographic representation of Le Corbusier's work.

The day of the inauguration of the Marseille
Unité d'Habitation, 1952. Photograph
by Lucien Hervé.

In his case, photography deserves to be considered in a far broader perspective,
both in terms of practices and uses – an approach that corresponds to the way
the artist himself considered this medium. We will therefore discuss photography
as a tool for representation, promotion and dissemination, as well as a means
for artistic endeavour. To carry out this project, an international team of experts
has been assembled by the Musée des beaux-arts in La Chaux-de-Fonds,
Le Corbusier's hometown. Specialists of Le Corbusier's work and of photography
combine their knowledge to address this subject. Two major collections have
provided the basis for this ambitious project: the library of La Chaux-de-Fonds, which
maintains records of the architect prior to 1917 (the date of his departure to Paris),
and that of the Fondation Le Corbusier in Paris, which undertook the conservation
of his archives until his death in 1965. Many documents have been brought together
for the first time, offering a new angle of research on the architect's work.

Le Corbusier was a man who was looking decisively towards modernity.
His architectural and urbanistic ideas were expressed not only in his projects
and constructions, but also in his visual research. But the 'new spirit' that drove

Le Corbusier, 1952. Photograph by Lucien Hervé.

the creativity of the artist during the inter-war period also appears in photography, the medium of modernity *par excellence* and a perfect response to the aesthetics of the machine, which took a prominent role at the time. Alexander Rodchenko in Russia, László Moholy-Nagy and Umbo (Otto Umbehr) in Germany, saw photography as the medium best able to portray and express modern life, and it is very likely that Le Corbusier knew the photographic work of these members of the avant-garde.

Like many of his contemporaries, Le Corbusier used the photographic medium in parallel with the pencil and brush. His vision was close to that of his colleague and assistant Charlotte Perriand:[2] both saw in photography a 'machine' that certainly allowed one to see, but also to communicate. It was not uncommon in the first half of the 20th century to see painters, architects and photographers working together, their various disciplines and ideas feeding one another. Neither Le Corbusier nor Perriand put any value on their photographic work in their lifetime. But today it is exciting to be able to see this creative side of their work that has remained largely unknown – it allows us to better understand their sources of inspiration and their creative processes. In retrospect, photography also seemed a natural element of a work that already extended into many disciplines. One could even say that the photographic 'machine' took a coherent place alongside set squares, pencils and brushes. 'Regarder' (looking at) and 'voir' (seeing) are terms Le Corbusier used regularly, like 'inventing' and 'creating'. These verbs must be understood both in the sense of 'observation' and in the sense of 'creative vision'. Both the visual reflection and the architectural research of Le Corbusier indeed claimed to escape convention and to address the senses and the mind directly.

Le Corbusier (then Charles-Edouard Jeanneret) left his hometown of La Chaux-de-Fonds at a very young age to discover the world: Paris, Munich, Vienna, Berlin, but also Chartres, Pompeii, Florence, Athens, Istanbul and Rome. His encounters and observations guided his thoughts. During his travels, he designed and deciphered the world through his sketches. But even then, as Tim Benton points out, he complemented this traditional approach by using a Kodak camera. In 1911, at the age of 24, Le Corbusier contemplated the Parthenon and analysed its position in the landscape. This interest is reflected in his photographs of the time that show an analytical eye and great care for composition. This same curious eye influenced his work on composition, contrast and framing on the beaches of Arcachon twenty years later, when he resumed photography after having abandoned his camera for the pencil in 1911. The series of photographs he undertook – and which he continued, notably during his stay in Brazil – are amazing in many ways: often remarkable for their artistic quality, these images were taken in an unusual manner with a very light film camera, used in 'frame by frame' mode. It turns out that there are no original prints of these images and that a very small proportion of Le Corbusier's negatives were actually developed during his lifetime. Is it because film was so difficult to project at the time? In 1936, the camera was indeed a machine that allowed the artist to *see*, to experiment on framing and to isolate fragments of reality.

But the 'mental images' that Le Corbusier accumulated seem to have been adequate for his purposes, and he did not appear to feel the need to keep a tangible trace of them in the form of prints. The recent discovery of thousands of his photographs, in addition to their aesthetic interest, allows us to reconstruct

an important part of Le Corbusier's creative process. These images, which retain an undefined status, almost to the extent of being virtual, seem to have been used by him as working notes, coming second after painting, which was of immense importance to him: he devoted every morning to the activity and practised throughout his entire life. In his photographs of the 1930s, we can find certain elements that also appear in his paintings, suggesting that it is his vision as a painter that influenced his approach to photography, and not vice versa.

Although the photographs taken by the architect were mostly unpublished, they deserve to be added to his extensive iconographic body of work, which integrates a variety of sources and has been one of his major working tools. From a very young age he had collected postcards, reproductions from magazines and images of all kinds, which were materials on which he based his research. As a visual artist, he thought that the creation of a visual order was also part of his role. Writing plays an important part in the development and precise definition of Le Corbusier's vision of architecture, but his publications clearly show that he used both images and words to express his thoughts. Catherine de Smet shows the central role played by photography in the development of the books published by the architect. The attention to the layout and visual quality of his publications shows that Le Corbusier wanted to create a real dialogue between text and image. These concerns link him to the broad movement of the inter-war period, in which artists dedicated themselves to initiating a true revolution in graphic arts and communication, in which photography played an important part.

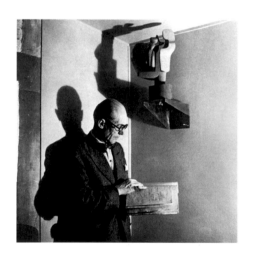

Le Corbusier in his studio at 35 rue de Sèvres, Paris. Photograph by Willy Maywald.

Le Corbusier's photomontages were thus part of a trend characteristic of the European avant-garde active in the wake of the First World War in Germany, Russia and France. Artists showed a keen interest in machines, which were omnipresent in the modern world, and integrated mechanical motion into their work. The German artist Hannah Höch said of photomontage: 'Our whole purpose was to integrate objects from the world of machines and industry in the world of art'.[3] Photomontage was also used for political purposes. In Germany, the former Dadaist John Heartfield worked for the Communist press; his satirical and militant photomontages were published in books, magazines and newspapers. In the USSR, the Constructivists used the same language for propaganda. Gustavs Klucis had been a pioneer of photomontage, soon to be followed by El Lissitzky, who was also convinced of the power of the photographic language. Lissitzky asserted: 'No kind of representation is as completely comprehensible to all people as photography'?[4] Artists of the avant-garde also saw photography as a means to account for a changing world. In this context, many of them incorporated the modern city in their work: for example, Paul Citroën, whose first photomontages dedicated to the city dated back to 1919, made his large photographic collage *Metropolis* in 1923 at the Bauhaus in Weimar when he was still a student. And in cinema, Walter Ruttmann sought to express the urban rhythm in his film *Berlin, Symphony of a Metropolis* (1927), as did Fritz Lang in *Metropolis* (1926).

In this atmosphere of excitement and visual experimentation, it is not surprising that the use of photomontage was also taken up by architects. Le Corbusier, aware of German and Soviet art, quickly understood that photography was a powerful medium capable of many uses. The multiplication of word and image printed by machine allowed for a wide distribution (the 1920s also saw an influx of posters and advertisements). Le Corbusier, the modern man, wanted

to communicate and it is therefore natural that he used the photographic image to promote his works, each of them being a manifesto.

During the inter-war period, however, the montage experiments of the avant-garde soon found applications beyond the book or the press. After the printed page and poster displays, the architectural space also became a medium for photography. For example, the Russian Constructivists created monumental friezes and this type of application particularly interested Le Corbusier: in his view, the purpose of art was not limited to the ornamentation of space. In his article, Arthur Rüegg recalls that Le Corbusier was convinced that images had a crucial role to play in architecture. Like his contemporaries active in Germany or the USSR, he believed in the fusion of disciplines. He therefore became involved in designing coloured wallpaper and photographic friezes for integration into his interiors. Again, they are never simply ornaments: for him, painting and photography had an artistic role to play in their interconnection with architecture, and one must consider the large photographic murals undertaken by Le Corbusier as a logical extension of the vision expressed in his publications. Through this medium also, he wanted to stimulate the viewer and communicate thought and emotion.

This concern did not falter in Le Corbusier's work; on the contrary, his fabrication of images became more complex with time. In 1958, in the Philips Pavilion undertaken for the Brussels World Fair, Le Corbusier added sound and coloured lights to the monumental photographs displayed by projection. At the time, the American photographer Edward Steichen was touring the world with his photographic exhibition *The Family of Man*, created in 1955 for MoMA in New York, where he headed the photography department. Designed as the ultimate visitors' experience, *The Family of Man* presented a photographic journey through the cycles of human life. The exhibition met with phenomenal success wherever it was shown.[5] With scenography by Steichen himself, inspired by the work of Herbert Bayer, it relied on a variety of formats and their arrangement in space. The layout was also directly involved in articulating the concept of the exhibition. It is very likely that Le Corbusier was at least aware of this exhibition, which stopped off in Paris in 1956. Similarities with the Philips Pavilion abound, not only in the theme and in the dynamic and spectacular design of the scenography, but also in the role of the curator, the real creator of the work. Again, the intention of the architect was not to build a series of individual works, but to create a device capable of immersing the visitor in a unique environment of sound and vision.

Apart from these experiments, in which the medium is pursued to produce the most spectacular results, Le Corbusier also saw photography, as well as more traditional media, as a means of promoting his architectural work. Since the 19th century, shortly after the invention of photography, architecture has been one of the favourite themes of photographers (echoing a long tradition, hitherto undertaken mainly through engraving), as evident in the numerous views of Rome, Egypt and Palestine dating from the early days of photography. In the 1860s, photographers were increasingly interested in the city and views of Paris by Charles Marville, Edouard Baldus and Louis-Emile Durandelle became commonplace. Photography was the perfect complement to architecture: not only in providing an inventory of architectural heritage, but also in its ability to document the contemporary city and celebrate the architectural achievements of the modern world. It had the advantage of being static, at a time when long

exposure periods were required and the difficulty of handling the equipment limited the flexibility of photographers.

Technical developments (better optics, simplified chemical processes) and the arrival of new photo-mechanical means of reproduction gave architectural photography a boost. In the 1930s, engraved illustrations were gradually replaced by photographs in newspapers, magazines and books. It was also at this time that professional journals for architects were created – *Domus* in Italy (1928) and *L'Architecture d'aujourd'hui* (The Architecture of Today) in France (1930). Photographers such as Julius Shulman in the United States and Albert Renger-Patzsch and Werner Mantz in Germany were commissioned to take exterior and interior photographs of contemporary buildings. Understanding that quality photographs were a useful way of promoting their work, architects guided photographers in their methods, sometimes even choosing the best viewpoints from which to capture their work.

It therefore seems natural that Le Corbusier, a man of his time, should have embraced photography to communicate his vision of architecture. But unlike the German architect Erich Mendelsohn, whose flagship book *Amerika* (1928) showed his photographs taken with a Leica camera in various American cities, Le Corbusier did not become an architectural photographer. Although he had a very clear vision of how his architecture should be photographed, he preferred to rely on professionals chosen by him. He granted them very little freedom, sometimes even checking their contact sheets or prohibiting the publication of images that displeased him. In his view, photography had to be utilized for promoting his work and not vice versa. It is therefore not surprising that the photographer's name was sometimes omitted from the photographic credit. As in the case of publications or photomontage, his philosophy was that photography was a way to document, but also and above all to persuade. Film opened up similar avenues and, like photography, would become a great advertising tool for the architect. Orchestrating his teams of photographers and film-makers, Le Corbusier developed a photographic archive that could support his vision.

But Le Corbusier's relationship with architectural photography changed after the Second World War. His enthusiasm for Lucien Hervé's images of the Cité radieuse (the Radiant City) in Marseille encouraged him to make greater use of photography as a communication tool. Veronique Boone describes the relationships the architect developed at that time with his photographers, especially Hervé, with whom he worked from 1949. Hervé was commissioned to photograph not only Le Corbusier's completed architectural projects but also his work in progress. Photographers were accustomed to working under the close supervision of the architect; few of them were trusted as much as Hervé. It was not until the 1950s that Le Corbusier gave some freedom to his photographers, as he did with René Burri, Pierre Joly, Véra Cardot and Ernst Scheidegger. It is therefore interesting to compare the work of these photographers commissioned by Le Corbusier with the work of photographers today, who no longer have to work under his watchful eye.

Most architectural photography projects are commissioned by an architect or contractor, but it is not always the case. They can also sometimes be personal

works, detached from the vision of the architect, in which the photographer is accountable to no one and is free to offer his or her own interpretation of the architecture. The precursors of this approach were two photography collections that marked the 1930s: *Changing New York* (1939) by Berenice Abbott and *American Photographs* (1938) by Walker Evans. But the photographers' quest for more independence from architects developed mainly in the photography of the 1960s. In the United States especially, photographers such as Robert Adams, Lewis Baltz and Lee Friedlander did not hesitate to question the contemporary city. Also relevant in this context are the books of the painter Ed Ruscha and *Learning from Las Vegas* (1972), a richly illustrated publication by Robert Venturi, Denise Scott Brown and Steven Izenour, architects who questioned architectural modernism. In Europe, Bernd and Hilla Becher participated in the same wave of renewal by documenting the remains of industrial sites, while Gabriele Basilico examined the morphology of European cities.

The urban landscape, in which architecture is almost no longer represented as an object in itself but, on the contrary, as a significant role player in a given context, has gradually become a major genre of contemporary photography. Jean-Christophe Blaser focuses on this new tradition through the vision that contemporary photographers have of Le Corbusier's architecture. He shows us that many of them have appropriated his architectural work and present a personal vision of it. The trip to Chandigarh, India, has indeed been an important and productive ritual for many photographers over the last fifty years. Others chose to focus on the early work of the architect – photographing, for example, the Villa Schwob (Villa Turque) in La Chaux-de-Fonds – or on his later achievements, such as the Monastery of La Tourette, or Notre-Dame-du-Haut in Ronchamp. For this new generation of photographers, the objective is obviously no longer to promote or to inform about Le Corbusier's work. The photographers' perspective on his architectural work can even be blurred (or sublimated), as in the photographs by Hiroshi Sugimoto or Stéphane Couturier. Younger generations are familiar with the work of their predecessors but they are still keen to offer a new approach on a body of work that has been photographed many times. In the early 21st century, it is thus striking to see that Le Corbusier's architecture still inspires young photographers.

In addition to these various approaches, an overview of Le Corbusier's relationship to photography and the uses he made of it cannot avoid addressing the issue of the representation of the architect himself through this medium, from traditional family albums to official images. Photography played a significant role in Le Corbusier's life from an early age. Looking at the photographs taken at different times of his life, one realizes that, even when very young, he was keen to be portrayed and quickly grasped the opportunities offered by the promotion of his image through photography. Klaus Spechtenhauser produces a portrait of Le Corbusier through both private and official pictures in which the architect appears. One can only be struck by the number of images produced specifically for posterity. Le Corbusier had a keen sense of the power of the media and quickly understood that the promotion of his work also depended on the promotion of his own image as an artist and architect. He has thus carefully staged his own image in front of the camera. Through a variety of portraits showing him as a man of the world, a traveller, a solitary creative genius or an artist sharing his thoughts in society, Le Corbusier used photography to shape an image that made him a truly iconic

figure of the 20th century. He was a great communicator and knew how to pose for photographs: the proof is that – like a handful of other artists of his time, such as Picasso, Dalí and Sartre – he is still instantly recognized by a wide section of the public, for whom his face is sometimes more familiar than his work.

Photography has undoubtedly been a major and enduring element in Le Corbusier's career: he integrated it into his communication strategies and his visual and intellectual research. For him, it was, in every sense of the term, a tool for developing his vision and his thought. The architect understood the power of photographic language and made every possible use of it. However, the articles and photographic work contained in this book are not intended primarily to reveal the unpublished work of an ignored or disregarded photographer, thereby integrating him in the history of photography.

The point here is not to give the architect the status of photographer in the literal sense: his actual practice of photography was too limited in time, although the rediscovery of his photographs of the 1930s has revealed previously unknown images of an unexpectedly high quality, showing a promising talent, which the architect did not attempt to cultivate. This interest in photography nevertheless found a way to express itself indirectly: first, by proxy, in his role as a contractor (a role not unlike that of the architect supervising his construction site); second – and above all – as a way of reflecting on and promoting his work. This book offers a new perspective on Le Corbusier by showing the major part played by photography in his thinking. In his work, all media – architecture, painting, writing – feed into one another, and photography, a medium emblematic of the modern mind, has allowed him to enrich his vision and participate fully in the making of his images.

Notes

1 In Le Corbusier, *Lettres à Charles L'Eplattenier*, Paris: Editions du Linteau, 2006, p. 278. (Written when Le Corbusier was travelling in Istanbul.)
2 On this subject, see the recent monograph by Jacques Barsac, *Charlotte Perriand et la photographie. L'œil en éventail*, Paris/Milan : Editions 5 Continents, 2011.
3 Quoted in Van Deren Coke, *The Painter and the Photograph*, Albuquerque: University of New Mexico Press, 1964, p. 259, and in Dawn Ades, *Photomontage*, London: Thames & Hudson, 1976, p. 13.
4 Quoted in Ades, *op. cit.*, p. 63.
5 *The Family of Man*, which brought together 503 images by 273 photographers from sixty countries, was the most visited exhibition in the world at the time. It was so successful that it was shown in thirty-eight countries between 1955 and 1962.

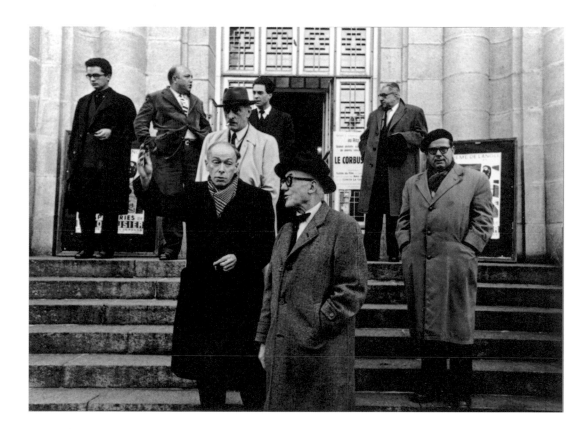

Right: Le Corbusier in front of the Musée des beaux-arts during his visit of the exhibition dedicated to his work, 'Le poème de l'angle droit et dix-sept tapisseries de Le Corbusier' (The Poem of the Right Angle and Seventeen Tapestries by Le Corbusier), La Chaux-de-Fonds, 1957.

Below: View of the exhibition.

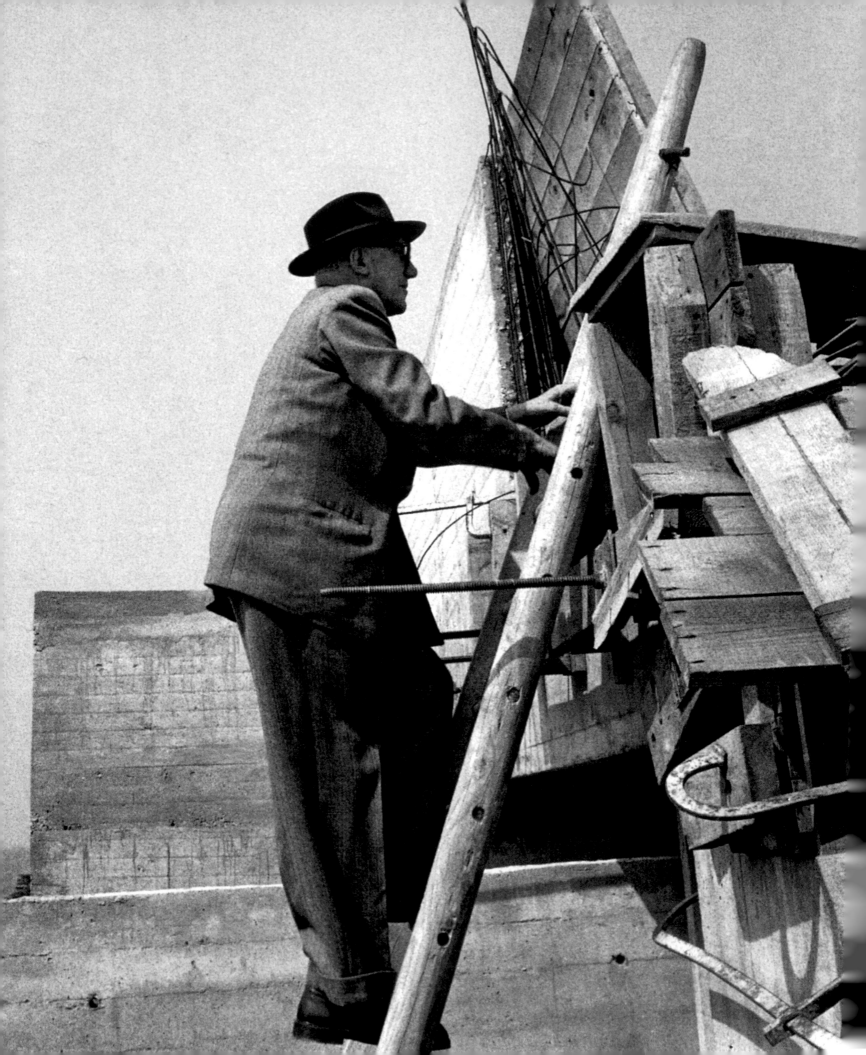

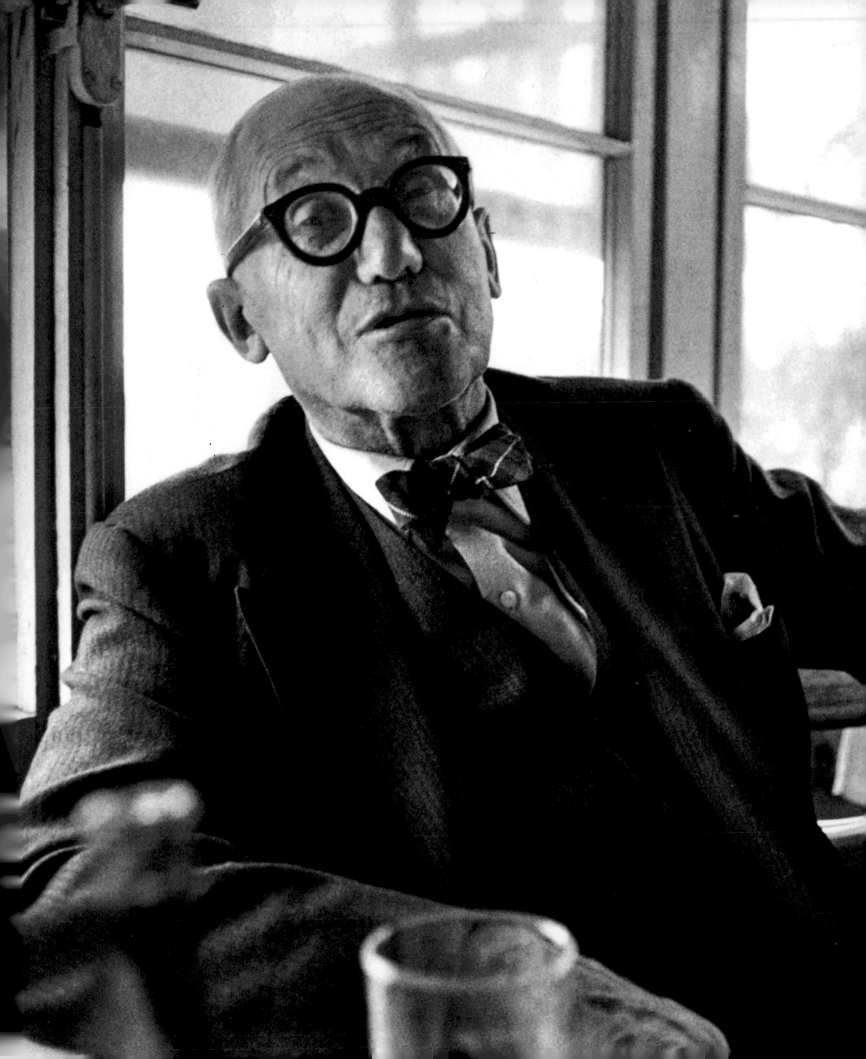

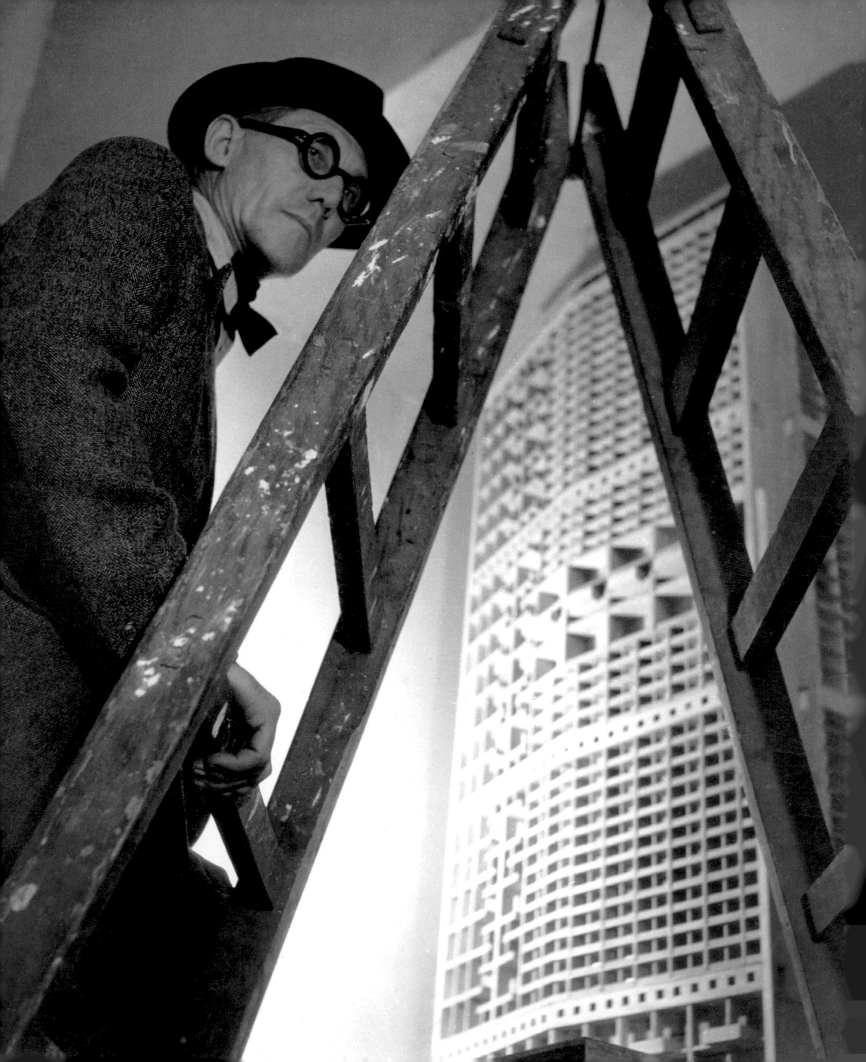

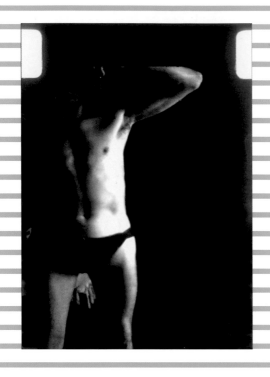
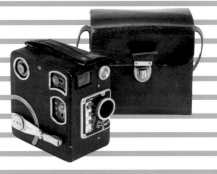

1

LE CORBUSIER'S
SECRET PHOTOGRAPHS

TIM BENTON

At some point during the summer of 1936, Le Corbusier obtained a spring-operated 16-millimetre film camera. Between June 1936 and the spring of 1938, he shot 18 reels of 50-foot (15.25metre) film, including around 120 short pieces of film and nearly 6,000 still photographs.[1] Among the film sequences are shots of the German airship the Graf Zeppelin in the Brazilian state of Pernambuco, a number of views of Rio de Janeiro (including some fascinating clips in what was then the favela of Santa Teresa) as well as several shots in his apartment in Paris, his mother's house at Vevey and the picturesque town of Vézelay, where his friend Jean Badovici had renovated some old houses and where Le Corbusier was a guest in December 1936. These filmed sequences are primarily of anecdotal and personal interest, but the still photographs taken with this film camera constitute a body of work of astonishing quality, revealing completely unexpected aspects of the architect's imagination. Many of these six thousand photographs repay close attention and can be considered works of art in their own right. But it is, above all, the way in which Le Corbusier used these powerful images to reflect on the morphology of natural and mechanical forms that commands respect and ensures that they will be considered alongside his drawings as providing a key to his imagination.

What makes these carefully composed images all the more remarkable is that it is highly unlikely that Le Corbusier ever managed to view them properly. Apart from a few shots of his Pavillon des Temps Nouveaux (built for the Paris Exhibition of 1937), printed in *Des canons, des munitions? Merci! des logis... s.v.p.* (Cannons, Ammunition? No, thanks. Housing Please, 1938), there is no evidence of any prints struck from the positive black and white film stock. And it was not possible to use the 16-millimetre film projectors of the day to view individual frames, for fear of burning the film.[2] Throughout his life, Le Corbusier was extremely coy about photography and rarely published his own photographs. I therefore consider his photographic activity to be private and indeed 'secret'.

FILM-MAKING

Le Corbusier's fascination with cinema is well known.[3] As early as 1926 he was involved with a film group that had shot some views of his housing estate at Pessac, and his meeting with the pioneering film director Sergei Eisenstein in Russia in 1928 has frequently been discussed.[4] From 1930 to 1931 he was in frequent contact with the young film-maker Pierre Chenal, who would make two films about modern architecture that featured the work of Le Corbusier.[5] The architect wrote admiringly of his friend's work:

> Quick, intelligent, analytical and lyrical, with a remarkable sense of timing, he manages to capture the essence of modernity with his whirring camera....Whereas the film-maker can easily handle passionate human dramas, amorous intrigues and detective stories, it is not so easy to set something before the public based only on what the camera can see within the four walls of a building. You need a unique talent to succeed without lapsing into an unbearable photographic cliché.[6]

Film is an art of montage, and as early as 1931 Chenal was capable of creating smooth and striking sequences of shots in the cutting room. But Le Corbusier appears to have learnt nothing from him, as far as his film-making skills were

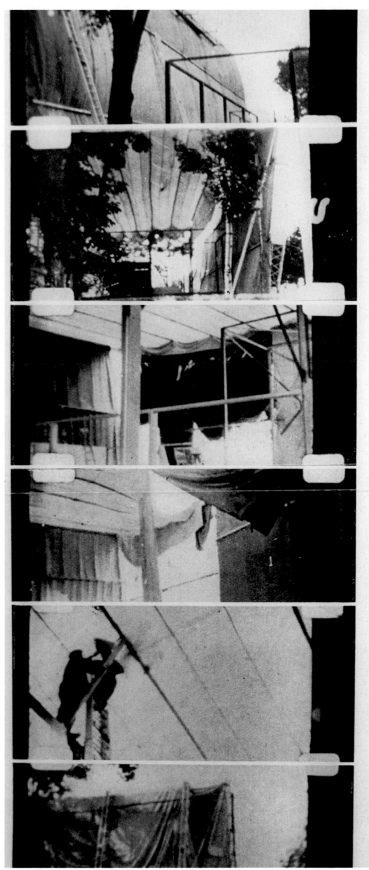

Les toiles sont tendues
ouest et est, laissant
libre le passage des
vents dominants.

Les 1.200 m² de toile
épaisse du plafond sont
hissés *d'une pièce*, sur
un échafaudage médian
et tirés à gauche et à
droite.

Alors on ferme le côté
sud.

La catastrophe !...
Une nuit d'orage, en
cours de travaux.
L'évacuation des eaux
du plafond (1.200 m²)
n'était pas encore
achevée. Une poche
d'eau formidable se
produit, tordant les
tubes et déchirant les
toiles.

La mise au point
minutieuse du plafond :
deux hommes au
sommet d'une échelle ;
un homme voltigeant
sur la surface
mouvante de la toile...

Enfin, la face nord est
tendue de toile.
Désormais, l'ouvrage
est à l'abri des tempêtes.

Page layout for *Des canons, des munitions? Merci! des logis...
s.v.p.* (Cannons, Ammunition? No, thanks. Housing Please),
showing some of the prints taken by Le Corbusier with his 16mm
film camera when the Pavillon des Temps Nouveaux was being
dismantled in January 1938.

33 Tim Benton

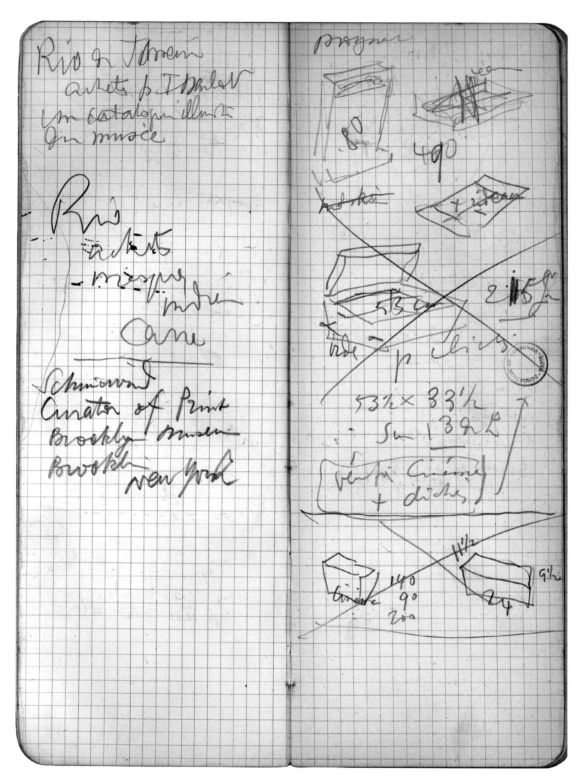

Le Corbusier's personal diary, a few days before
he left for Brazil on 8 July 1936, with a sketch
of his suitcase and estimations of the space
needed for his film camera and lecture slides,
with measurements.

concerned. His shots typically took the form of rapid pans, which waved about from side to side and up and down. This is the exact opposite of the advice given to amateur cinematographers in magazines such as *Le Cinéma chez soi* (Cinema at Home), which gave its readers basic advice on technique. Under the heading 'Do not move your camera!', Lucien Pierron counselled:

> The panning shot, there's your enemy! How many films ruined by a shaky camera! If you take twenty bad films, fifteen of them will have been ruined by this fault....At any rate, let us pan the camera gently, very gently so that the movement of the camera should be imperceptible.[7]

Pierron also pointed out that moving the camera risked creating a blurred image. In another article, the issue of economy was linked to the length of shots.[8] Film-makers were advised to take no more than one-hundred frames for a head shot (four seconds) and two hundred for groups and landscapes, 'but only, obviously if the latter are animated'. Le Corbusier panned like mad, with a rapidity and irregularity that produced both the blurred images and that sense of nausea that Pierron warned about.

Why did Le Corbusier acquire a film camera? On 11 May 1936 he noted in his diary: 'Tell P. Chenal to shoot a film in 24 Nungesser + Leman'.[9] It is quite likely that Chenal suggested to Le Corbusier that he might do the job himself, and indeed the first shots he took with his new camera were of his apartment at 24 rue Nungesser et Coli, in the suburb of Boulogne-sur-Seine, Paris, and of his mother's house, Villa Le Lac, at Vevey on Lake Geneva.

The film camera used by Chenal in his early documentaries – *Paris cinéma* (Paris Cinema, 1929), *Petits métiers de Paris* (Small Trades of Paris, 1933) and *Architecture d'aujourd'hui* (The Architecture of Today, 1930) – was the Zeiss Ikon Kinamo.[10] This model, along with the Siemens B (1932) and C (1934), was one of the lightest and smallest spring-operated cameras on the market and was used by many of the pioneering avant-garde documentary film-makers of the period. The well-known Dutch film-maker Joris Ivens, for example, cut his teeth on documentaries shot with Kinamo cameras.

One of the fifteen boxes of 50-foot 16mm film that have survived at the Fondation Le Corbusier, with indications of content: 'Summer 1936; 24 Nungesser et Coli; paintings; rope painting T100 (with tripod); sport Jean Bouin stadium; three bones; Film; Corbu on the roof and lucerne lawn'.

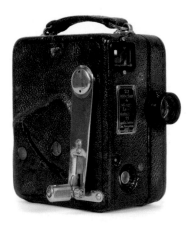

Zeiss Ikon Kinamo 16mm camera, with Carl Zeiss lens 2.7/15mm, series no. 3749, 1928. It was with a camera of this type that Pierre Chenal shot his first films, including *Architecture d'aujourd'hui* (The Architecture of Today), dedicated to Le Corbusier's architecture.

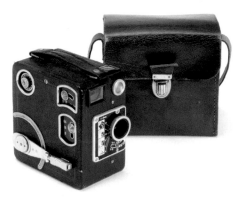

Siemens B camera with Bush Glaukar Anastigmat lens 1:2.8/20mm, c. 1933. The identification of this model with the one owned by Le Corbusier is based on the characteristic fingerprint of its negatives and Le Corbusier's self-portrait in a mirror.

AGFA MOVEX 12 3.5	CINÉ-KODAK B - 3.5	ENSIGN	AGFA MOVEX Simple 8
AGFA MOVEX 30	CINÉ-KODAK B - 1.9	KEYSTONE	BELL & HOWELL 127 SIMPLE 8
BELL & HOWELL Auto-Load	CINÉ-KODAK B B - 1.9	PAILLARD H	BELL & HOWELL 134 DOUBLE 8
BELL & HOWELL FILMO 70	CINÉ-KODAK K	SIEMENS	CINÉ-KODAK Modèle 20 3.5
BELL & HOWELL FILMO 75	CINÉ-KODAK M	SIMPLEX POCKETTE	CINÉ-KODAK Modèle 25 2.7
BELL & HOWELL FILMO 121	CINÉ-KODAK SPÉCIAL (couleur courbe)	STEWART WARNER	CINÉ-KODAK Modèle 60 1.9
BELL & HOWELL FILMO 141 et FILMO 153	CINÉ-KODAK SPÉCIAL (couleur droit)	VICTOR 3	EMEL KEYSTONE STEWART WARNER
CINÉ ANSCO	CINÉ-KODAK MAGAZINE	VICTOR (premiers modèles)	NIZO 8 E
CINÉ-KODAK E - 3.5	CINÉ NIZO	ZEISS MOVIKON (à bobine)	REVERE
CINÉ-KODAK E - 1.9	DE VRY	ZEISS MOVIKON K 16	SIEMENS 8 R

Page of *Der Filmkamera-Katalog: 16mm 9,5mm 8mm Single-8 Super-8 Doppel-Super-8, The Complete Catalog of Movie Cameras* by Jürgen Lossau (Hamburg: Atoll Medien, 2003), showing the diagram of the 'fingerprints' produced by film cameras of the period 1926–38. Only in the case of the Zeiss Movikon (the designation of the Kinamo after its purchase by Zeiss in 1926) and the Siemens cameras does the image overlap the sprocket holes on one side.

So, what camera did Le Corbusier own? This remains a mystery. There is no clue in the documentary record, either in his correspondence or his diary, about the purchase or use of his film camera. A possible clue can be found in a tiny sketch in his diary (p. 34), showing an empty suitcase, some dimensions and the note: 'check cinema + photos' ('vérifier cinéma + clichés').[11] 'Cinéma' was the word Le Corbusier used to refer to anything to do with film-making. Further down the same page, on the left, we see the word 'cinéma' again and the dimensions '140 x 90 x 200'. This page in his diary occurs on the eve of his departure to Brazil on 8 July 1936 and may be interpreted as reflecting his concern at the space available in his suitcase for his transparencies and film camera.[12] The dimensions could well be those of a carrying case for the camera – and a leather case of this size (similar to a Siemens camera case) can be seen in one of the photos of his studio.[13]

Le Corbusier probably acquired his film camera at least a month before his departure to Brazil. We can deduce this from the fact that one of the Kodak film boxes is inscribed 'Summer 1936' and that there is a continuity of shots in this and three other films.[14] It would be tempting to imagine that Chenal lent Le Corbusier his own Kinamo camera, but Le Corbusier's machine seems to have been slightly different. At any rate, we can be sure that Le Corbusier was aware of the significance for avant-garde documentary film-makers of lightweight film cameras, such as the Kinamo Universal, capable of taking still pictures as well as films.

There are two reasons for supposing that Le Corbusier's film camera was in fact a Siemens, Model B or C. His films are distinguished by a strange feature: the images overlap the sprocket holes on one side only. According to research carried out by journalist Jürgen Lossau in his catalogue of film cameras of the 1920s and 1930s, the 'fingerprint' of Le Corbusier's camera corresponds closely to the Siemens cameras (bottom left).[15] Only the Siemens and Zeiss Movikon cameras present this kind of asymmetrical arrangement of the image with respect to the sprocket holes. Zeiss Movikon was the name given to the Kinamo cameras after 1926.

Most of the film cameras manufactured at the beginning of the 1930s were relatively thin, typically measuring 3 to 4 centimetres. In a self-portrait taken by Le Corbusier in a mirror, it is just possible to decipher – despite the underexposure of the negative – the outline of a squat box that is similar to the Siemens Model B, with the metal plate on which the lens is mounted clearly visible (opposite).

All the 50-foot (15.25-metre) reels of film were mounted together onto a big reel in 1987. Analysis of the inscriptions on the surviving film boxes and a cross-reference to Le Corbusier's movements between the summer of 1936 and the spring of 1938 allow us to identify the individual reels and put them in order. This helps us to understand why and when Le Corbusier began to take still photographs with his film camera. The first seven reels (of his apartment in the rue Nungesser et Coli, his mother's house, Villa Le Lac, at Vevey and the trip to Brazil) consist almost entirely of film sequences. Only on the eighth reel, during his return from Brazil on the Italian ocean liner the SS *Conte Biancamano*, did he begin to experiment with the still-frame function of his film camera. During the fortnight at sea he took nearly six hundred photographs. It is quite likely that he had used up most of his film and decided to experiment with the one reel that remained. From this point on, the camera was used primarily for taking still photos, with occasional flurries of film-making, for example at Vevey and Vézelay in the autumn and winter of 1936.

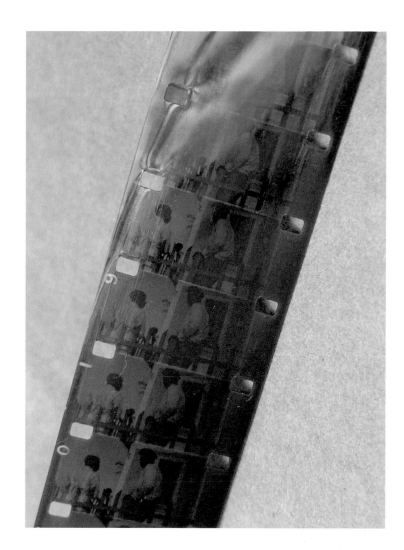

Segment of 16mm film produced by
Le Corbusier's camera, showing the favela
of Santa Teresa in Rio de Janeiro, July or August
1936. The placing of the image on the film
matches the fingerprint of Siemens cameras.

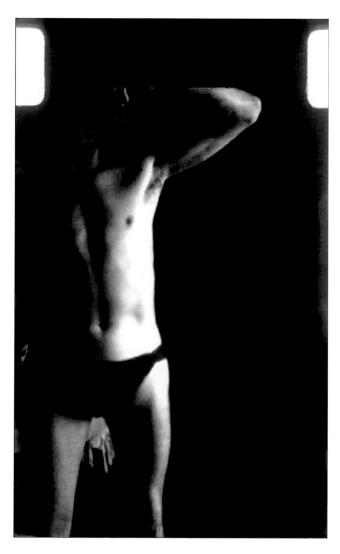

Le Corbusier, self-portrait with film camera,
1936. Le Corbusier took a number of pictures
of himself, naked or nearly naked. In this picture,
taken at Le Piquey in September 1936, the outline
of the Siemens camera can just be identified
(reversed in the mirror).

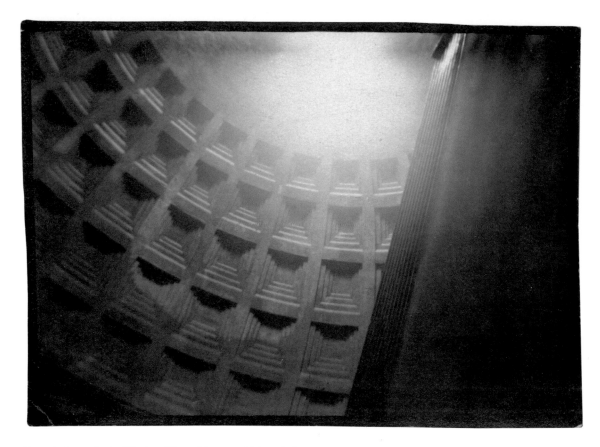

Four photographs by Charles-Edouard Jeanneret taken during
his travels, 1911–16.

Above: The Pantheon, Rome. Photograph taken with the Kodak folding
Brownie (6 x 9cm roll film) bought in Naples a few weeks earlier.

The staircase of a hundred steps, Versailles, c. 1911.

Street and house, probably near Tarnovo, Bulgaria, 1911. Photograph taken with a 6 x 9cm roll-film adaptor on the ICA Cupido 80 camera.

View of Pera, Istanbul, 1911 (6 x 9cm negative, Cupido 80 camera).

THE PHOTOGRAPHS

Although it is easy to understand why Le Corbusier became interested in film around 1930, his return to photography is more puzzling. The young Charles-Edouard Jeanneret was a photography buff. During his travels between 1907 and 1911 in Italy, Germany and Austria, and on his 'Voyage d'Orient' (Journey to the East), he took hundreds of photographs. Starting with a cheap Kodak camera taking square-format pictures, he went on to invest in an expensive plate camera, the Cupido 80.[16] Many of the glass plates taken with this camera, which he developed himself, betrayed technical weaknesses in exposure, framing and development. Occasionally, however, we find some photographs of real merit, in terms of their composition and the handling of light. But his main aim was to document buildings, sculptures and works of decorative art, looking closely both at classical and vernacular work. A hallmark of some of his most interesting photographs was his attempt to capture the essence of a building, while hiding the 'noble' decorative details. His photograph of the Pantheon in Rome (left), which he later reprinted several times in his publications, is an example of this approach.[17] The massive Roman architecture is reduced to a play of light and shade – we could almost be looking at a turbine rotor. Similarly, after taking a number of photographs of the Palace of Versailles, he chose the most elusive and abstract view to publish in his articles. The 'staircase of a hundred steps' (left) effectively hides the palace itself, and its classical architecture, but renders the monumental scale of Louis XIV's ambition. The theme of the staircase features in a number of Jeanneret's photographs during his trip to the East. In his photographs, as in his drawings, he was clearly trying to extract the underlying form and principles of classical and Renaissance architecture without copying 'the styles'.

It is not that Jeanneret was incapable of taking 'good photographs', as is evident, for example, in his plunging view of a street winding up a hill in Pera, Istanbul

(p. 39, top right). There are also several pleasant views of mosques and vernacular houses that bear witness to his attention to the effects of lighting, texture and composition. A particular interest of his was the way in which some houses hide their interior spaces behind a wall (see p. 39, top left), and this subject found expression both in his drawings and photographs.

But the practice of photography did not satisfy him for long. He soon abandoned any mechanical intervention between his eye and the subject. And when it came to communicating the experience of his Journey to the East in his publications and exhibitions, he turned to drawing.[18]

> I bought myself one of the little Kodak cameras that Kodak was selling for six francs in order to sell film to all those idiots who use it (I was one of them), and I noticed that by entrusting my emotions to a lens I was forgetting to have them pass through me – which was serious. So I abandoned the Kodak and picked up my pencil, and ever since then I have always drawn everything, wherever I am.[19]

THE EYE OF THE PHOTOGRAPHER
AND
THE EYE OF THE DRAUGHTSMAN

Artists not only draw what they see but also what they know of the subject – they bring out what seems important to them. This is especially true of architects, who are always curious to understand the function and underlying structure of buildings. The architectural drawings Jeanneret made during his Journey to the East became more analytical and less picturesque as the journey progressed. Increasingly, he endeavoured to grasp and analyse buildings in plan or in bird's eye view, in order to better understand the circulation and the relationship of volumes and spaces.

Photography, on the other hand, necessarily handles the visible in a more passive way. Photographs are produced by light falling on a sensitized surface. But this is not to say that photographers are unable to impose their character on photographs. If the work of the great photographers (such as George Brassaï, who was admired by Le Corbusier) is readily identifiable, this is due to their expertise, a certain way of capturing effects of light and shade and the treatment of tonality. In these ways, photographs can be said to have 'character'. Photographic 'character' ranges from the neutral (apparently lacking in composition) to the abstract. But most well-known photographers, like most artists, take pains to establish a kind of dialogue between the recognizable subject matter and the play of light and shade in their images. However, during his Journey to the East in 1911 Jeanneret was more interested in the subject matter of his photographs than in whether or not they possessed such qualities. There are several different types of photograph. For some critics, 'photographic' effects (of composition, light and shade) are of secondary importance; it is the subject that is crucial – the human scene captured and transferred onto paper.[20] Some of Le Corbusier's photographs of the 1930s are simply snapshots of his wife or mother, his friends or his dog, Pinceau II. Although fascinating for Le Corbusier buffs, these images rarely depart from the anecdotal genre. Similarly, the several hundred detailed photographs that

Two photographs taken by Le Corbusier with his 16mm film camera in 1936 and 1938.
Above (top): His wife, Yvonne, and Jean Badovici on the beach at Le Piquey,
September 1936.
Above (bottom): Yvonne in the living room of the Villa E 1027, surrounded by Eileen
Gray's furniture, Roquebrune-Cap-Martin, 1938.

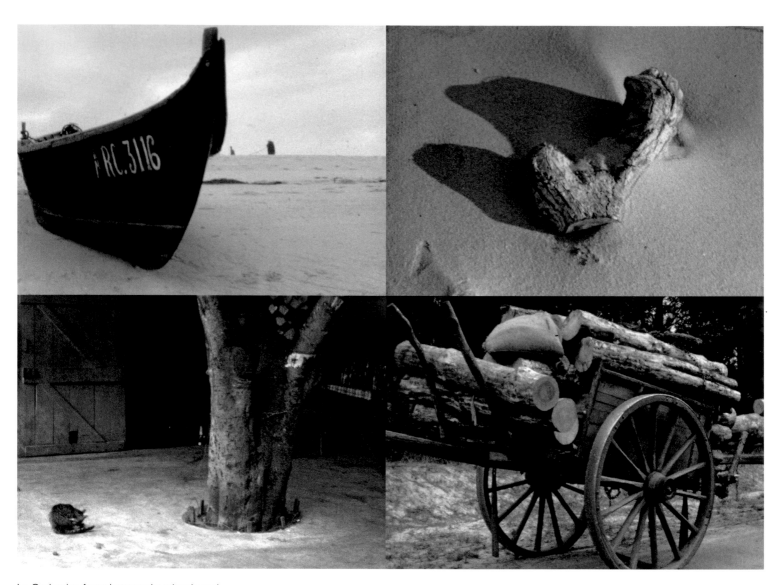

Le Corbusier, four photographs taken in and around Le Piquey (1936–37), showing motifs that had already appeared in his 1930s sketches and paintings, 16mm film camera.

Two photographs taken by Le Corbusier with his 16mm camera in 1937 and 1938. Above: Villa E 1027, designed by Eileen Gray and Jean Badovici, Roquebrune-Cap-Martin, 1938. Le Corbusier stayed in the house and painted some of his murals during this visit.

Portrait of his mother visiting the apartment at 24 rue Nungesser et Coli, Paris, 1937.

were taken of his paintings provide a unique insight into how he saw his own work, but they are of little general interest as photographs.

Le Corbusier collected images of people, buildings and places (postcards, illustrations in magazines and books), which he used as an aide-memoire and as a stimulation for his painting.[21] But (unlike the photographs he took between 1907 and 1911) he took very few architectural photographs with his film camera from 1936 to 1938. Even when filming and photographing in and around the house that he designed for his mother, he tended to focus on the views of the lake and the garden. Exceptions are the photographs he took of the house at Roquebrune, designed by Eileen Gray and Jean Badovici (left above and p. 41, bottom), which offer rare glimpses of the house and its furnishings in 1938.

The vast majority of the photographs that Le Corbusier took between 1936 and 1938 are of natural subjects, seen in detail and fairly abstract. Many of these are the photographic equivalents of the little sketches he made in his notebooks and sketchbooks as visual reminders and stimuli for his painting. There are hundreds of these. From 1928 he had been using natural objects in his paintings: bones, seashells and flotsam found on the beach. He described these 'objets à réaction poétique' (objects for stimulating the imagination) as his 'PC', his personal collection. Many of them have been conserved in the archives of the Fondation Le Corbusier. One of the bones from this collection can be recognized in his painting Léa (1932). Le Corbusier shot a film sequence of this bone, which resembles an aeroplane circling a megalith.

Le Corbusier's paintings of 1928 to 1935 are full of observations made in and around Le Piquey, a small village on the spit of sand separating Arcachon Bay from the sea: boats, fishermen, oyster ladies, coils of rope, sea shells, women and the wooden Hôtel Chanteclerc.[22] In 1936, he revisited this iconography in his photographs. These photos are not for the paintings and drawings, but indicate a kind of repetition and a new view of familiar painterly motifs. The scene of the tree, the little metal table and the chair in the courtyard of the Hôtel Chanteclerc was frequently drawn and painted by Le Corbusier (overleaf, left). He liked to transform the tree into the form of a woman's torso, and often drew a female nude beside it.

The characteristic long and shallow boats of Arcachon Bay lagoon, complete with their heavy coils of rope, were another favourite theme of his drawings and photographs (overleaf, right). The horse-drawn lumber cart, logs of wood and tree roots, which appear in his painting Le Bûcheron (The Logger, 1931), feature in many of his photographs. Countless details of 'objets à réaction poétique' are photographed on the beach, half embedded in sand.

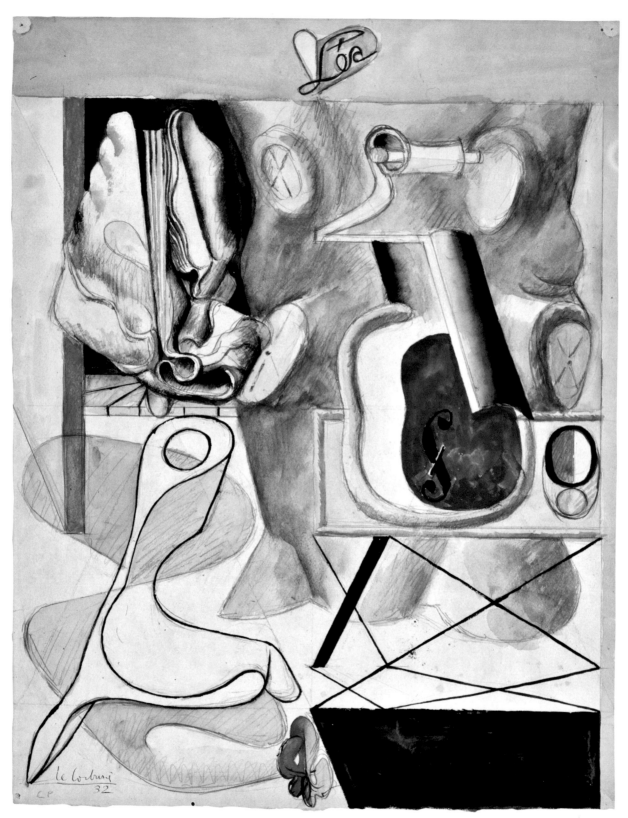

Le Corbusier, preparatory sketch for the painting *Léa*,
1932 (pencil, graphite, coloured ink and watercolour,
49.5 x 38cm). In this sketch, one can see a metal table
and the trunk of a tree from the courtyard of the Hôtel
Chanteclerc, as well as a bone from the architect's
collection of found objects, which he also filmed.

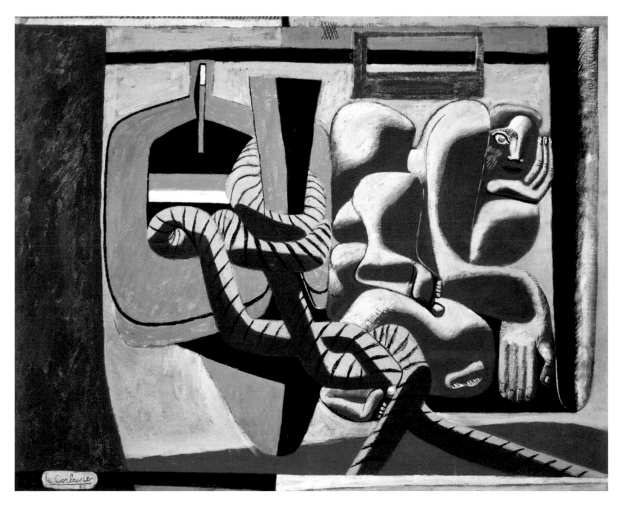

Le Corbusier, cartoon for the tapestry *Marie
Cuttoli*, 1936 (oil on cardboard, 11.4 x 14.6cm).
Images of ropes and boats featured in his
photographs from Arcachon Bay. The association
of these forms with the female body can be found
in many of his paintings of this period.

THE CINEMATOGRAPHIC PHOTOGRAPH

Le Corbusier also took other types of photographs with his film camera. These, more abstract and surprising, were clearly conceived as forming part of an almost cinematographic series.

Each sequence was shot looking down at the sand, immediately in front of him, and he managed to create an astonishingly varied range of effects from this perspective. Working with a particular theme or motif – footprints, ripples, patterns of pebbles or shells – he would take a dozen or so images, each one bringing a different emphasis of light and shade. Above and beyond the 'photographic' effects of composition and range of black and white tones, Le Corbusier usually looked for symbolic associations. For example, he was fascinated by the 'cosmic' effects of the tides, waves and wind, which he saw at work in Arcachon Bay. In a series of images of sand criss-crossed by the footprints of seabirds and formed by the effects of ripples of water, we lose almost all sense of scale. We could be looking down on the desert, as Le Corbusier had done in an aeroplane piloted by Louis Durafour on 18 March 1933 when they flew from Algiers to Laghouat and Ghardaïa.[23]

In his photographs of sand, Le Corbusier is also trying to understand the way in which the sea, rising and falling with the tides and driven by the wind, moulds the surface of the sand. This is both a highly architectural way of looking (searching for cause and effect) and a reflection on nature and its cosmic system, on a miniature scale.

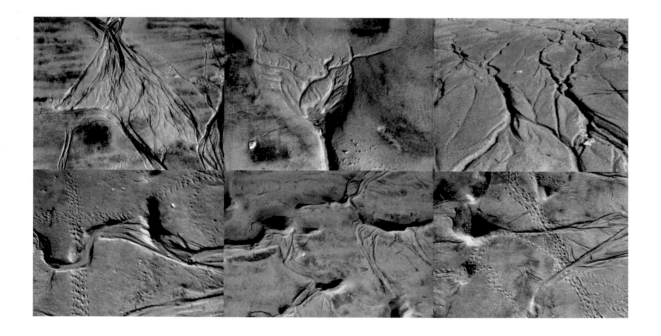

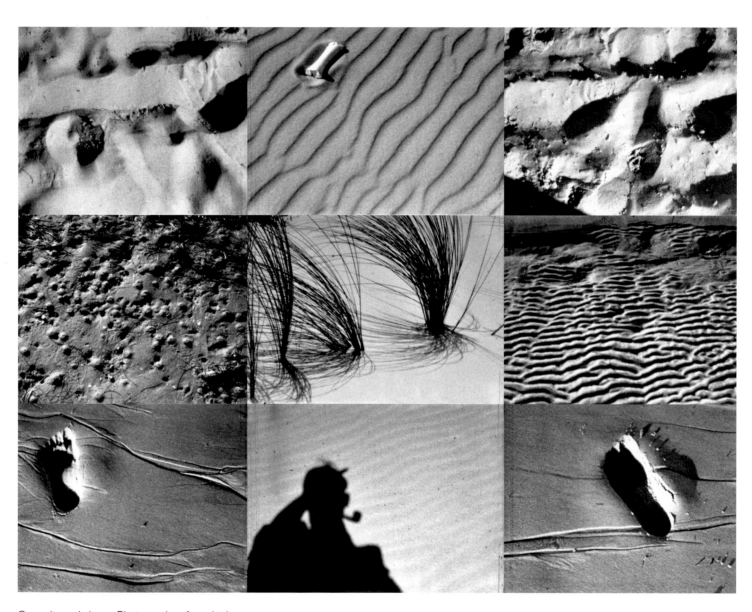

Opposite and above: Photographs of sand taken
by Le Corbusier at the beach at Le Piquey with his
16mm film camera, 1936–37. These almost scaleless
images can be compared to the descriptions of
landscape transformed by the actions of wind and rain
made by Le Corbusier during his aeroplane flights.

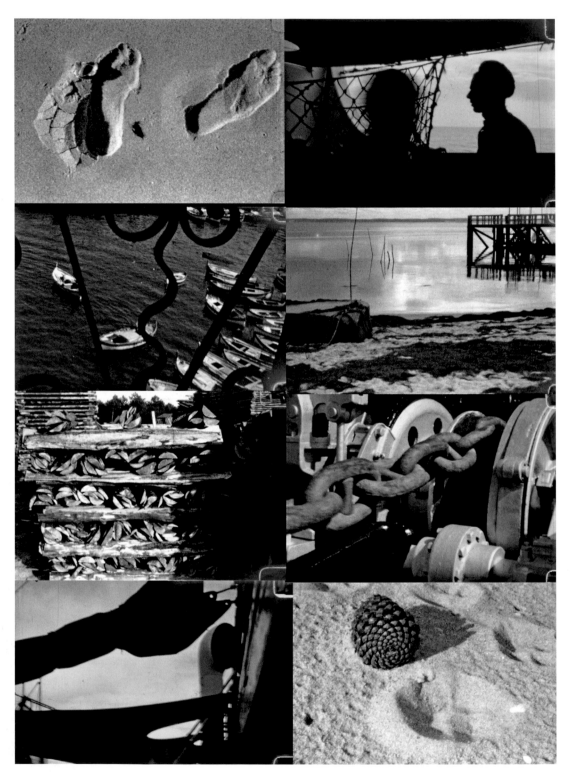

This selection of photographs taken
by Le Corbusier with his 16mm film camera
between 1936 and 1937 illustrates the range
of photographic styles adopted.

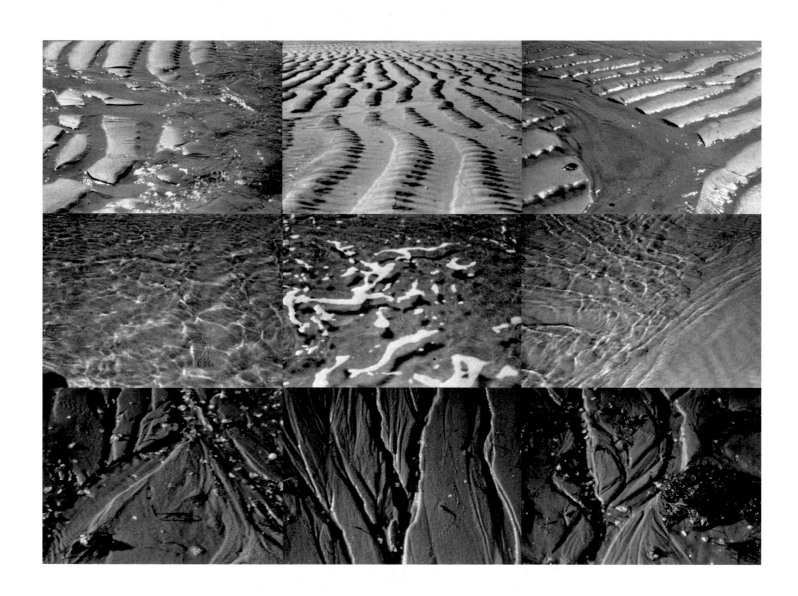

A few of Le Corbusier's many studies of sand
and water, these images focus on the effects
of the tide on the beach at Le Piquey, 1936–37,
16mm film camera.

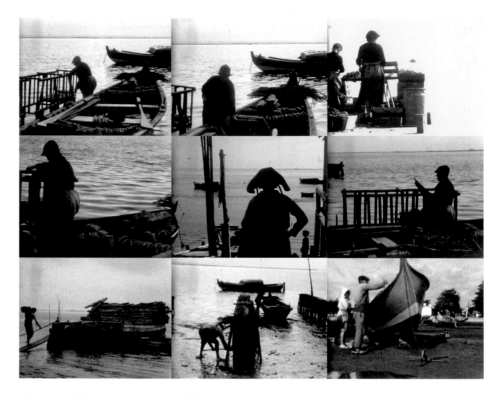

Above: Le Corbusier, photographs of fishermen, men
and women working the oyster beds and the lumberjacks
of Arcachon Bay, 1936–37, 16mm film camera. Le Corbusier's
sympathy for these workers, whose traditional world
was threatened by technical progress, is evident.

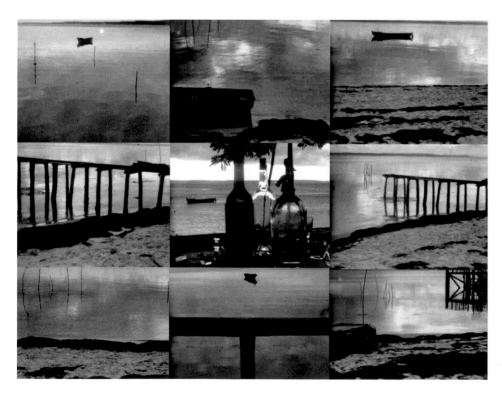

Views in and around Le Piquey, photographed
by Le Corbusier with his 16mm film camera,
1936–37. These delicate images reveal
Le Corbusier's romantic sensibility.

THE SEARCH FOR AUTHENTICITY
AND THE LOSS OF 'HONESTY'

Le Corbusier did not only observe the forces of nature and inanimate objects. He loved the simple life and admired the men and women who worked the pine forests and oyster beds of Arcachon Bay. His book *Une maison – un palais* (A House, A Palace, 1928) includes a long and moving description of the 'honest people' who preserved craft traditions and retained a sense of authenticity in their lives.[24] Many of Le Corbusier's photographs record this threatened community and the rustic cabins in which they lived (opposite, top). The visitor's book at the wooden Hôtel Chanteclerc, where he often stayed, includes this inscription by him:

> I like wooden houses because they are honest: both spiritually and in construction. Le Piquey is nearly finished! I knew it before the roads and the builders came. The lagoon, governed by the thirteen-hour rhythm of the tides – a truly cosmic rhythm – breeds constant diversity and infinite combinations. Now the houses have become 'Basques' with false beams in painted cement and fake wood!...I do believe that if the land had been in the hands of savages, the other half – the lagoon – would have been saved. Where the hell can one still find something true...?[25]

Another group of views in and around Le Piquey constitutes a set of seascapes that recalls the work of the landscape painters that Le Corbusier knew from his early days in La Chaux-de-Fonds. A melancholy romanticism characterizes the photographs and sketches of the 'pinasses' (wooden canoes) that worked the tidal waters of Arcachon Bay (opposite, bottom). These views are a million miles away from the robust and erotic flavour of his paintings of the period and give an interesting insight into the complexity of his reactions to landscape.

If Le Corbusier mourned the loss of innocence of Arcachon Bay, his modernist eye was still sensitive to images of geometrical order and mechanical production (below), which he collected alongside images of the vernacular. The style of these photographs, their framing and composition, differ markedly from his other pictures at Le Piquey.

We have been focusing on Le Piquey, but similar contrasts could be found in the many hundreds of photographs Le Corbusier took on the coast in Brittany, in the woods around Vézelay and at Piacé, where he visited his friend, the farmer and ceramic artist Norbert Bézard.

Selection of details of industrial building materials, photographed by Le Corbusier at Le Piquey, 1936–37, 16mm film camera. Le Corbusier's admiration for the hard and massive profiles of industrial products contrasts with his studies of natural forms and maritime landscapes.

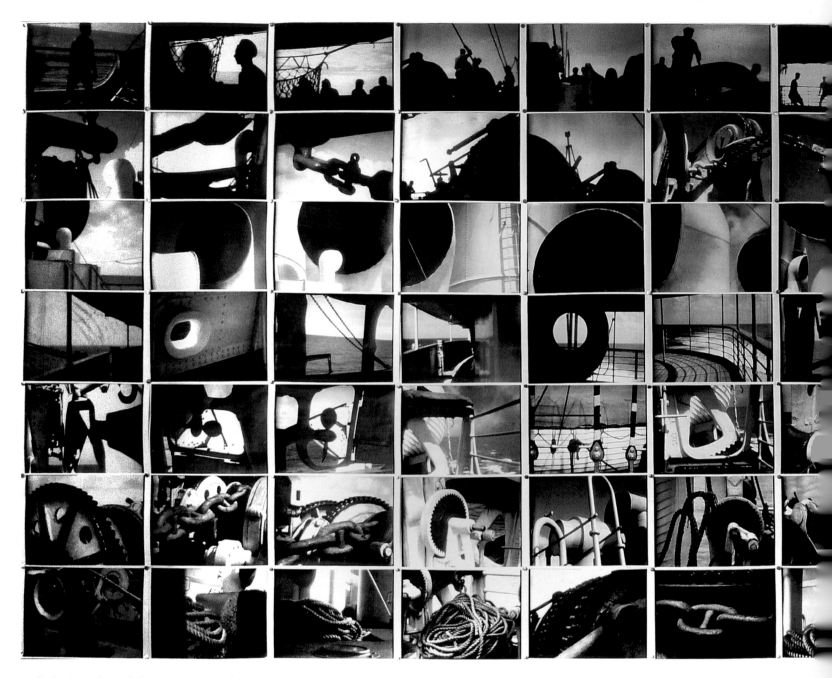

Le Corbusier, collage of sixty-three photographs
shot on the SS *Conte Biancamano*, August
1936, 16mm film camera. The 583 photographs
taken during this sea voyage constitute
a complete lexicon of mechanical forms.

LE CORBUSIER, PHOTOGRAPHER?

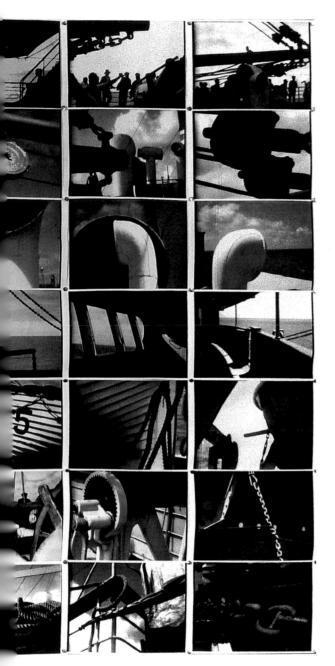

What kind of judgment can we make, in the end, on Le Corbusier as a photographer? From a technical standpoint, he lacked the patience to master the controls of his film camera. Almost all of the hundreds of frames he shot in Algeria in 1938 are hopelessly overexposed and almost invisible. Many other pictures taken indoors are too dark to be usable. He had no focus control on his camera: anything close to the camera would always be slightly out of focus. However, the majority of the photographs that were correctly exposed and taken at a suitable distance are carefully framed with a real photographer's eye. Like the best protagonists of the New Photography[26] of the 1920s and 1930s, he had the ability to capture unusual and disconcerting images. An extraordinary example is provided by the six hundred photographs he took on the Italian ocean liner the SS *Conte Biancamano*, on the trip back to France from Brazil in the autumn of 1936. A large section of this ship, complete with promenade decks, the bridge and passenger saloons, has been preserved in the Leonardo da Vinci National Museum of Science and Technology in Milan. Most people would admire the Art Deco interiors and think about life on board during an Atlantic crossing. There are even some films of this experience, taken by well-to-do Italians, showing the passengers in their fur coats, amusing themselves on the sun decks. Le Corbusier's photographs show none of this. His images form a kind of iconographic dictionary of technological form (by 1936 rather out of date) relating to naval architecture, which harks back to his *L'Esprit nouveau* (The New Spirit) essays in 1920 to 1921, later published in *Vers une architecture* (1923; published in English as *Towards a New Architecture*, 1927). Three of these essays were entitled 'Eyes That Do Not See' and included images of ocean liners, aeroplanes and motor cars as stimulating examples of modernity.

Le Corbusier's views on ocean liners are familiar to many from his discussion of them in his book *L'Art décoratif d'aujourd'hui* (1925; published in English as *The Decorative Art of Today*, 1987).[27] In the course of lectures he gave in 1924 in Geneva, Lausanne and twice in Paris, he compared the external structure of the ocean liner *Paris* (which he considered a marvelous expression of the modern spirit) with the Art Deco staircase, ballrooms and first-class cabins of the interior.[28] The decorated interiors represented for him an old world out of touch with modern reality. His photographs of the SS *Conte Biancamano* ignore completely the daily life of the first-class passengers, the dining rooms and luxury cabins and concentrate on the details of its mechanical functions, using repetition to accumulate a sense of rhythm and geometry. A group of photographs also recorded the lives of the steerage passengers, crowded onto the foredeck, and some of the sailors. Taken together, these images form an extraordinary composition (left).

The publication of Le Corbusier's photographs can certainly be welcomed as offering a privileged insight into the architect's imagination and aesthetic, but many of them also lay claim to be considered seriously as photographs in their own right.

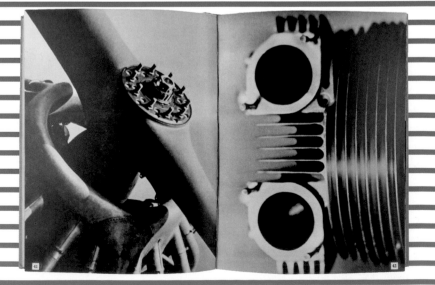

2

'BEWARE PRINTER!': PHOTOGRAPHY AND THE PRINTED PAGE

CATHERINE DE SMET

Representing the very essence of 'l'esprit nouveau' (the new spirit) and a prime example of 'the tools of a modern machine-oriented civilization', photography is central to Le Corbusier's books.[1] His use of the medium goes beyond the mere presence of photographs on the cover or, very often, on the inside pages of his publications. Le Corbusier was extremely particular about the visual and physical qualities of his books and usually designed the page layouts himself.[2] He took full advantage of the advances in 20th-century printing technology, which were geared towards the growing use of photo-mechanical techniques.

Although Charles-Edouard Jeanneret's first published work, *Etude sur le mouvement d'art décoratif en Allemagne* (1912; published in English as *A Study of the Decorative Art Movement in Germany*, 2008), does not include illustrations, *Après le cubisme* (After Cubism, 1918), co-authored with the artist Amédée Ozenfant, was accompanied by a 'free insert', which reproduced ten works by the authors (paintings, drawings). This insert, entitled *Bulletin Thomas*,[3] was entrusted to the photographic printer Le Delay in the rue Claude Bernard in Paris, whereas the sixty pages of the book were printed elsewhere. But Le Corbusier's subsequent publications clearly demonstrate the architect's desire to avoid such a separation of word and image as well as his considerable research into the potential dialogue between text and images on the printed page. *L'Esprit nouveau*, which provided the main ingredients for several of his works published by Crès, was the first example of this experimentation. However, although photography was developing rapidly in the press at that time, the adaptation of these layouts into book format was sufficiently unusual to be included among the selling points in the prospectus that accompanied the publication of *Vers une architecture* (1923; published in English as *Towards a New Architecture*, 1927): 'These magnificent illustrations provide a powerful parallel message alongside the written text. This modern concept of a book, consisting of a vibrant explicit message from the illustrations, enables the author to avoid lame written descriptions; the message simply jumps out of the images.'[4]

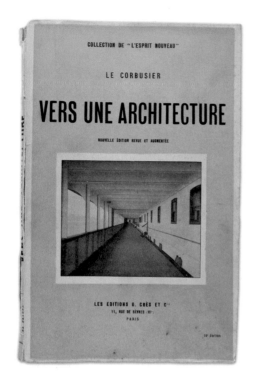

Cover of the third edition of *Vers une architecture* (*Towards a New Architecture*), Paris: Editions Crès & Cie, coll. 'L'Esprit nouveau', first published in 1923.

RECYCLING

In 1935 the art historian and critic Elie Faure described Le Corbusier's books as: 'at first sight chaotic, but mischievously constructed' and emphasized the extraordinary diversity of the images: 'with improvised photos, often beautiful, sometimes funny, aerial shots, pictures of wheels and engines, outdated crockery, stylized furniture, pipes, telephone receivers'.[5] Many other curiosities could easily be added to this list: press cuttings, children's drawings and animals (monkeys, ostriches, fish), etc. – not to mention the numerous works of art, of all types, from all corners of the world and from all periods, and objects and characters from every continent that appeared in his publications. Images from this diverse collection are often shown alongside photographs of Le Corbusier's architectural work. For example, the elongated facade of the two private mansions he designed in Auteuil[6] (shown on a left-hand page) is echoed (on the facing page), in the silhouette of the ocean steamer *Flandre*; elsewhere, an image of Sultan Mahembe and his two sons (borrowed from the magazine *L'Illustré*), with their 'black heads

Two pages of *L'Art décoratif d'aujourd'hui*
(*The Decorative Art of Today*), Paris: Editions
Crès & Cie, coll. 'L'Esprit nouveau', 1925.

against a white background, fit for governing', is juxtaposed with a photograph of the studio that Le Corbusier designed for Ozenfant, in a joint demonstration of 'The Law of Ripolin'.[7]

Illustrations such as these were often borrowed from elsewhere, and although some were duly acknowledged (either under the relevant image or at the end of the work), others were unattributed. Le Corbusier not only cut out images from magazines and other publications to reproduce in his books (including advertising brochures and sales catalogues), but he also sometimes took images from his own previously published books, which he then reproduced in his new books. An illustration in *La Ville radieuse* (1935; published in English as *The Radiant City*, 1967) was presented with no mention of any source.[8] But when it reappeared three years later in his book *Des canons, des munitions? Merci! des logis... s.v.p.* (Cannons, Ammunition? No, thanks. Housing Please, 1938),[9] it was accompanied by the following 'acknowledgment': 'The shell theme, which appears on the cover, is drawn, after several successive photo sessions, from an old magazine whose name escapes us now.' The illustration is, in fact, a photomontage, created from images of at least four different scenes (fighter planes, the details of a gun, warships, shells), of which Le Corbusier made enormous use – it appears several times in the book.[10]

It was during the 1930s, in particular with *Croisade* (Crusade), in 1933, that Le Corbusier set about creating his own photomontages. The practice, which had become commonplace, was no longer the preserve of modern typography, from which he always attempted to distance himself.[11] Before this, the images from popular culture that appeared in his books, juxtaposed on the page with more sophisticated cultural references, recalled various artistic practices of the period (such as collage and recycling). But the page layouts also recalled the editorial tradition of the *Magasin Pittoresque* (Picturesque Store)[12] and, unlike artistic trends of the time, remained quite classical in form. His originality in the

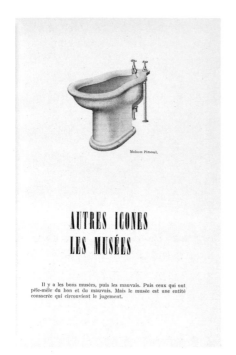

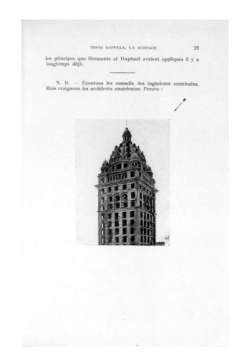

Above, left: Page of *L'Art décoratif d'aujourd'hui* (*The Decorative Art of Today*), Paris: Editions Crès & Cie, coll. 'L'Esprit nouveau', 1925.

Above, right: Page of *Vers une architecture* (*Towards a New Architecture*), Paris: Editions Crès & Cie, coll. 'L'Esprit nouveau', 1923.

use of images was motivated by his desire that they should provide 'explanation' and 'revelation' – a point he emphasized in the prospectus that accompanied the publication of *Vers une architecture*. He reframed, retouched (for example, as in the shots of the Villa Schwob in *L'Esprit nouveau*[13]) and sometimes cut out the objects or people that appeared in the photographs, whose clean forms thus leapt from the page: the turbine from the Gennevilliers power station and the 'Innovation' travelling trunk are, for example, isolated from the context of the original photograph and reproduced in such a way that their evocative power is intensified.[14] Le Corbusier's famous image of the bidet by the manufacturer Maison Pirsoul, which heads his article 'Other icons: The Museums' (left above),[15] is the most striking example of this – the effect is enhanced, at least for readers familiar with the avant-garde movement of the era, by its reference to Marcel Duchamp's 'readymade' porcelain urinal entitled *Fountain* (1917).[16] Also notable are the startling examples in which it is simply the absence of an image that attracts attention: as in the empty frame on one page of *Urbanisme* (1925; published in English as *The City of Tomorrow and its Planning*, 1929), 'Left blank for a work expressing modern feeling';[17] and in *L'Art décoratif d'aujourd'hui* (1925; published in English as *The Decorative Art of Today*, 1987), when the text gives the story behind a missing image.[18]

MONTAGE

The marriage of words and images, which evolved over time, but to which Le Corbusier paid constant attention, gives rise to an extraordinary semantic richness. The prospectus intended to vaunt the merits of *Vers une architecture* when it was published in 1923 in fact seems rather to underplay this: to talk of the 'parallel message' that the images provide does little justice to their carefully constructed complex relationship with the accompanying text. This impression is endorsed on page 29 (above), where the last lines are comprehensible only

after close scrutiny of the photograph reproduced immediately below the text. A typographer's arrow is used to reinforce the link, pointing to the over-elaborate dome that tops the skyscraper in the photograph, clarifying the 'NB' in the text and indicating why it is necessary to be wary of American architects. Meaning, therefore, does not derive from reading in 'parallel' but from reading sequentially.

In *Croisade* we read that, 'The majority of pictures that accompany architecture come from the weekly magazines *Vu* and *Voilà*',[19] citing two of the three recently founded French magazines that devoted a significant amount of space to photographs: *Vu* was founded in 1928 by Lucien Vogel, *Voilà* the following year, and *Regards* in 1932. The political mission of photomontage is here used,[20] not without a certain irony, as ammunition in the battle that Le Corbusier, freshly accused of Bolshevism, launched against Gustave Umbdenstock, an influential architect, whose work and ideas he set out to ridicule. In the middle of *Croisade*, images from *Vu* and *Voilà* are grouped with drawings from Umbdenstock and juxtaposed in such a way as to highlight the differences in aesthetic approach (below). The caption, written in the third person, reads: 'Leaning on the rails of the ship, Le Corbusier was thinking…'. The first illustration exploits this humorous distancing perfectly, playing on the contrast between mechanically produced images and hand-crafted art forms: Le Corbusier is photographed in profile leaning on the guard rail and pensively looking at an imposing, heavily decorated lighthouse: the (drawn) work of the enemy.

In terms of graphics, *Aircraft* (1935) is the most modernist of Le Corbusier's books.[21] This approach was doubtless inspired by a commission from the London publisher, The Studio, who had invited the architect to produce the first volume in a series entitled *The New Vision* – a title that clearly reflects a desire to showcase the latest photographic developments. To the collection of images that were supplied to him by the publisher, Le Corbusier added 'certain more lively documents'.[22] What was missing, in his view, was 'any material that showed what one can see from an aeroplane' and 'maybe some colourful, but very necessary, documents concerning the life of the aviators'.[23] The images appear on the pages in all sorts of arrangements, sometimes running off the edges and with the gaps between the photographs often filled with full-tone black (overleaf, left). Although

Cover and pages of *Croisade, ou le crépuscule des académies* (Crusade, or the Twilight of Academies), Paris: Editions Crès & Cie, coll. 'L'Esprit nouveau', 1933.

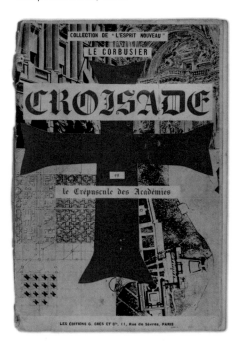

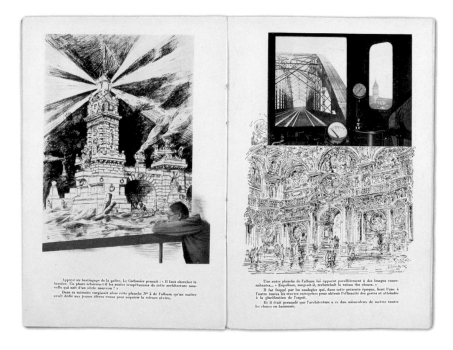

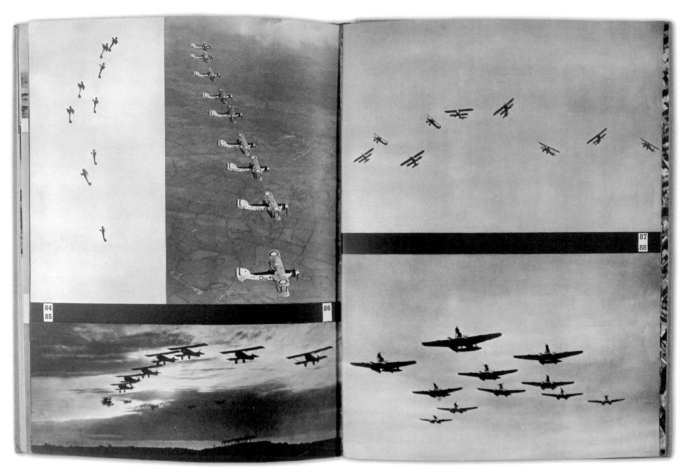

such page layouts preserved some of the graphic amateurism common in Le Corbusier's books, they also reflected the techniques used in certain other contemporary works, especially in *Paris* (1931) by Moï Ver.[24]

Le Corbusier took note of contemporary publications. *Quand les cathédrales étaient blanches: voyage au pays des timides* (published in English as *When the Cathedrals Were White: A Journey to the Country of the Timid People*, 1947), published in 1937, does not contain a single photographic illustration ('Standard format, please – nothing modern', he wrote to his editor when preparing the book).[25] But the sequence of sketches with which the book ends, and which seems to transport the reader progressively away from New York, appears to be making direct reference to Erich Mendelsohn's *Amerika* (1928), a book in which, by contrast, photography plays a central role. There the images retrace the journey in the opposite direction – one's arrival in New York. Mendelsohn, a German architect, offers three perspectives of entering the port. His boat approaches the city ('In the haze the first outlines of the surroundings. Then, rising up, stretching into the sky, the Woolworth spire'[26]), while Le Corbusier's is moving away from it ('New York was disappearing'[27]). One arrives, the other leaves: points of view confront one another. One could think that Le Corbusier's annotation of the last sketch, 'into the country of the timid people', was designed specifically to react to Mendelsohn's comments alongside his own images, which read: 'endless roar of victory'. The use of a drawing as the illustration medium, here perfectly appropriate, was sometimes the result of constraints that meant there was no other option. For instance, Le Corbusier wanted to reproduce a photomontage on the cover of *Destin de Paris* (Fate of Paris, 1941),[28] but to avoid the cost of photoengraving, a drawing that could be reproduced at little cost was created from the photomontage in question.[29]

COLOUR VERSUS BLACK AND WHITE

At the International Exhibition in Paris in 1937, photomontage and large-scale photography finally, if belatedly, triumphed in France.[30] The exhibition of the Pavillon des Temps Nouveaux, created for the occasion, followed the general trend. Le Corbusier's description of its construction, and the guided tour he gives readers in his book *Des canons*, give rise to page layout effects that attempt to create a visual reconstruction of this specific environment. The numerous images – often views of the photomontages exhibited in the galleries – are themselves cut out in various forms: as a staircase, as a trapeze, in an irregular polygon shape or in forms with less angular contours. The building site, and the various stages of construction are represented using a montage of images, one after the other in vertical bands, which conserve the original contact-print aspect, a process that could well have been inspired by László Moholy-Nagy.[31] The cover – the most startling in Le Corbusier's career in print – brought the 'shell theme' into a new composition. The warships have been removed from the right-hand side of the image and replaced by part of the 1937 'Map of Paris' crossed by the river Seine. This complex cover page, very likely the work of Le Corbusier himself (his personal sketches certainly support this view), is based on the use of full-tone colours that contribute directly to the composition: bright red for the double images of planes, guns and shells, with more transparent colours for the city map – green of course, but also blue, marking the thin line of the river. After the half-title, the

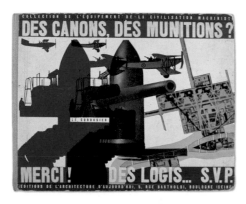

Cover of *Des canons, des munitions? Merci! des logis... s.v.p.* (Cannons, Ammunition? No, thanks. Housing Please), Boulogne-sur-Seine: Editions de L'Architecture d'Aujourd'hui, coll. 'L'Equipement de la civilisation machiniste', 1938.

Opposite: Pages of *Aircraft*, London: The Studio, 1935.

MONTAGE ET ÉQUIPEMENT

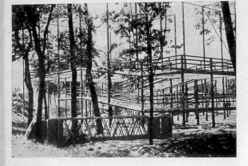

UN CONTENU

STANDARD D'OSSATURE
STANDARD DE PANNEAUX

L'ensemble architectural constitué par les rampes et les locaux divers était porté par un jeu de poteaux d'acier (larges ailes) et de poutrelles de fer et bois obéissant à un standard : travées de 3 mètres de large, espacement des poteaux de 3 m. 50 dans l'autre sens ; la hauteur était celle des dimensions standards que nous préconisons et appliquons depuis longtemps pour tout ce qui concerne l'habitation : une hauteur de 4 m. 50, divisible en deux fois 2 m. 20. Nous n'hésitons jamais à en refaire l'expérience pour vérifier si cette dimension est vraiment à bonne échelle humaine.

Les parois recevant les démonstrations furent construites de panneaux de contre-plaqué standards, de dimension uniforme de 3 m. × 1 m. ou de 3 m. 50 × 1 m., avec un remplissage au droit des planchers de 3 m. × 0 m. 40 et 3 m. 50 × 0 m. 40.

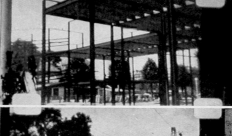

Tout d'abord l'ossature du « contenu » est installée. Poteaux acier, profil double et larges ailes.

Puis on dresse les premiers pylônes du « contenant ».

Les câbles sont installés, équilibrant les travées.

M. Malâtre,

M. Tonnelier, les constructeurs du « contenant ».

Les mains du chef-monteur de Ridder.

Above and opposite: Two pages of *Des canons, des munitions? Merci! des logis... s.v.p.* (Cannons, Ammunition? No, thanks. Housing Please), Boulogne-sur-Seine: Editions de L'Architecture d'Aujourd'hui, coll. 'L'Equipement de la civilisation machiniste', 1938.

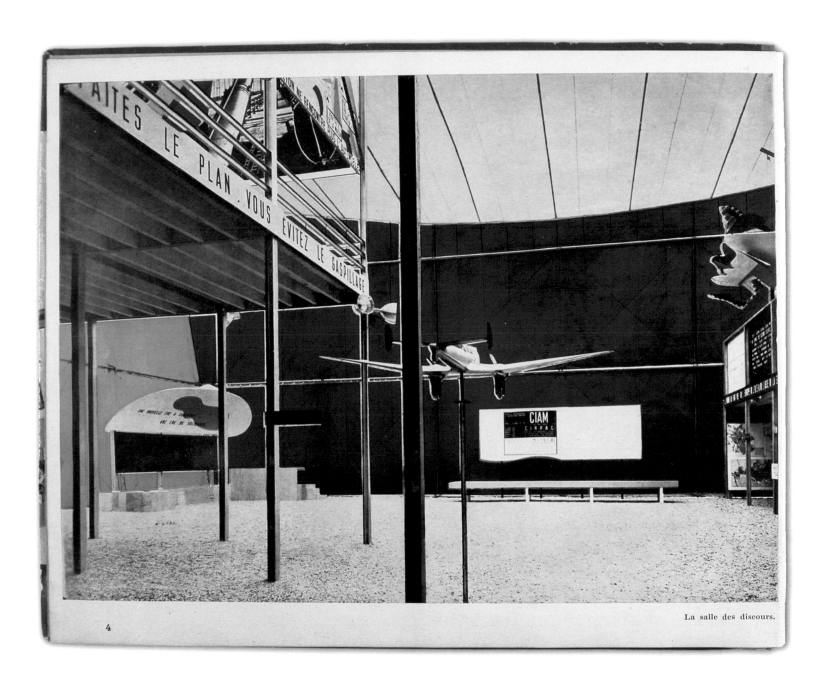

La salle des discours.

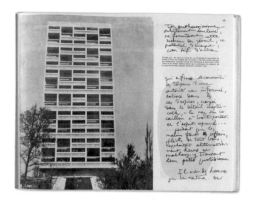

Page of *Les Plans de Paris* (The Maps of Paris),
Paris: Editions de Minuit, 1956.

contents and the title pages, the picture of the Pavillon conference room, with which the book opens, echoes the glossy cover. The same vivid colours, placed on certain parts of the photo, transform the room that is represented.

This use of colour is unusual in Le Corbusier's printed work, in which black and white predominate. When colour is used, it is applied, as can be seen in *Des canons*, in full-tones and, most often, also to highlight line drawings. Apart from a few colourful transpositions of paintings, it was not until the publication of Le Corbusier's final book in 1960 that a colour image of his studio was seen.[32] Areas of full-tone colour, more frequently found towards the end of the 1940s, were dissociated from the photographs, and would even sometimes partly cover them. In the 1948 special edition of *L'Architecture d'aujourd'hui* (The Architecture of Today) and in *Les Plans de Paris* (The Maps of Paris, 1956),[33] for example, they are autonomous graphic elements on the page (left and opposite).

FROM THE BAZAAR TO THE MUSEUM

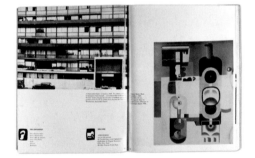

Pages of *L'Atelier de la recherche patiente*
(*My Work*), Stuttgart: Hatje, 1960.

In the 1940s and 1950s Le Corbusier's output focused on the many different aspects of his work: architecture and urbanism, of course, but also drawing, painting and sculpture. During this period he used illustration as a means of demonstrating the essential unity in everything he did. A book offers the possibility of bringing everything together: differences in scale, context, and physical material are merged into the photographic black and white – printed paper becomes the only materiality of the work. By means of eloquent overlapping and superimposition (such as the skyscraper in Algiers bursting through a painting, or the drawings superimposed on the villa in Garches[34]), Le Corbusier underlined the relationships between the various aspects of his art. He would use shrewd juxtapositions and enlarge certain details to make the analogies more striking: the curves in an image would reflect those of a town planning project, or the plans of a villa would bring to mind the composition of a painting. *New World of Space* (1948) is constructed around this principle,[35] which he used on numerous occasions, up to and including in his last book, *L'Atelier de la recherche patiente* (published in English as *My Work*, 1960). In place of the idea of romantic clutter whereby temples rubbed shoulders with motor cars, such as predominated in the 'Esprit nouveau' series, came the idea of the 'imaginary museum' – although in a very personal form. Whereas the books of André Malraux bring together works from all around the world and from various epochs, those by Le Corbusier reunite the works of a single man.[36]

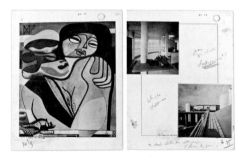

Pages of one of the mock-ups of *L'Architecture d'aujourd'hui* (The Architecture of Today), special Le Corbusier edition, 1947–48.

Opposite: Pages of *L'Architecture d'aujourd'hui* (The Architecture of Today), special Le Corbusier edition, 1948.

Page layout is critical, and its design is an artistic challenge in its own right. The mock-ups that are preserved in Le Corbusier's archives show how important this work was to his creative activity. We find him hesitating ('Can we do without these shots?'[37]), changing his mind ('No, not this shot = very poor!'[38]), giving instructions ('Beware printer! This picture is not rectangular – don't cut corners.'[39]) and sometimes issuing threats ('Beware! I shall refuse my press pass if the shots that mark the beginning of the work get touched up'[40]). His instructions to the printer are numerous and give a clear indication of his expectations: here he wants the images in 'coarse screen format'; there he wants a 'full-bleed image'. The conversion process was particularly interesting: the photographs that Le Corbusier wished to have reproduced would very often first be sketched on the mock-up pages (sometimes

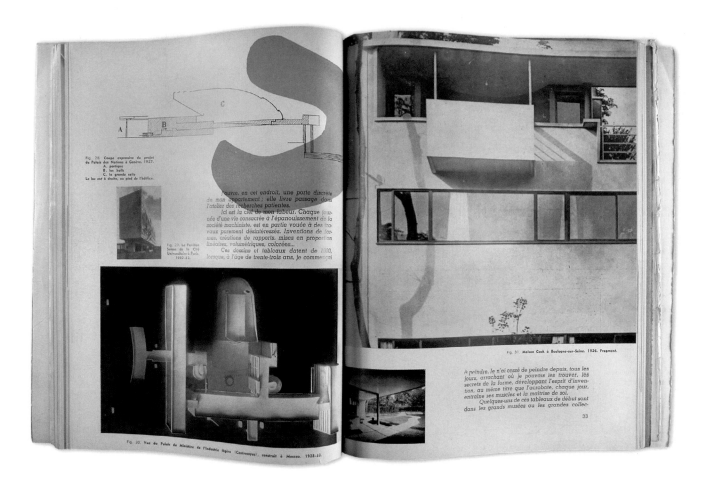

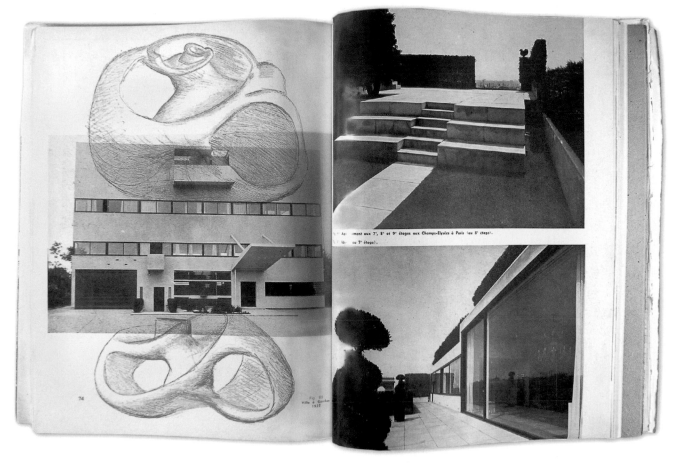

Old Cemetex envelope, used by Le Corbusier to keep photographs and drawings that were to be published in the book *Une petite maison* (A Little House), as indicated by his handwritten notes. Cemetex was a company that supplied building coverings.

with the photographer's name or with page references, if they had appeared in a previous publication), before the first proofing allowed the images to be positioned accurately. Sometimes the photographs themselves would be taken from sketches to ensure greater precision in the framing. Images appear and reappear endlessly, from one book to the next and in a variety of different formats.

There were six successive mock-ups for the book *Une petite maison* (A Little House, 1954), the first 'Carnet de la recherche patiente' (Sketchbook of patient research), a series created by Le Corbusier in which he would subsequently publish, but with a different publisher, the monograph devoted to the chapel in Ronchamp.[41] The mock-ups document how the book was prepared, and represent a fine example of 'recherche patiente' (patient research). Le Corbusier makes extensive use of photography to enable readers to discover and visit the villa he had built some thirty years earlier for his parents. He adds a sequence of sketches in his own hand, created between 1945 and 1951 according to the text, to conclude the guided tour. This double illustration, using both photographs and drawings, enabled him to increase the number of viewpoints and at the same time demonstrate some of the many aspects of his skills. The photographs are attributed to 'Mademoiselle Peter, teacher of photography in Vevey', but this recognition is somewhat weakened by the comment, 'based on information from LC'.[42] Clearly, the recognition of copyright in this area was hardly automatic. A short list of photographers (inserted between various company names and those of some priests) is offered under the heading 'People' at the end of *Ronchamp*: 'the good among the awful!'[43] Le Corbusier disputed the remuneration due to Claudine Peter because of the '50 preparatory sketches' he gave her to indicate what the images should look like.[44] ('The Swiss are often quite outrageous in this area,' he wrote to Hans Girsberger, his publisher and negotiator.[45]) 'How, with such prices,' he asked Peter, 'do you imagine that a book can get published and pay for its paper, printer, author and, on top of this, the photographer?'[46] A delicate question indeed.

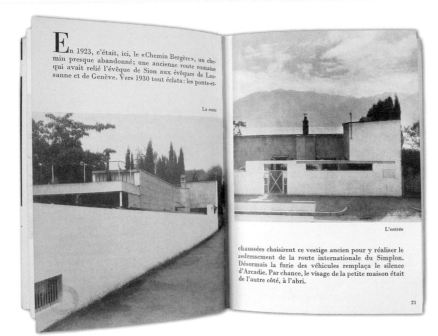

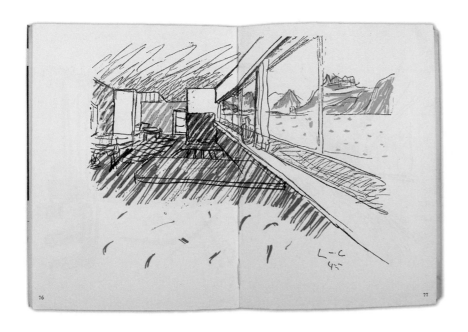

This page: Pages of *Une petite maison* (A Little House), Zurich: Girsberger, coll. 'Les Carnets de la recherche patiente', no. 1, 1954.

Overleaf and following pages: Cover of *Une petite maison* (A Little House), Zurich: Girsberger, coll. 'Les Carnets de la recherche patiente', no. 1, 1954, and pages of one of the mock-ups of *Une petite maison*, 1953–54.

UNE
PETITE
MAISON

LE CORBUSIER

AUX EDITIONS GIRSBERGER
ZURICH

les carnets
de
la
recherche
patiente

1

CARNET N° AOUT 1954

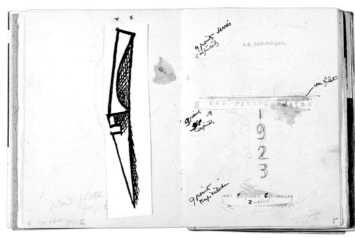

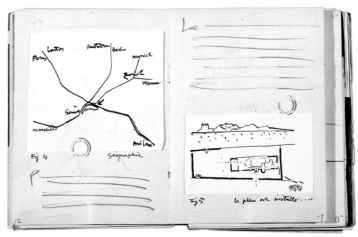

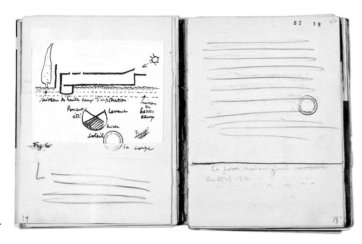

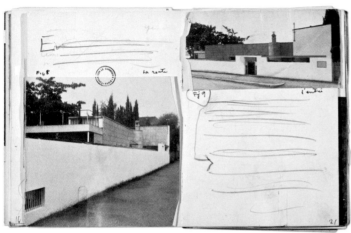

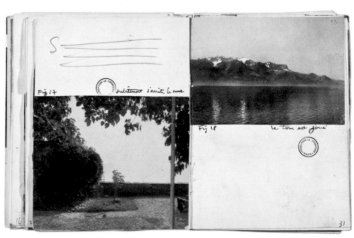

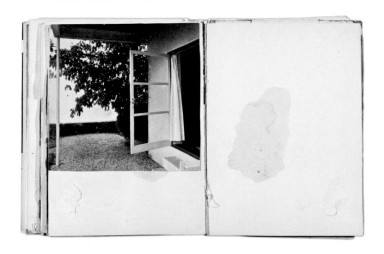

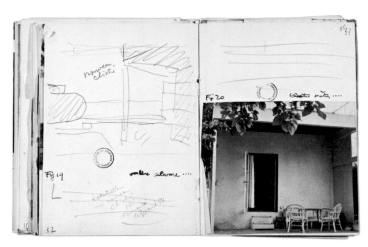

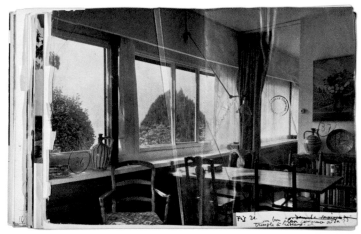

Fig 32.

ici l'écoulement des
eaux de pluie.

46.

Fig 33 FONDATION LE CORBUSIER · PARIS · ou lanterneau

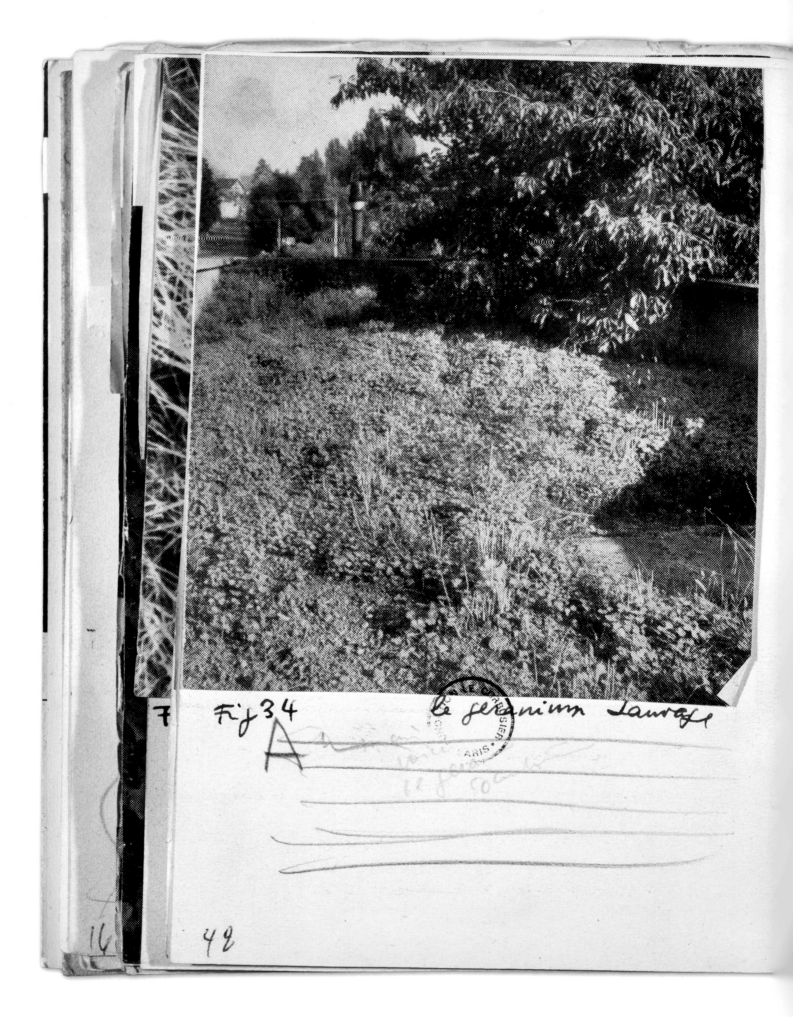

Fig 34 Le géranium sauvage

Fij 35 ...fin d'automne

49

Fg 36 marcher sur le toit...

Fig 37

• descendre de son toit

3

MONUMENTAL
PHOTOGRAPHS

ARTHUR RÜEGG

According to the German philosopher Walter Benjamin, in our domestic spaces, we 'bring together the far away and the long ago'[1] in order to create a private universe. In the context of the interior environment, photography evokes ideas, moods, and biographical moments and keeps them in memory. Around 1917, Charles-Edouard Jeanneret displayed an engraving of the Villa Albani (from Giambattista Piranesi's *Vedute di Roma* [Views of Rome], 1778) on the rear wall of his private office and next to it a photograph of the eastern facade of the Parthenon mounted on cardboard (opposite) – perhaps as a reminder of his Voyage d'Orient (Journey to the East) in 1911, but also with an eye to Mediterranean classicism as a source of an architecture to come.[2] The photograph and the engraving were object-like 'dispositifs à émouvoir'(devices for creating emotions) and in this respect they were similar to objects such as the easel painting, another 'dispositif à émouvoir'. That a photograph, once enlarged to the height of a room, could become part of the architectural shell itself was as difficult to imagine then as it would be in the years that followed. As the propagandist for a new architecture without ornament, Le Corbusier rejected 'decoration' as emphatically as he did the 'cladding' of the naked architectural form. 'The easel painting…proposes a conversation with someone. I would always admit the raison d'être of an easel painting,' he commented in a conversation with Georges Charbonnier in 1960, adding, 'What I don't admit, on the other hand, is decoration.'[3]

PHOTO 'FRESCOES'

Drawing a delicate distinction between 'animation' and 'decoration', Le Corbusier reacted to the question of when it was legitimate to put up a mural or a decorative design of any kind: 'Decorate?…one doesn't decorate…one animates…one adds some soul…one animates a container, the dwelling, through the miracle of colour.'[4] What he meant by this can be understood from the Pavillon Suisse at the Cité Universitaire in Paris: a freestanding box of a building with a freeform ground floor. To cover the partition walls in the student dormitories, Le Corbusier prescribed the colour Salubra wallpapers, which he had developed between 1930 and 1931.[5] In his 'Rapport sur la construction du pavillon suisse' (Report on the construction of the Swiss Pavilion) of August 1931, several months before construction began, he left unanswered the question of whether the walls of the common room on the ground floor – the 'salle courbe' (curved room), which on the plans is described as a 'bibliothèque-réfectoire' (library-refectory) – should also be covered with Salubra wallpaper or be given 'a possible decoration to be discussed.'[6] He apparently did not decide to cover the entire fifty-centimetres-thick rubble-stone wall that forms the northern end of the 'salle courbe' with a photo fresco the full height of the room (overleaf) until 1933, shortly before the official opening.[7]

We can only speculate on the reasons for this decision. The curved wall that abutted a glass facade was certainly not suited for hanging traditional easel paintings. Painting the curved wall in a strong colour, which would be seen from afar, would also have transformed the spatial effect, in the same way as an artistic decoration does. But Le Corbusier evidently believed that putting something extravagant in this particular place would create a stronger contrast for the eye. However, a mural, as the client had proposed, was (still) out of the question: 'I refused. I made a photographic fresco measuring 11m by 4m, constructed from 44 joined panels – like postage stamps stuck one upon the other on a board – of 1m by 1m each, and representing all sorts of things. The ensemble formed a symphony.

Le Corbusier in his apartment 20 rue Jacob, Paris,
after 1917. The Parthenon (photograph) and the Villa
Albani (engraving) evoke important references for the
young architect.

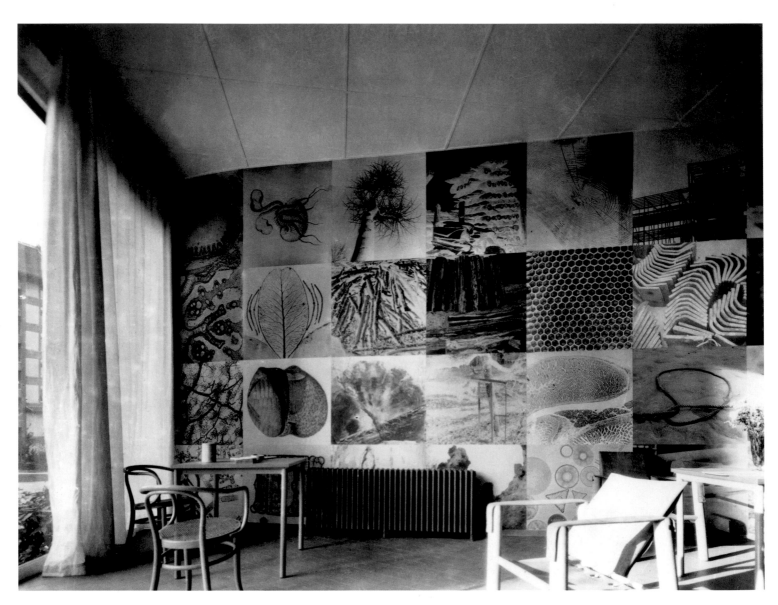

Le Corbusier and Pierre Jeanneret, Pavillon
Suisse, Paris, 1929–33. Photo 'fresco' in the
'salle courbe' (curved room), 1933. The interest
in organic forms is linked to a radical revitalization
of the young architect's formal language.
Photograph by Marius Gravot.

I was the conductor. Without any fuss, by the way. It was composed in an hour. It was the explosion of shocks that I had been experiencing for a long time.'[8] In the lobby, Le Corbusier created a kind of *repoussoir* (foil) for this planar composition by placing white on black photographs – presumably negative prints – on the aerodynamic piping (overleaf, top left).[9]

Defining the iconographic program of the large installation was as important as enlivening these strategic points on the ground floor. Like the form and building material of the curved wall itself, this program was closely linked to a radical renewal of the visual idiom of the artist–architect. As early as 1927 to 1928, weathered stones, shells, fruit, pinecones, strings, and segments of bone had interested Le Corbusier as pictorial subjects – they became 'objets à réaction poétique' (objects for stimulating the imagination).[10] The point of departure for this extension of Le Corbusier's artistic vocabulary was his intense study of nature – he produced countless sketches alongside painter Fernand Léger, while Charlotte Perriand (the furniture and interior designer) and Pierre Jeanneret (Le Corbusier's cousin and partner) explored similar phenomena with the help of a camera from 1932 onwards. The 'large mural by Le Corbusier,' Perriand recalled in 1997, 'was composed of enlarged prints of photographs he and Pierre Jeanneret had taken at Le Piquey: wind-whipped sand, tree trunks, and rocks smoothly rounded by the sea, together with microbiological and mineralogical landscapes.'[11] Whether Pierre Jeanneret photographed these motifs formed by and in nature during joint trips to Spain, North Africa or Arcachon Bay in southwest France has not yet been possible to determine; Le Corbusier himself only began to take photographs again in 1936.[12] However, in addition to the many microphotographs purchased at Le Naturaliste and other such stores[13] and a photograph of the construction of the Pavillon Suisse, at least two of the images come from the photographic research of Perriand and Pierre Jeanneret, and another image, which shows rocks in Haute-Savoie, from Charlotte Perriand's alone.[14] Wherever the photographs came from, for Le Corbusier the demonstration was successful in terms of form as well as content: 'The insatiable lens reveals the macrocosm and the microcosm. Everything can be retold, shown, built from the sensational apparitions of the world, of the immense and unknown world. Where the eye succumbs, the lens takes over.'[15]

 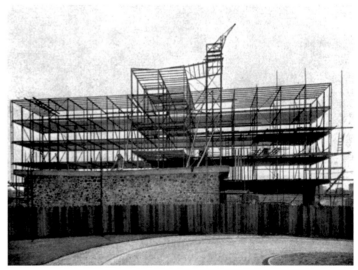

Two photographs used for the photo 'fresco' in the Pavillon Suisse. Above, left: Charlotte Perriand and Pierre Jeanneret, *Equerres ordonnées* (Orderly Arrangement of Corner Irons), 1933. Above, right: Skeleton of the Pavillon Suisse, c. 1932.

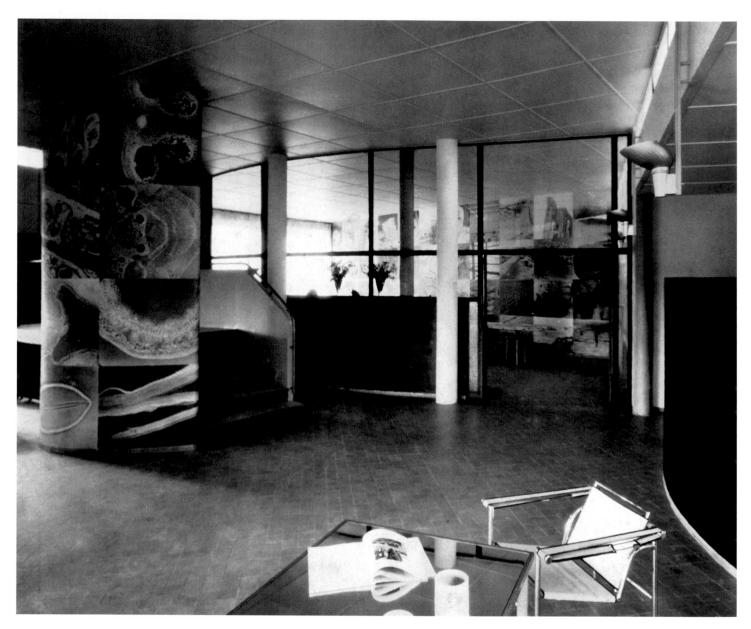

Above: Le Corbusier and Pierre Jeanneret, Pavillon Suisse, Paris, 1929–33. Photo 'frescoes', seen from the lobby. In the foreground, the installation shaft is used as a kind of *repoussoir* (foil) for the large photo 'fresco' of the 'salle courbe' (curved room). Photograph by Marius Gravot.

Below: Pavillon Suisse, plan of the ground floor.

PHOTO COLLAGES

Le Corbusier did not limit himself to 'using, as architect, photographic enlargements as frescoes.'[16] Around 1935 he began to paint walls as well – first in the vacation home of his friend, Jean Badovici, the architect and editor of *L'Architecture Vivante* (Living Architecture), in Vézelay, and later also in the Villa E 1027 in Roquebrune-Cap-Martin, which Badovici built with the furniture designer and architect Eileen Gray. 'I have a…fierce desire to sully the walls', he once reported to 'dear Bado' at the beginning of one of his vacations, 'ten compositions are ready, which is enough to daub over everything.'[17] Between 1936 and 1937 he applied the compositional method of these post-Purist murals to the design of enormous photomontages by overlapping colourful forms painted on wood panels not only with lines but also with photographic enlargements.

Le Corbusier, mural painting in the Villa E 1027, Roquebrune-Cap-Martin (Eileen Gray and Jean Badovici, architects), 1938 (detail).

Below: Le Corbusier and Pierre Jeanneret, Pavillon des Temps Nouveaux, Exposition Internationale, Paris, 1937. External perspective, heliography enhanced with watercolours, 74 x 110cm. The pavilion was in the annex of the exhibition, Porte Maillot.

The technique was by no means new. In France one would have been reminded of the covers of the magazine *Vu*, founded in 1928, which were montaged and coloured using every conceivable technique.[18] For the popular Salon des Arts Ménagers (an annual show of household appliances) in 1936, Perriand created (together with Jean Bossu, Emile Enri, Georges Pollak and Jacques Woog) an enormous collage, measuring 3 × 16 metres, entitled *La Grande misère de Paris* (The Great Misery of Paris), which was intended to illustrate the bleak living conditions in the capital to the countless visitors streaming through the Grand Palais: enlarged photo collages, pasted to canvas frames and partially coloured, overlapped with blocks of text in various colours (overleaf, right).[19] The following year, the Exposition Internationale in Paris turned out to be a true laboratory of monumental imagery.[20] Sonia Delaunay, Raoul Dufy, Fernand Léger, and Pablo Picasso created gigantic murals; the photographer Germaine Krull contributed an equally imposing photomontage. There was an impressive number of photographic compositions in both the Spanish Pavilion and Perriand and Léger's Pavillon de l'Agriculture.

With an eye to the Exposition Internationale, Le Corbusier made several proposals to build a model urban unit in the Bastion Kellermann in Paris. But his plans came to nothing, so he tried to develop the basic theories of modern urban planning

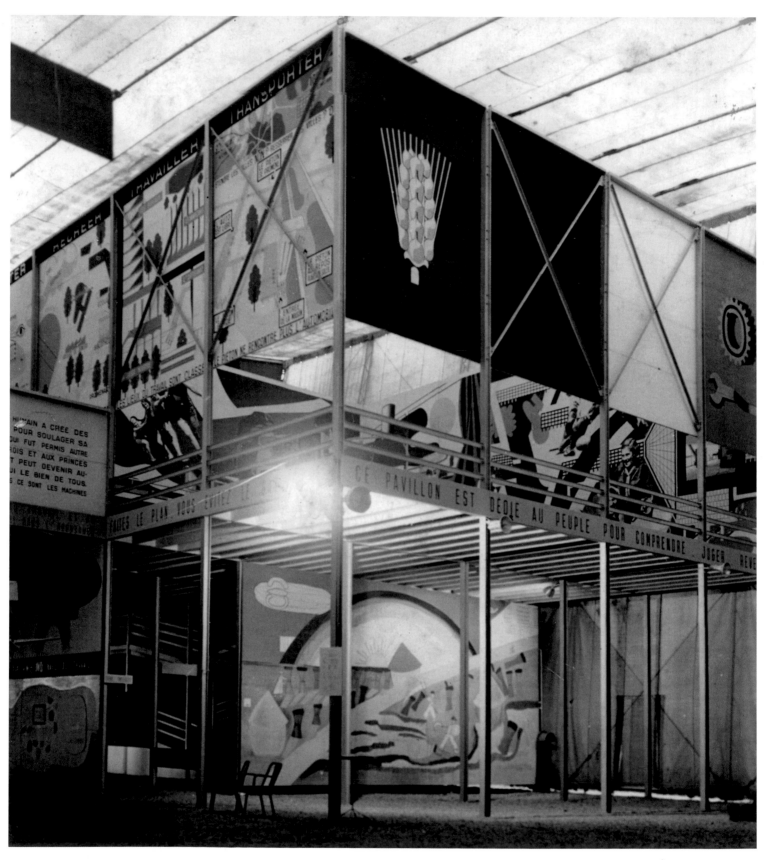

Le Corbusier and Pierre Jeanneret, Pavillon
des Temps Nouveaux, 1937. At the top, view
of the 'artistic visualization of the four functions
of modern urban planning'. At the bottom,
enlargement of a child's drawing.
Photograph by Albin Salaün.

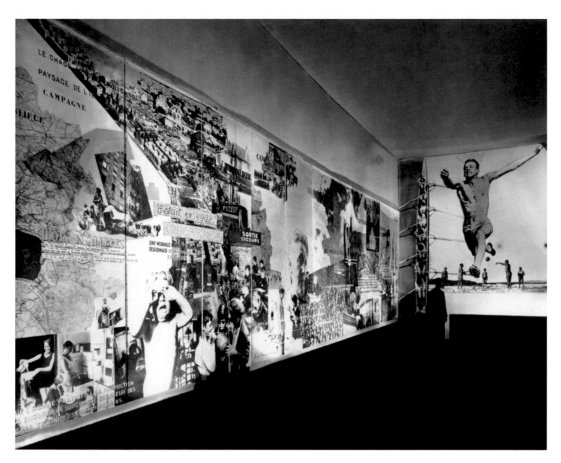

Charlotte Perriand with Jean Bossu, Emile Enri, Georges Pollak and Jacques
Woog, *La Grande misère de Paris* (The Great Misery of Paris), photo collage
for the Exposition de l'Habitation at the Salon des Arts ménagers, Paris, 1936.
An expression of Charlotte Perriand's social commitment. Photograph by Studio Kagaka.

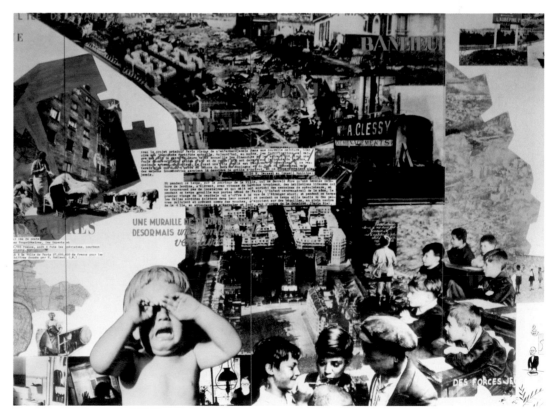

La Grande misère de Paris, reconstituted for the exhibition 'Charlotte Perriand –
Designerin, Fotografin, Aktivistin' at the Museum für Gestaltung, Zürich, 2010 (detail).

The cover of *Cinquième congrès CIAM Paris 1937, Logis et loisirs* (Paris: Editions de L'Architecture d'Aujourd'hui, 1938), with the motif of *L'Esprit de Paris* (The Spirit of Paris), a photo collage created by Le Corbusier for the Pavillon des Temps Nouveaux, Paris, in 1937.

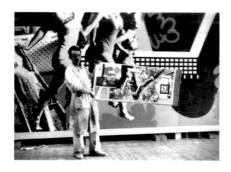

Worker with Le Corbusier's bozzetto in front of the photo collage *Habiter* (Dwelling) at the Pavillon des Temps Nouveaux, Paris, 1937.

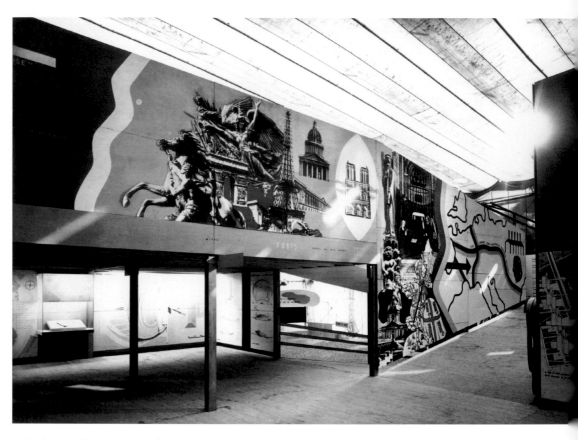

Le Corbusier, *L'Esprit de Paris* (The Spirit of Paris), photo collage, Pavillon des Temps Nouveaux, Paris, 1937. One of Le Corbusier's two large photo collages exhibited in the pavilion. Photograph by Albin Salaün.

using pictorial means. Le Corbusier and Pierre Jeanneret designed a colourful tent to house an 'Exposition ambulante d'éducation populaire' (Travelling exhibition of popular education).[21]

Charlotte Perriand arranged a site in the annex of the exhibition near the Porte Maillot and involved her artist friends in the project.[22] She also began co-ordinating the exhibition, but several months before the exhibition opened, she called off the collaboration with the studio of Le Corbusier and Pierre Jeanneret. With the support of CIAM-France,[23] fifteen topics were addressed in a vast visual programme, mounted on exhibition panels, that totalled 1,600 square metres. In keeping with Le Corbusier's scenography, the exhibition stands were built into a two-storey steel frame. Different architects or artists were responsible for each stand: for example, José Lluís Sert and Elie Faure for the 'Ville Fonctionelle' (The Functional City) and Le Corbusier for 'Plan de Paris' (Map of Paris). With an eye to strong effects and immediate comprehension, they used, above all, large collages (in the tradition of Soviet agitprop) but also explanatory models, enlarged children's drawings, powerful symbols and striking slogans (p. 88).[24] The images were designed to tell stories, much like documentary films, frescoes, or stained glass windows in medieval churches, or idealized images.

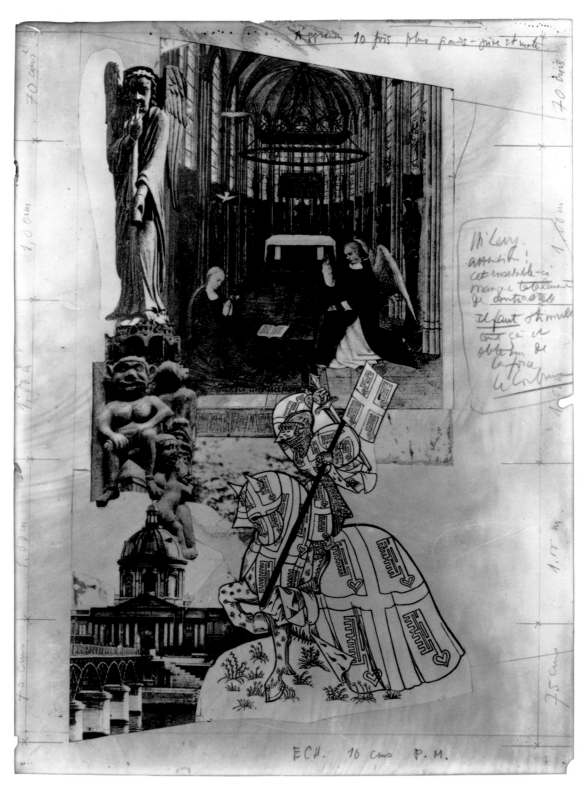

Le Corbusier, project for the right part
of the photo collage *L'Esprit de Paris* (The Spirit
of Paris), Pavillon des Temps Nouveaux, Paris,
1937. Reproduction of a collage annotated by
Le Corbusier: 'This collage at 1/10 scale should
have been enlarged to about 4.50m'.

Le Corbusier, project for the cover of the book
Des canons, des munitions? Merci! des logis...
s.v.p. (Cannons, Ammunition? No, thanks.
Housing Please). Colour pencil and wash
drawing on paper, 21 x 28cm.

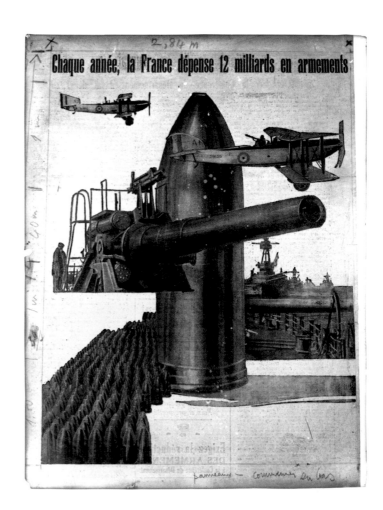

Advertisement featured on an exhibition panel at the Pavillon
des Temps Nouveaux, Paris, 1937 (reproduction of the original
annotated advertisement). It was also used for the cover of the
monograph on the pavilion, *Des canons, des munitions? Merci! des
logis... s.v.p.* (Cannons, Ammunition? No, thanks. Housing Please).

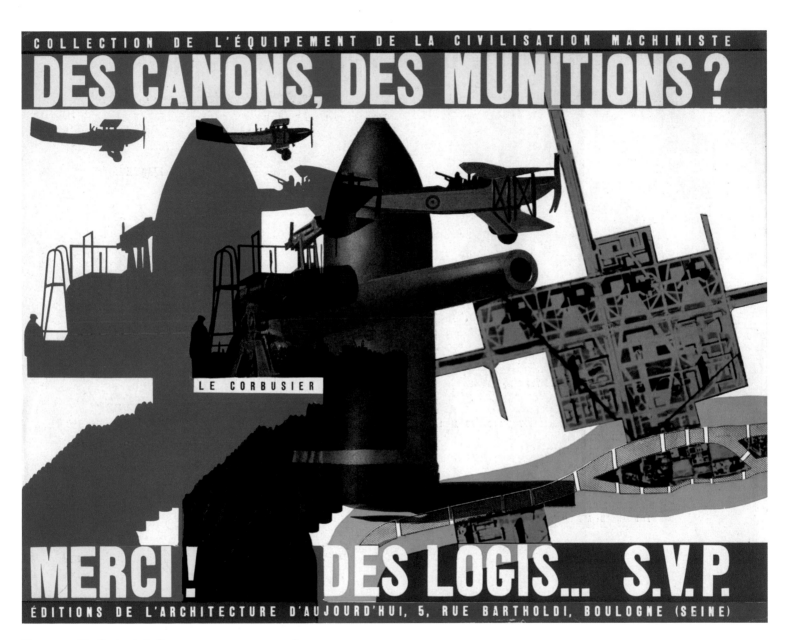

The cover of Le Corbusier's *Des canons,
des munitions? Merci! des logis... s.v.p.*
(Cannons, Ammunition? No, thanks. Housing
Please), Paris: Editions de L'Architecture
d'Aujourd'hui, 1938. Two different patterns
are superimposed, including the 1937 'Plan
de Paris' (Map of Paris). This is also the version
that was used on the order form.

Le Corbusier, project for the photo collage
Habiter (Dwelling), which was exhibited
in the Pavillon des Temps Nouveaux, Paris,
in 1937. Ink and cuttings of Salubra wallpapers
on hard paper, 21 x 31cm.

At the base of the ramp leading from the second to the third floor, Le Corbusier
presented *L'Esprit de Paris* (The Spirit of Paris): 'the true face of Paris – audacity,
elan, creative spirit, vivacity, acuity, elegance, successive manifestations of the
revolutionary spirit (Roman, Gothic, Renaissance, classical, steel and concrete
of the nineteenth and twentieth centuries); the Cartesian spirit – the torch, for
thousands of years, of white civilization. Always action!'[25] This work can be seen
on two surviving illustrations that show previously unpublished small preparatory
collages of fragments of photographs and drawings (p. 91). The originals were
photographed, enlarged (the right halves were about 4.5 metres high), pasted
to wooden panels and supplemented with paint. In this composition, Notre Dame
cathedral constitutes the 'calm' centre, the hinge between the medieval 'naissance
de l'Occident' (birth of the West, on its right) and contemporary Paris (on its left),
turned upside down by technical progress (p. 90, right). The dawn of a new era

was translated into an aggressive-looking tangle of forms, with photographs of the Eiffel Tower, François Rude's *Départ des Volontaires de 1792* (*Departure of the Volunteers of 1792* – the relief on the Arc de Triomphe in Paris known as *La Marseillaise*), and Guillaume Coustou's *Les Chevaux de Marly* (*Horse Tamers*) on the Champs-Elysées.[26]

A preliminary design for Le Corbusier's second large composition, with Salubra wallpaper samples taped to it (opposite), has been identified by Ivan R. Shumkov.[27] The motif *Habiter* (Dwelling), which measures approximately 6 × 14 metres, was painted and pasted on wooden panels by an unknown hand (overleaf). It was based on a cartoon that no longer survives. The colours are simple to reconstruct in this case, since they follow an associative logic (green = vegetation, blue = sky). The originals of the grainy photographic enlargements of athletes are probably from magazines, whereas the sharp architectural images are from the architect's archive of photographs. Le Corbusier evoked 'a new residential quarter where children play, where young girls run, where athletes exercise at the base of the buildings and in parks that the urban planner has created for leisure.'[28] On the left edge of the painting is an interior from Le Corbusier and Pierre Jeanneret's Immeuble Molitor, completed in 1934 (and 'where one sees the sky through the large glass windows'); and on the right, Le Corbusier's studio in the same building ('permitting meditation in solitude');[29] at bottom centre is an aerial view of the meandering structures of the Ville radieuse (Radiant City). Names of functions and keywords that had been introduced on other exhibition panels nearby were included discreetly in the collage. The gigantic image was part of an 'artistic visualization of the four functions of modern urban planning': a central message of the exhibition, which included not only Le Corbusier's photo collage *Habiter* (Dwelling) but also smaller compositions by Léon Gischia and Lucien Mazenod (*Recréer*; Recreating), Fernand Léger (*Travailler*; Working), and Georges Bauquier (*Transporter*; Transporting) (p. 98).

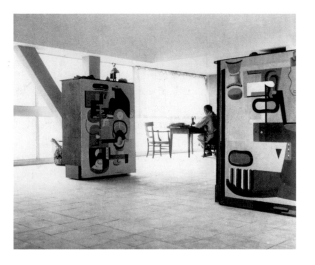

Three photographs used for the photo collage *Habiter* (Dwelling).
Above: Living-room in the Immeuble Molitor, Paris, *c.* 1934.

Le Corbusier's studio in the Immeuble Molitor, Paris, *c.* 1934.

Detail of a block of the Ville radieuse, *c.* 1935.

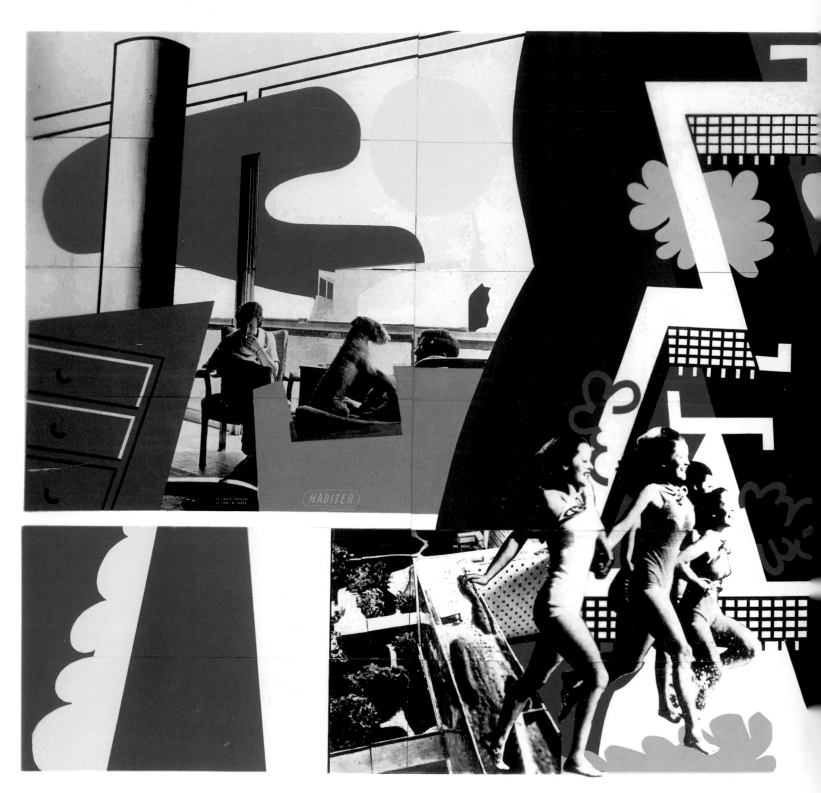

Le Corbusier, *Habiter* (Dwelling), photo collage,
Pavillon des Temps Nouveaux, Paris, 1937. This
ensemble was part of the 'artistic visualization
of the four functions of modern urban planning'
– one of the exhibition's central messages.

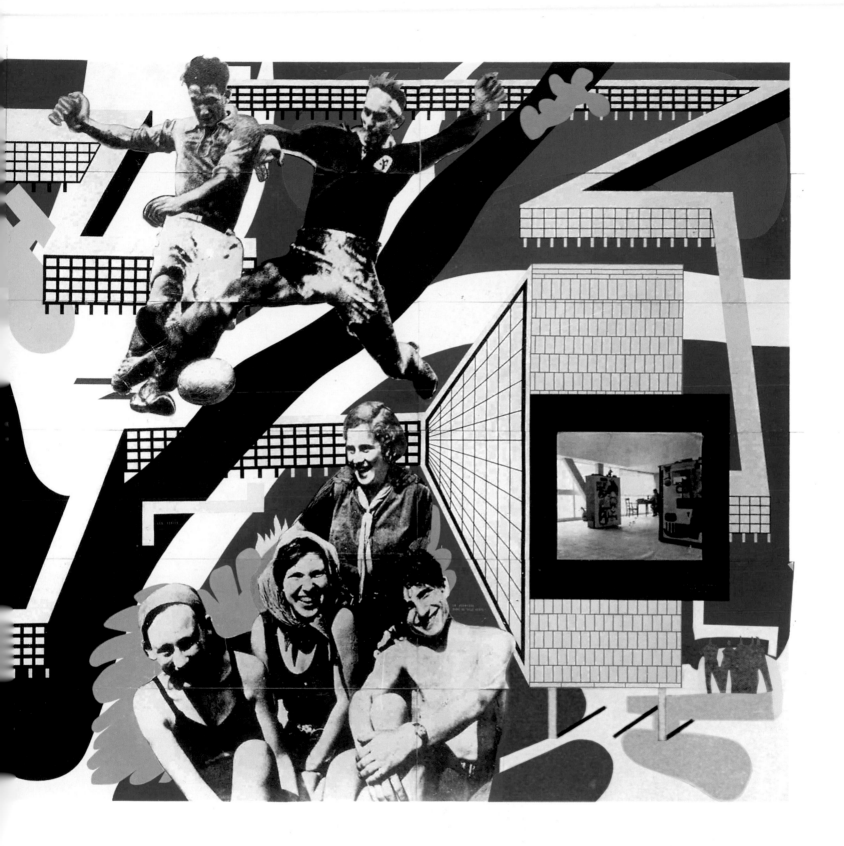

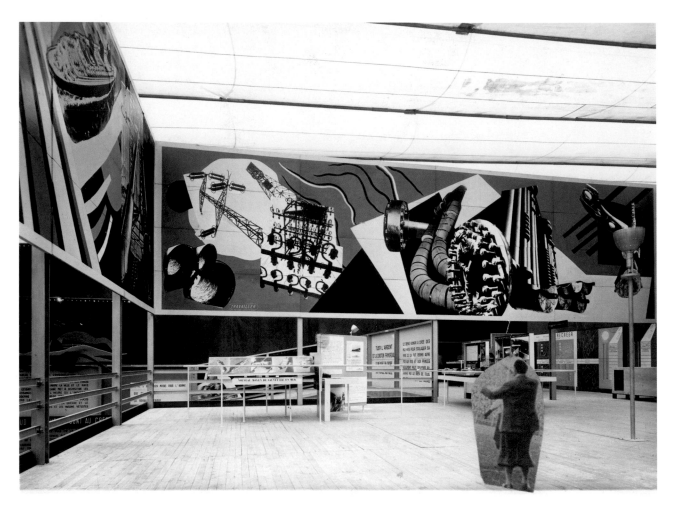

Two photo collages belonging to the 'artistic visualization of the four functions of modern urban planning':

Above: Fernand Léger, *Travailler* (Working), Pavillon des Temps Nouveaux, Paris, 1937.

Right: Lucien Mazenod, *Recréer* (Recreating), Pavillon des Temps Nouveaux, Paris, 1937.

Opposite: Charlotte Perriand and Fernand Léger, *La France agricole* (Agricultural France), photomontage pasted on painted background. Placed on the left panel of the entrance, Pavillon du Ministère de l'Agriculture, Exposition Internationale de Paris, 1937. The Pavillon du Ministère de l'Agriculture was very close to the Pavillon des Temps Nouveaux. Photograph by François Kollar.

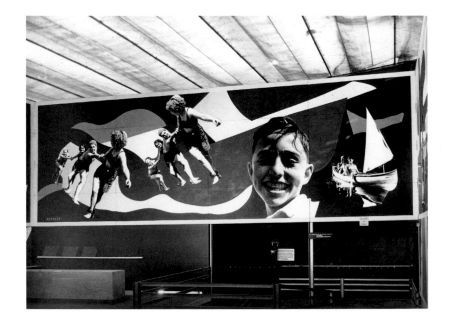

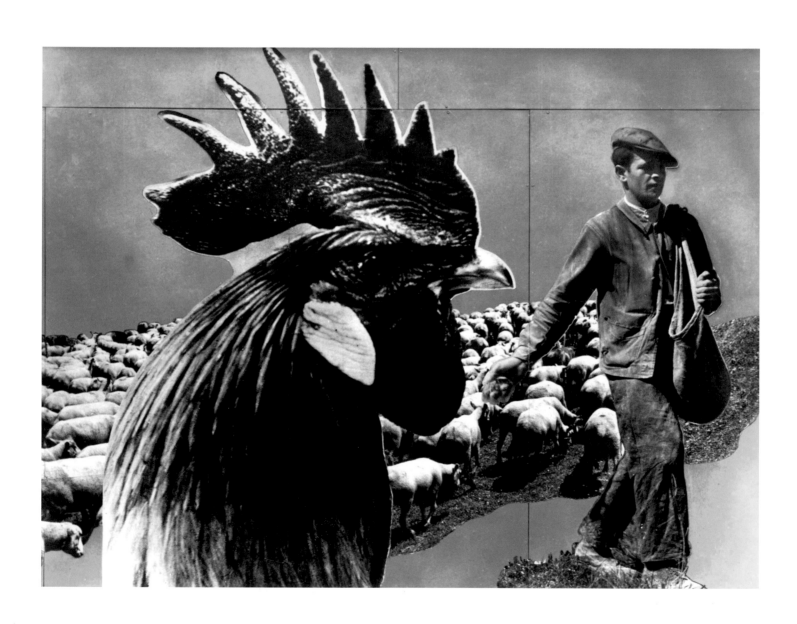

'PHOTOGRAPHIC CAMAÏEU'

Le Corbusier's studio at 35 rue de Sèvres, Paris, c. 1959–60. In the background, Le Corbusier's mural painting, *Femme et coquillage* (Woman and Seashell), 1948. Photograph by René Burri.

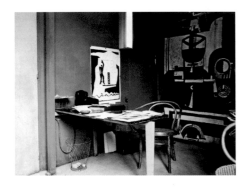

Le Corbusier's 'studiolo' inside his studio at 35 rue de Sèvres, Paris. This photograph shows the latest state of the room (after extension), c. 1965. On the right, the 'photographic camaïeu'. Photograph by Eugène Claudius-Petit.

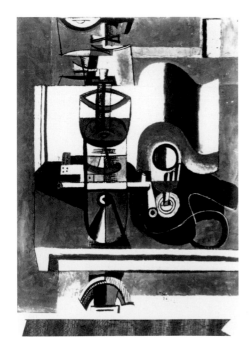

Le Corbusier, *Verres, bouteille et livre* (Glasses, Bottle and Book), 1932. This photograph was used as a model for the 'photographic camaïeu' in Le Corbusier's 'studiolo', 1948.

Propaganda and artistic intervention: these two functions also characterize Le Corbusier's presentations of monumental photographs in the postwar period. When he and his new head of the studio, André Wogenscky, reorganized the studio at 35 rue de Sèvres in Paris, he covered the entire rear wall of the studio with the mural *Femme et coquillage* (Woman and Seashell, 1948), which fulfills the same spatial function as the photo fresco in the Pavillon Suisse (1933). Both are exemplary demonstrations of the use of painting and photomontage, respectively, in architecture, in accordance with the definition he gave in May 1936 on the occasion of the *La querelle du réalisme* (published in English as 'The Quarrel with Realism: The Destiny of Painting', 1937[30]): 'With one stroke, open all the doors to the depths of the dream, precisely were real depth does not exist....This is a fantastic occasion to collaborate with the painter. It is architectural camouflage in the service of thinking.'[31]

In the front of the studio Le Corbusier installed a small, windowless 'studiolo' for himself, with a floor area of 2.26 × 2.59 metres and a height of 2.26 metres (left). This was his first practical application of the 'Modulor' system of dimensions he was in the process of developing. This cell, painted 'English green', was given an interesting visual treatment. On the rear wall Le Corbusier displayed one of his new sculptures, produced in collaboration with the carpenter–sculptor Joseph Savina, thus confirming the architect's commitment to find a synthesis of the visual arts, which would become his trademark from this point on. To the left of the entrance there was a black-and-white reproduction of a Purist painting the full height of the wall – this may seem disappointing, since it was not even a 'genuine' photograph. But Le Corbusier apparently saw it differently: 'For very little money, the photograph makes it possible to realize a play of graphic fantasies. One can reproduce the canvas one likes, enlarging it as a whole or enlarging only one of its fragments. Moreover, one can also reduce it to the dimensions one chooses. It is a way of introducing tapestry into a dwelling. A grey tapestry, that is, but with nuances; grey is the most beautiful of colours.'[32] He was obviously attempting, with the aid of the photographic process, to extract a new original from the oil painting *Verres, bouteille et livre* (Glasses, Bottle and Book, 1932).

This approach is also reflected in the office spaces that Le Corbusier designed according to the Modulor system for the textile company Claude et Duval in the war-ravaged city of Saint-Dié-des-Vosges in 1950. Wood, with a natural finish, and luminous colours were juxtaposed with the new form of photographic mural, which the artist–architect had referred to as 'photographic camaïeu' in his book *Le Modulor*, published the same year (a camaïeu is a technique that employs two or three tints of a single colour).[33] In the office of one of the company's owner, Jean-Jacques Duval, the barely recognizable subjects of a fragment from Le Corbusier's Purist painting *Nature morte aux nombreux objets* (Still Life with Numerous Objects, 1923) interact with an adjacent composition of red, green, yellow, white and black surfaces (opposite). Abstract versus figurative, colour versus black and white: the elements of this wall design dovetail on several levels to form a dialectically charged whole. This whole is the new original.

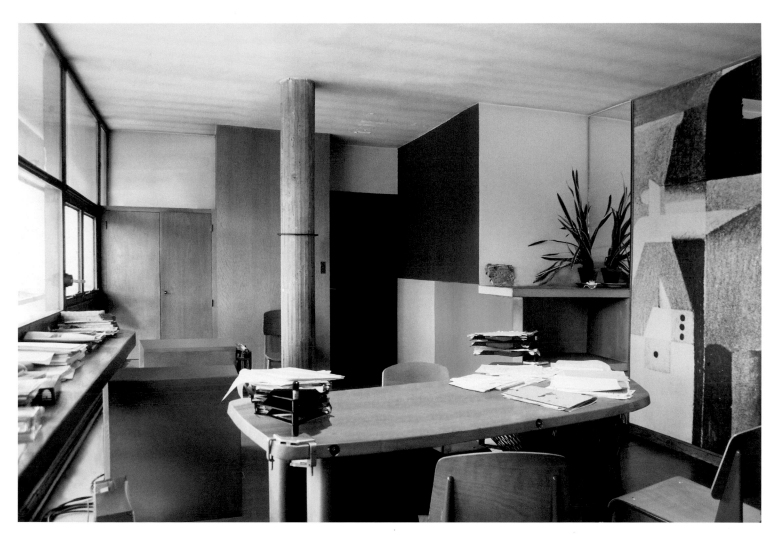

Jean-Jacques Duval's office, Saint-Dié-des-Vosges, 1950. The furniture is by Charlotte Perriand and Jean Prouvé. On the right, the 'photographic camaïeu', a fragment of the painting *Nature morte aux nombreux objets* (Still Life with Numerous Objects), 1923.

Elevation of the partition next to the desk, designed by Le Corbusier, which combines hard colours with the reproduction of a fragment of a black-and-white Purist painting.

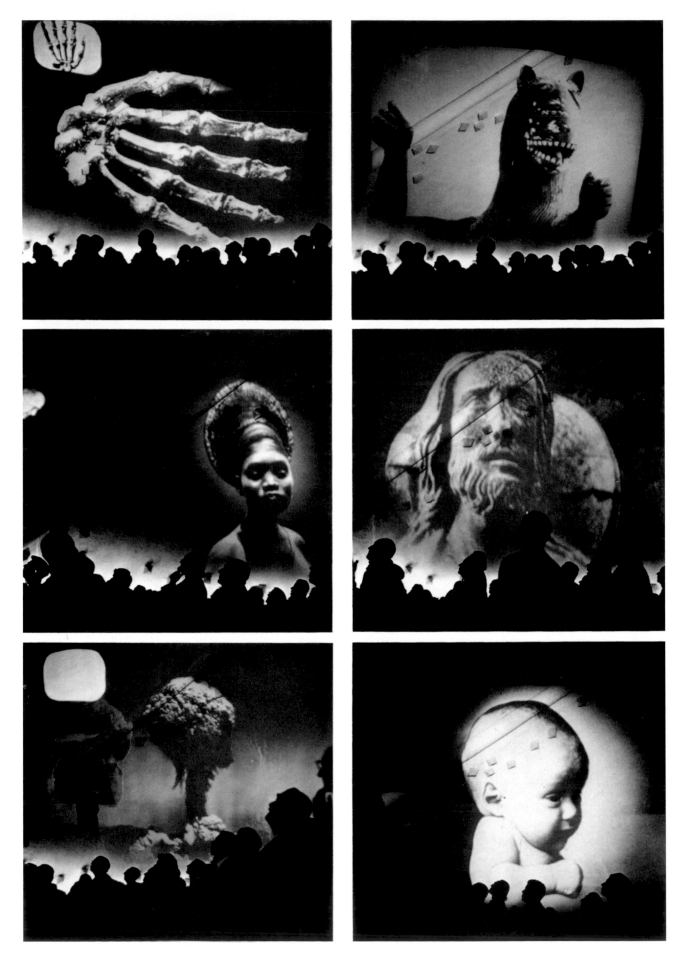

LE POÈME ELECTRONIQUE

Above (top and bottom): Pavillon Philips, Exposition Universelle, Brussels, 1958, external views. Built with concrete elements mounted in a structure of metallic cables and painted silver.

Opposite: A selection of images from Le Corbusier's *Poème électronique* (Electronic Poem), Pavillon Philips, Exposition Universelle, Brussels, 1958.

Creating a dynamic, forever changing whole from the dovetailing of colour and black-and-white images was probably the ultimate challenge for the ageing master. 'Not by coincidence', notes Stanislaus von Moos, 'another World's Fair was needed to provoke a singularly extravagant variation of long-forgotten themes of architectural expressionism, anticipating in such a way the neo-expressionist freestyle of Frank Gehry. When the Philips company appointed Le Corbusier as architect, it was to get a memorable envelope for their venue at the Brussels World's Fair of 1958. It was to be filled with multimedia presentations prepared by Philips's own engineers.'[34] Together with the Greek composer, mathematician, and architect Iannis Xenakis, Le Corbusier developed for the electronics company an expressive, tent-like construction of curved projection surfaces, with a floor plan that recalls a stomach (the pavilion had to be able to 'swallow' and then spit out again around five hundred people every ten minutes).

Le Corbusier, however, made it clear from the outset that he didn't want to provide primarily the shell but rather, above all, the content: 'I will not make you a pavilion with facades. I will make you an electronic poem and the bottle that will contain it.'[35] He succeeded in taking over the initiative and, despite the client's initial resistance, managed to involve the experimental sound artist Edgard Varèse in the project and to combine various forms of artistic expression into a total and multimedia work of art. Le Corbusier himself wrote the script for a seven-part 'electronic poem' that offered a survey of the evolution of humanity, from prehistory to the 1950s, and concluded with a look towards a possible future. The eight-minute presentation combined different lighting and sound effects, and employed four large film projectors; eight theatre spotlights with rotating filters; five floodlights, some with colour filters; six ultraviolet spotlights; fifty light bulbs, to suggest stars; several hundred coloured fluorescent tubes; and three sets of five parabola mirrors with colour filters.[36] To top it all, a phenomenal technical installation containing more than four hundred loudspeakers distributed the sound.

Based on a few surviving film documents and various, more recent, reconstructions, we can just about imagine what this odd audiovisual spectacle might have been like: changing light-baths of intense colour (the 'ambiances'), lit-up phosphorescent sculptures, sharp flashing beams of light (the Tritrous,[37] three small projections on the wall around the large images), and black-and-white film projections distorted by the curves of the walls, seemingly pockmarked by the numerous loudspeakers. The sharply contrasting images were not placed next to the colour, as in the 'photographic camaïeu', but were overlapping it – not unlike the way in which drawings overlap the colour in Le Corbusier's paintings. Varèse's electronic music seems to have evolved with considerable autonomy. The fact that image, colour, rhythm, and sound each have their own rules was further emphasized by the imprecision of the synchronization (the various machines had to be started individually by pressing a button at the beginning of the performances) – so much so that Bart Lootsma, in an important article, described *Le Poème électronique* (The Electronic Poem) as a 'brilliant failure'. A failure that did not result simply from synchronization issues but also had to do with 'the aesthetic principles the authors employed.'[38]

Le Corbusier assembled the seven sequences of his evolutionary history from loosely connected fragments of images, which he had projected – sometimes

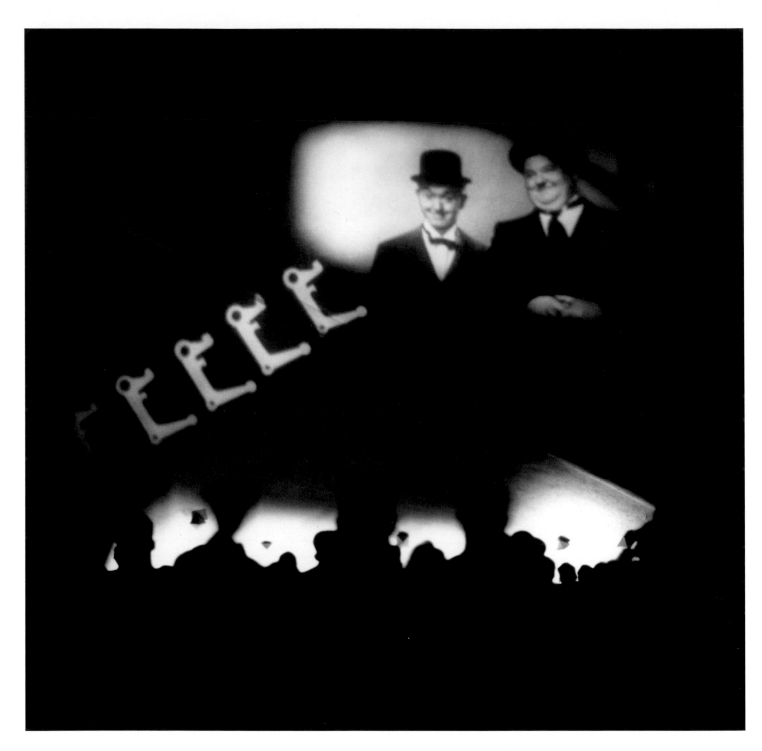

Le Corbusier, *Poème électronique* (Electronic Poem), Pavillon Philips, Exposition Universelle, Brussels, 1958.

Above: Image from sequence no. 6, 'Harmonie' (Harmony) with Laurel and Hardy in the top right-hand corner.

Opposite: Image from sequence no. 7, 'Et pour donner à tous' (And to give to all) with the superimposition of the 'Plan de Paris' (Map of Paris, 1937) and the photograph of a densely populated contemporary city.

from left and right – in a staccato-like alternation.[39] In terms of subject matter, his 'minutage' (timing and sequencing) followed a schema that was similar to that of Charlotte Perriand's *La Grande misère de Paris* (p. 89), in which the history of Paris was rolled out first, followed by the desolate state of the slums of Paris, finally to suggest the possibility of a radiant future with the programme of the Front populaire, a coalition of left-wing movements. Le Corbusier uses strong and evocative keywords: 'Genèse' (Genesis), 'D'argile et d'esprit' (Of clay and

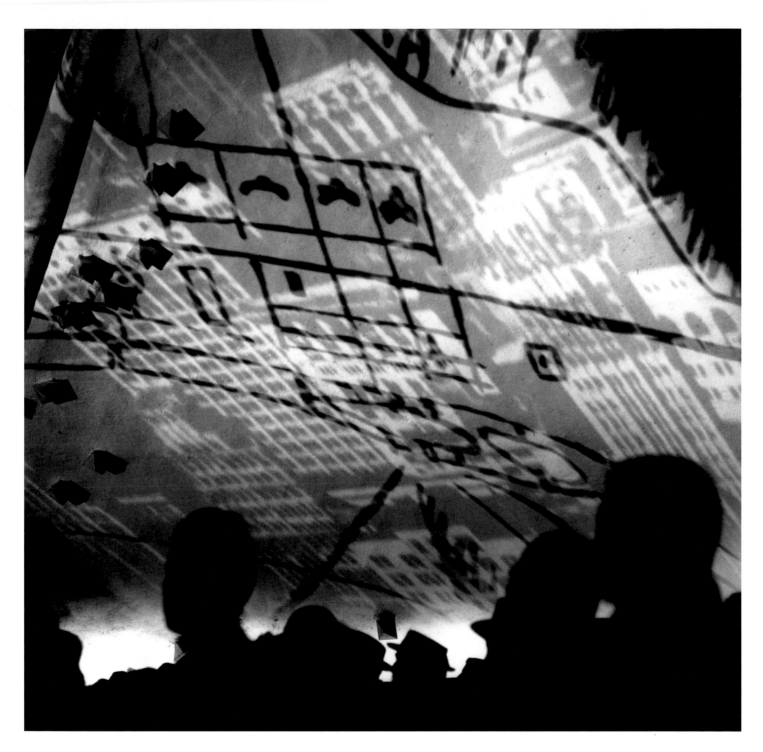

of spirit), 'Des profondeurs à l'aube' (From the depths to the dawn), 'Des dieux faits d'hommes' (Gods made of men), 'Ainsi forgent les ans' (Thus the years forge), 'Harmonie' (Harmony), 'Et pour donner à tous' (And to give to all). For the beautiful monograph on the Brussels Pavilion, the designer and editor Jean Petit, who was collaborating on the 'script and images' of *Le Poème électronique*, selected several of the memorable formulas included in Le Corbusier's message:[40] he began with Michelangelo's unfinished allegory *Day* in the Medici Chapel in Florence (*c.* 1530),

Above: A vertical cut and view of the space behind the barrier of the Pavillon Philips. We can see some of the fluorescent lights (of different colours) and a string of projectors used to create 'atmosphere' thanks to their chromatic filters.

Opposite: Le Corbusier, *Poème électronique* (Electronic Poem), Pavillon Philips, Exposition Universelle, Brussels, 1958. Image from sequence no. 7 'Et pour donner à tous' (And to give to all) with the 1930 Plan Obus for Algiers. Photograph by Lennart Olson.

then a bullfight and skeletons of humans (the Cro-Magnon skull from the Musée de l'Homme in Paris) and dinosaurs, apes and old men, the eyes of animals and people, images of gods and masks (of King Behanzin of Dahomey from the Musée de l'Homme, which Le Corbusier had sketched as early as 1908), concentration camps and toy weapons, depictions of gods from various cultures (Giotto's *Lamentation of Christ* from the Cappella degli Scrovegni, Padua, *c.* 1305), statues of smiling buddhas and kore[41] (from the Acropolis Museum, *c.* 500 BC). Then, in the second half, images of highly advanced technology, miners, surgeons, astonished young people, the lattice construction of the Eiffel Tower, and parts of machines. (Petit chose not to illustrate Charlie Chaplin or Laurel and Hardy in the monograph, even though they appeared in the projection.) Finally, in the last part of the book, Le Corbusier's projects and buildings for Algiers and Chandigarh were shown, followed by a muddy path, and, as an end note, a 'baby ballet' – all signals of a better world that was to be constructed on the basis of new humanistic values. With clear-sightedness, Le Corbusier sketched out attitudes towards life at the height of the cold war: on the one hand, the euphoria over the technology of the time; on the other hand, the omnipresent scenarios of catastrophe – 'catastrophes war volcanos typhoons Buchenwald = important', he noted in one 'Carnet' (sketchbook).[42]

Many of the images were from the Musée de l'Homme, with which Le Corbusier had long been familiar, while others were from the Muséum National d'Histoire Naturelle and the Palais de la Découverte; some were provided by the American Library (images of concentration camps and of American scientists and skyscrapers).[43] Le Corbusier himself revealed two particularly important sources of inspiration: Elie Faure's *L'Esprit des formes* (The Spirit of the Forms, 1927) and André Malraux's *Le Musée imaginaire de la sculpture mondiale* (The Imaginary Museum of World Sculpture, 1952–54).[44] The title of Malraux's book provided the keyword to which Jean Petit alluded in the aforementioned monograph, *Le Poème électronique*, when he referred to the 'nomenclature of optical images' as a 'list that could perfectly determine the bases of a sort of ideal museum of the imagination.'[45] Discovering important images and objects from all eras and in all sizes, analyzing and ordering them and then using them in a different context, first intuitively then on the basis of a theoretical approach, had long been a passion of Le Corbusier's. Like Malraux, he made no distinction between the oldest and the most recent cultural assets: 'Recognizing the "series", creating "unities" across time and space, rendering palpable the view of things in which man has inscribed his presence' – these were the guiding principles upon which he based a 1935 exhibition on primitive art in today's home.[46] Whenever a worthwhile challenge emerged, Le Corbusier attempted to stage, almost as a manifesto, his personal 'musée imaginaire'.

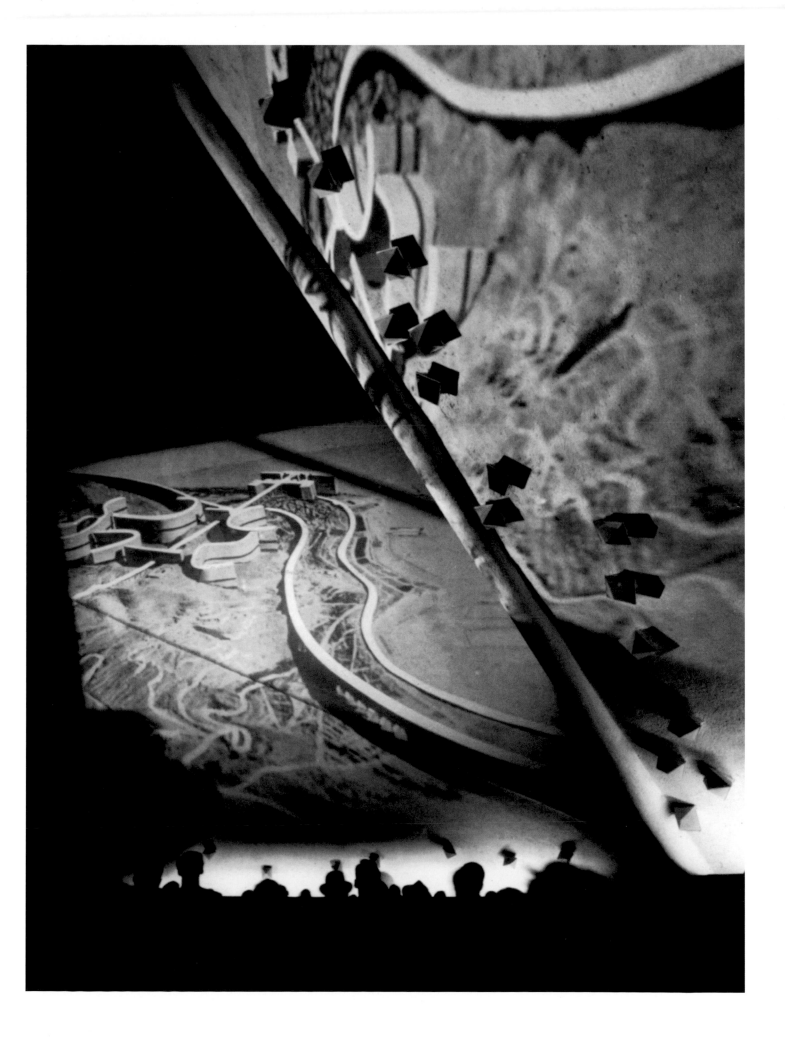

Le Corbusier, studies for the *Poème électronique* (Electronic Poem), second script, *c*. May 1957. Black and white pencil, cuttings of coloured papers and photographs.

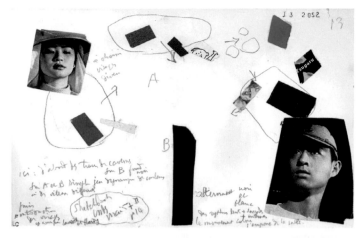

Lucien Hervé, contact sheets showing
the inside of the Pavillon Philips, Exposition
Universelle, Brussels, 1958.

Above: The speakers that punctuate the interior
'skin' of the pavilion are clearly visible.

Opposite: Views taken during the projection
of the *Poème électronique* (Electronic Poem).

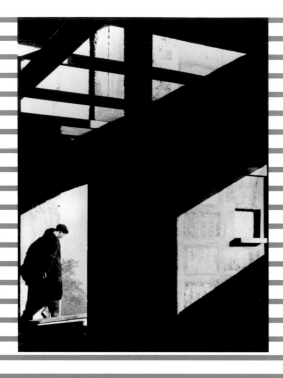

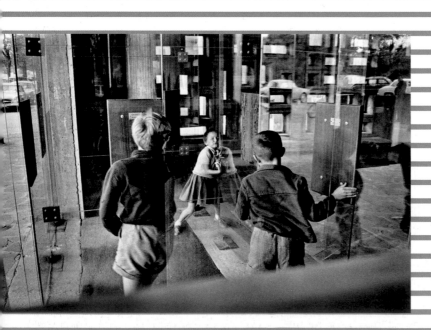

4

THE PROMISE
OF THE RADIANT CITY:
THE VISUAL MEDIA CAMPAIGN FOR
THE UNITÉ D'HABITATION IN MARSEILLE

VERONIQUE BOONE

The Marseille Unité d'Habitation (or Housing Unit) is definitive among the works of Le Corbusier. The length of time it took to plan this highly innovative building, the controversies that surrounded its construction, its impact on post-war architecture and Le Corbusier's overall approach – all have contributed to securing its place as a major historical landmark. The project also represents a landmark in terms of Le Corbusier's use of the visual media in publicity. The control he exerted over images of the site and his promotion of the building generated a series of projects and collaborations that would never be seen again.

This control over images is best demonstrated in the circular entitled 'Notice for the Use of Photographers', issued by Le Corbusier.[1] In this document he makes three main stipulations: all photographs taken of the construction site of the Marseille Unité d'Habitation (also known as the Cité radieuse, or Radiant City) must be sent to the architect, at the photographer's expense; the photographer can only publish images that have been selected by the architect; and the architect has the right to use any submitted photographic document for his own personal requirements. 'I am master of my site and, in permitting the taking of pictures, I do not authorize any photographer to take commercial advantage of them.'[2]

COLLABORATION WITH LUCIEN HERVÉ

On a fine day at the end of December 1949, the photographer for *France Illustration*, Lucien Hervé, arrived in Marseille to take photographs of the famous site that had been recommended to him by Father Couturier. His photographs capture the subtleties of light and shade, texture and proportion, and the relationship between the building and surrounding landscape. Hervé returned with some 650 photographs depicting the soft, harmonious and tactile effects of the building. These peaceful images revealed nothing of the controversy that was taking place in the media, and in Marseille, concerning the building's construction. The editorial staff of *France Illustration* were not at all convinced by what they saw and refused to publish, but Le Corbusier was enthusiastic and thanked Hervé, adding, 'You really have the soul of an architect and you know just how architecture should be viewed.'[3] This was the start of a collaboration that was ended only by the maestro's death in 1965. With Hervé as his photographer, Le Corbusier was better equipped to take advantage of the recent changes in the way in which images could be controlled. Before the Second World War, Le Corbusier exercised control over the *types* of images that were taken; but after the war, due to the popularization of photography, Le Corbusier had to focus on controlling their means of *distribution* (where and in what manner images were reproduced), and this was made more viable by the use of a personal photographer.[4] The appointment of a photographer not only enabled Le Corbusier to retain some control over the representation of his architecture but also ensured that the significantly increased demand for images could be met.

Lucien Hervé photographed the Marseille Unité d'Habitation repeatedly, as he did all Le Corbusier's construction sites and buildings, his paintings, scale models and scenes from his private life. In the following description of the Marseille Unité d'Habitation in *Modulor 2*, Le Corbusier describes clearly what delighted him about Hervé's photographs:

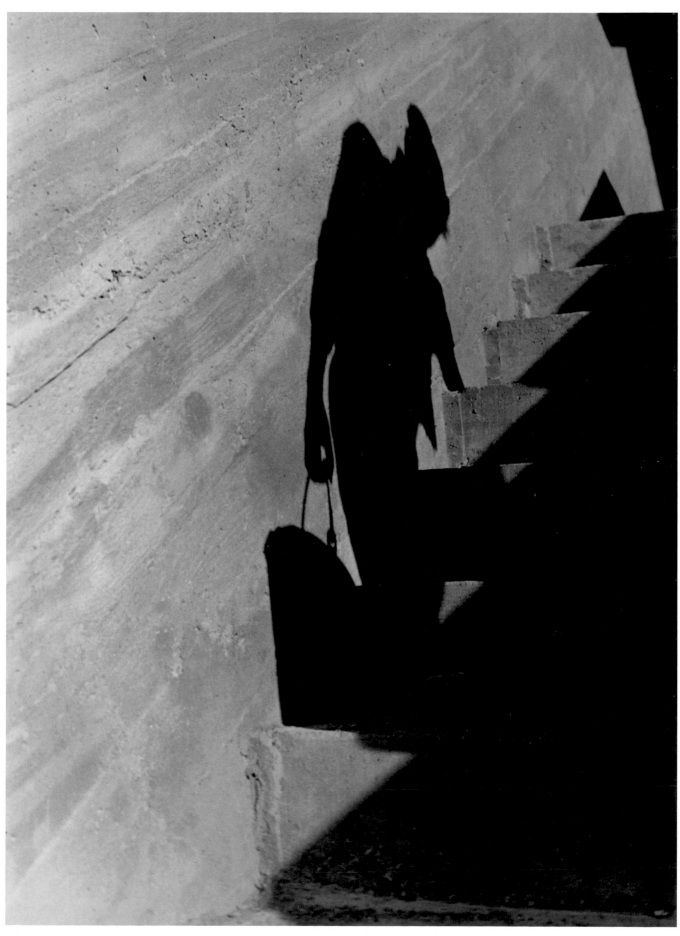

Lucien Hervé, construction site of the
Marseille Unité d'Habitation, 1950. **115** Veronique Boone

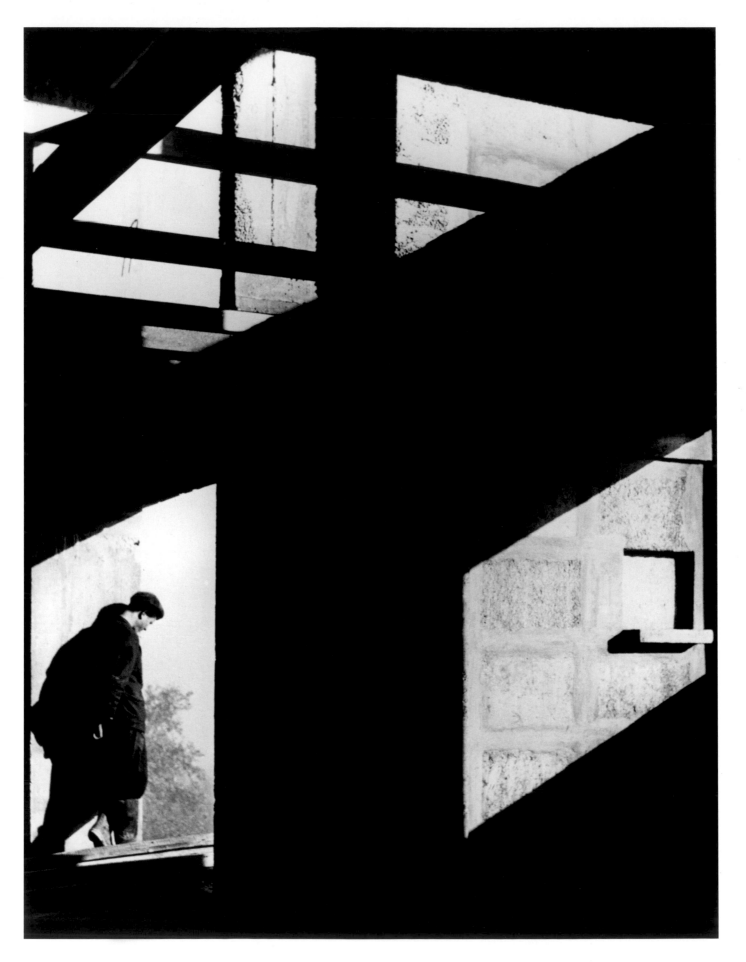

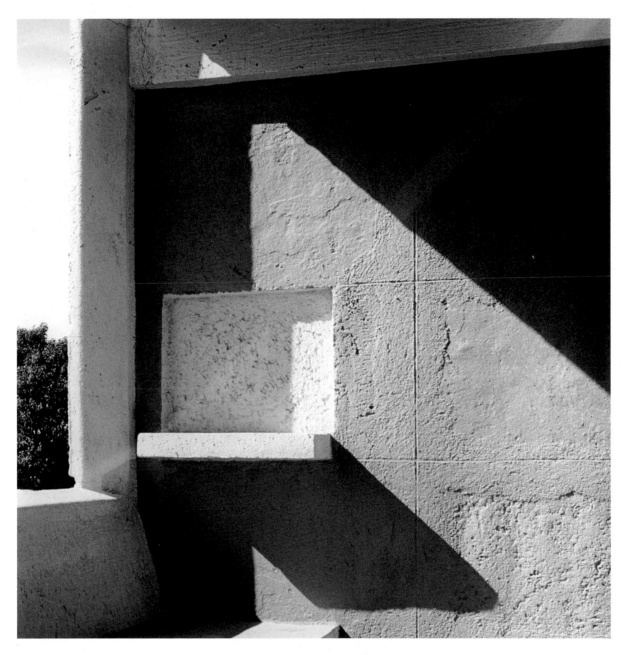

Opposite and above: Lucien Hervé, construction site of the Marseille Unité d'Habitation, 1949. On his first visit, Hervé was moved by the beauty of the structure in its environment. He took more than 650 photographs of the building on that day.

Here are some photographs of the frame, taken at random, showing reinforced concrete beams and pillars and section steel combined with short beams of folded sheet aluminium, balustrades of vibrated and perforated concrete. The site is full of them; an atmosphere of coherence, of proportioning, of living together in friendship reigns everywhere; repercussions of one form, one surface, one line on another. That is where the triumph of the Marseille Unité lies: in this internal

structure which made visits to the site so comforting, so encouraging because of this harmony, daughter of precision, sensed by everyone.[5]

One of Hervé's photographs of the Unité, purposely turned through 90°, illustrates these words perfectly (opposite); but one could almost say the inverse – this description of the site applies to Hervé's photographs, as the proportions are equally elegant.

By the time the main structure was complete, Hervé had been appointed personal photographer to Le Corbusier, which triggered a new phase in creating photographic publicity for the Unité. Not only would publicity and communication increase significantly as a result of the visual media, it would also change form. Hervé's photographs are the perfect illustration of a building that is in harmony with its environment, and of people in harmony with the construction.

DOCUMENTING ON-SITE CONSTRUCTION

The photographs made on behalf of the MRU (Reconstruction and Town Planning Ministry), like this one of the interior of the Unité d'Habitation's show flat by Marcel de Renzis (1949), usually adopt the 'reconstruction' point of view and aim to be as objective as possible.

Unlike Hervé's more artistic portrayal, the images and the films created during the initial phase of construction communicate information in a direct and rational way. The photographs are really no more than pictures of scale models or general views of the activities taking place in the building site. Wide-angled shots of the interior were taken once the show flat was ready.[6] The images are technically accomplished but rarely depart from the informative and descriptive (left). They were usually taken by local photographers who worked for the Reconstruction and Town Planning Ministry (MRU for Ministère de la Reconstruction et de l'Urbanisme) or for the photographic company La Photographie Industrielle du Sud-Ouest, as well as by photographers such as Henri Moiroud and René Zuber, who, for approximately two years, took pictures of the Marseille site at Le Corbusier's request.[7] Zuber was dispatched to Marseille to film and photograph the pouring of concrete for pillars and the casting of the mould for the Modulor and technical services floor.[8] A circular addressed to the main contractors on the site outlines the intention of these sessions:

> We wish to take regular cinematographic pictures of the Le Corbusier Unité d'Habitation site in Marseille in order to produce a number of films after the construction work has been completed. On the one hand, these films will show Mr Le Corbusier's vision of architecture and urban design, of which this building will be the first completed example. And on the other hand, the pictures will show the technical aspects of the building's design and how the construction was actually carried out.[9]

Although Le Corbusier did not expressly request it, the site also appeared in certain filmed sequences: in cinema newsreels,[10] for example, and in publicity films for the MRU.[11] The accompanying commentaries emphasized the positive aspects of the building from the point of view of the national programme for the post-war rebuild of housing stock: the use of reinforced concrete in building, the ability to accommodate hundreds of families, plus the argument that, even though the building is tall and dominant, it 'will rise high into Marseille's skyline, without detracting from the traditional aspect of the city'.[12] In the various film sequences,

Telegram from André Wogenscky to Le Corbusier's studio, concerning the dispatch of photographer René Zuber to the building site for the pouring of concrete for the pillars. This document illustrates Le Corbusier's desire to document the construction of the Marseille Unité d'Habitation.

This photograph of the construction site of the Marseille Unité d'Habitation, taken by Lucien Hervé in 1949, was intentionally turned at 90° by Le Corbusier to better illustrate his message when published in *Le Modulor*: proportions reign, in architecture as in photography.

the Unité d'Habitation project was used to display the merits of the MRU's actions and decisions regarding urban reconstruction. Such projects were designed to show the French people how they might embrace modern living and how architects had recourse to modern construction techniques, such as prefabrication and the use of reinforced concrete. In contrast to Le Corbusier, who wanted to present the Unité as a unique project, both in terms of its construction and as a housing model, the MRU presented the Unité as part of the realization of new urban planning and as one among many examples of housing and other construction projects under the aegis of the MRU.

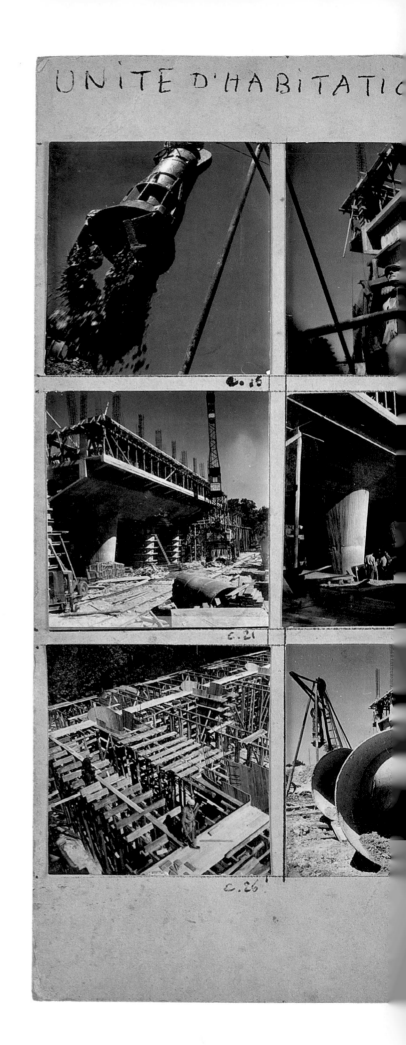

René Zuber, Marseille Unité d'Habitation
photographs (contact sheet), 1948.
In an effort to monitor and archive the
construction of his key building, Le Corbusier
contacted photographer René Zuber when
construction first started and asked him
to document its various stages.

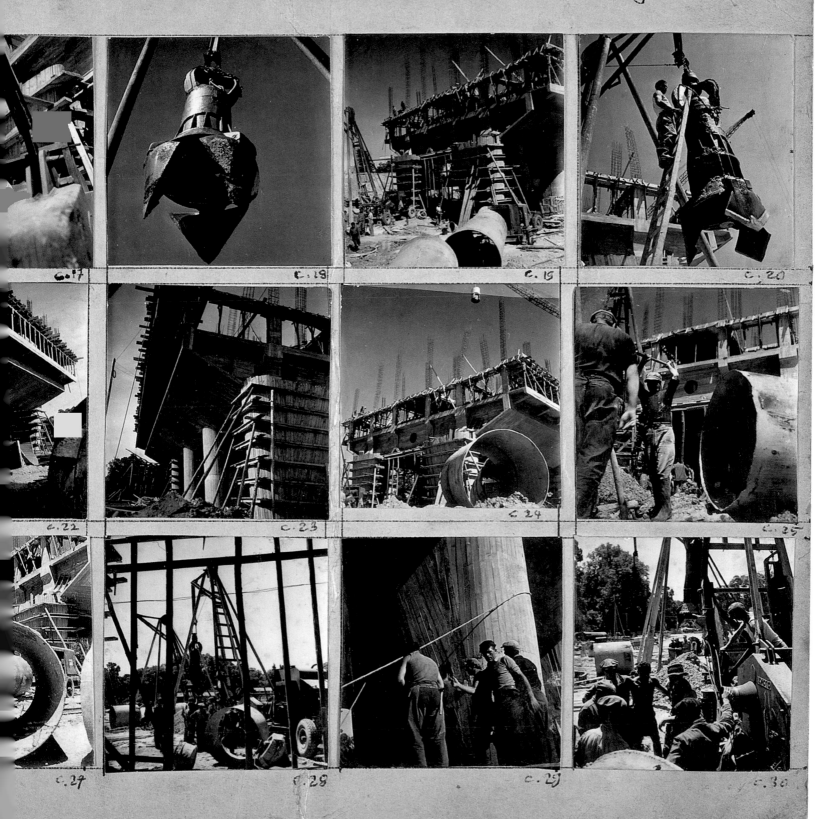

A FICTIONAL FILM

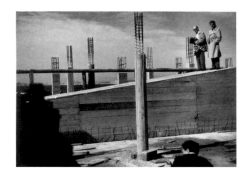

Le Corbusier and Jean-Pierre Aumont on the roof-top terrace of the Marseille Unité d'Habitation, where the architect explains tomorrow's housing.

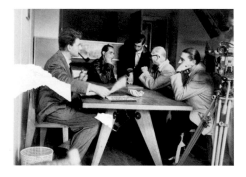

Jean-Pierre Aumont, Le Corbusier, Georges Candilis and Shadrach Woods in the show flat. Photograph by Marcel de Renzis.

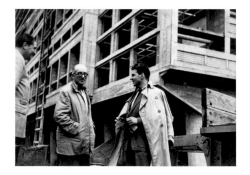

Le Corbusier and Jean-Pierre Aumont during filming. Photograph by Marcel de Renzis.

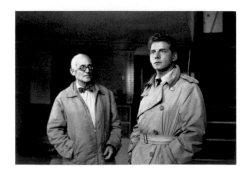

Le Corbusier and Jean-Pierre Aumont during filming.

As construction advanced, there was a greater need to progress beyond simply recording and documenting information. Publicity for the project entered a new phase: the strategy was now to take a positive stand and influence the debate concerning the acceptance and illustration of future housing. Hervé thus showed a contextualized vision of the Radiant City – he recognized that the Unité symbolized promise. A few months before Hervé set off for his first reporting tour of Marseille, the film director Nicole Védrès contacted Le Corbusier to invite him to join a team of eminent people – described as 'tomorrow's men' – who were to take part in a fictional film entitled *La Vie commence demain* (Life Begins Tomorrow, 1950), aimed at a popular audience. Le Corbusier, André Labarthe, Jean-Paul Sartre, André Gide, Daniel Lagache, Jean Rostand and Pablo Picasso were to be interviewed by a young man (Jean-Pierre Aumont) as representatives of 'tomorrow's world', even though the participants were all middle-aged by then. More than a traditional fictional narrative, the film presents a medley of interviews and takes full advantage of this type of presentation. Effectively, Védrès produced a film version of what magazines such as *Life* or *Paris Match* had been doing for some time: allowing the main protagonists to tell the story, rather than reporting the bare facts alone. This became a format that was widely used in the years to come, both in the cinema and on television.

Le Corbusier's role in the film was to explain the concept of the human housing of tomorrow and describe the construction of the Marseille Unité d'Habitation. Before the war he had tended to appear on screen in a very stiff, conventional attitude, rather like a lecturer in front of a blackboard;[13] but here he was far more relaxed as he presented the concept of the Unité in situ, surrounded by the beams and pillars of the building site, with the splendid Marseille landscape in the background. The guided tour continued in the show flat, just as Le Corbusier presented it in a radio interview around the same time with Frédéric Pottecher.[14] Each subject was treated in a realistic and accessible way: Le Corbusier stressed the advantages the Unité offered for future residents, contrasting it with post-war slums. Although the housing of the future was presented from a building site, the contrast with housing of the past was nevertheless clear: the sun-drenched building appeared perfectly integrated into the local landscape, offering a new way of life. At the end of the interview, as if reading a story to a child, Le Corbusier was shown explaining his urban planning ideas to the young male interviewer who was lying in a bed in the Unité's show flat. It was hoped that by sleeping the night there the interviewer would absorb the full experience of the 'life of tomorrow'. The film was screened at various festivals, including Edinburgh[15] and Venice,[16] and was nominated for an award at the Fourth BAFTA Awards ceremony.[17] Although it received a somewhat subdued reception in France, this international recognition meant that the Marseille Unité d'Habitation was seen in cinemas as far away as the United States. On the other hand, the showings did not reach the mass audience Le Corbusier and Védrès would have wished for, but were largely seen by film buffs and art lovers who were already receptive to the ambition behind the building.

This page: Set photographs, 1949. Nicole Védrès began her film *La Vie commence demain* (Life Begins Tomorrow) – in which Le Corbusier is one of 'tomorrow's men' – while the Marseille Unité d'Habitation was under construction. Le Corbusier was interviewed by Jean-Pierre Aumont on the future of housing.

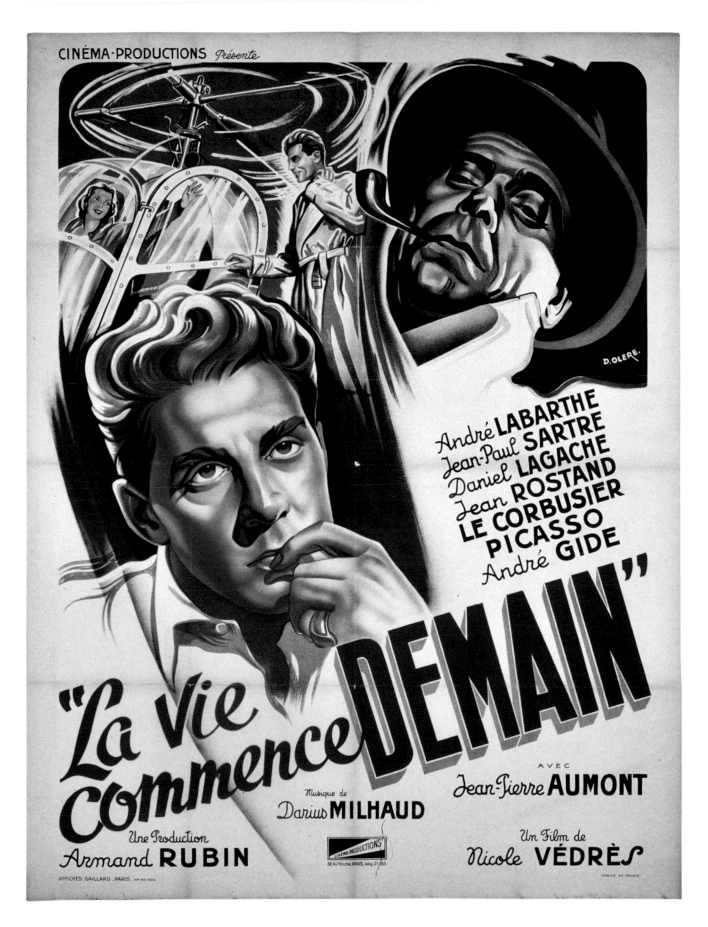

Poster for the film *La Vie commence demain*
(Life Begins Tomorrow) by Nicole Védrès, 1949.

THE ULTIMATE COMBINATION OF
FILM AND PHOTOGRAPHY

Still from the film *Architecture d'aujourd'hui* (The Architecture of Today) by Pierre Chenal, 1931.

In 1952, as the construction of the Unité d'Habitation neared completion, Jean Sacha, a friend of Hervé, made a short film about the Unité depicting the architectural, technical and organizational aspects of its construction. At the end of the summer, Hervé joined Sacha on site as artistic consultant.[18] He took numerous photographs of the film-making process, Le Corbusier and the Unité d'Habitation, which are now among the best known images of the site, especially the image of Le Corbusier in front of the Modulor and one of the architect with a radiant, sun-kissed face. Hervé became artistic consultant as a result of his friendship with Sacha, but his role dovetailed with Le Corbusier's persistent desire to influence all visual representations of the Unité. 'Jean Sacha likes my ideas and will accept my point of view',[19] Le Corbusier wrote before completing his collaboration with Sacha. So the same compositions appear in the film as in Hervé's photographs: for example, the film reproduces the photograph of Le Corbusier in front of the Modulor.[20] This take was also published in *L'Architecture d'aujourd'hui* (The Architecture of Today),[21] and later became a sort of talismanic image after careful cutting and contrast adjustment by Hervé.

Le Corbusier, who wanted total control over the picture angles, the dialogue and the music,[22] also wrote the script,[23] and made the decision that the film should be produced in colour. This decision contradicted his earlier opinion that films and photographs are best in black and white, and had more to do with the availability of new technology than an artistic choice about the work. In the film the camera lingers over the building, ready to welcome its first residents, and gives detailed shots of external fixtures and communal areas (the landscape around the Unit, the entrance, the interior pathway) as well as technical service areas, such as the roof-top terrace. The film ends on a lyrical note, with Le Corbusier gazing over the distant landscape, reiterating his concept of the ideal living conditions for humanity in this city of the future. This vision is not unlike the first film produced under Le Corbusier's guidance, *Architecture d'aujourd'hui* by Pierre Chenal, which came out in 1931,[24] and concludes with an image of scale models of towers shown in a real pastoral setting, as the perfect illustration of the city of the future.

'I have dedicated forty years of my life to the study of housing. I brought the Temple back within the family, at home. I restored natural conditions to human life. This undertaking can only be made successful with the help of the wonderful young people who surround me: passion, faith and integrity. They are the ones I want to thank today.'

Words in the closing scene of the film *La Cité radieuse* (The Radiant City) by Jean Sacha, declaimed by Le Corbusier on the roof of the Marseille Unité d'Habitation.

Model of one of the Plan Voisin's skyscrapers for the film *Architecture d'aujourd'hui* (The Architecture of Today) by Pierre Chenal, 1931.

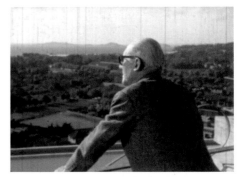

Final scene of Jean Sacha's film *La Cité radieuse* (The Radiant City), 1952.

Photograph taken by Lucien Hervé, during
the filming of *La Cité radieuse* (The Radiant
City) by Jean Sacha, 1952.

F_ 94

F_ 125.

F_ 90

Lucien Hervé, contact sheet of photographs taken during the filming of *La Cité radieuse* (The Radiant City) by Jean Sacha, 1952. Hervé's photographs are often identical to the film's shots.

126

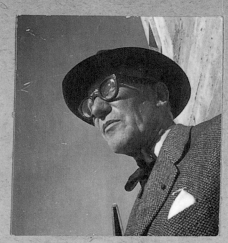

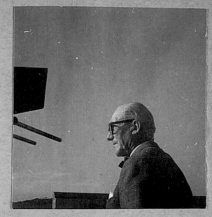

F. 46

F. 45

F. 47

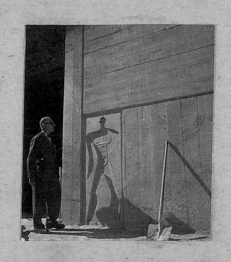

F. 127

F. 128

F. 92

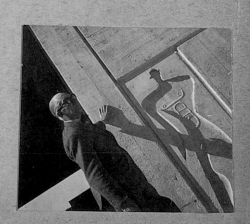

F. 25

F. 54

Jean Sacha's film *La Cité radieuse* (The Radiant City) came out in October 1952. The apartments had been occupied since July of that year, so to some extent the film could have been considered outdated by the time of its release. A new form of publicity was therefore needed to promote the success of the Unité. Le Corbusier proposed the addition of an introduction to the film informing the public that the Unité was already occupied.[25] He also planned to write a book on life in the Marseille Unité d'Habitation and in the nursery school in particular in collaboration with Lillette Ripert (Mme Ougier), a committed teacher at the Unit's nursery school.[26] The book, which was finally published in 1968, was intended to celebrate the Radiant Cities of Marseille and Rezé-les-Nantes, describing how the children flourished in the schools, thanks to the benefits of increased light, space and sunshine. It brings together two different photographic approaches to the Unité. Mme Ougier commissioned a series of photographs from Louis Sciarli in 1960;[27] these evoke the pleasure of living, growing up and blossoming in the top storey of the Radiant City. The other collection of photographs is by Hervé, taken from 1949 onwards and showing the architecture of this great flagship building in the context of the surrounding landscape. The collection also includes photographs that depict a day in the life of the resident children by means of a timeline. Just as Le Corbusier had employed Hervé for his architectural instinct, he had similar confidence that Mme Ougier's images would capture the lives of the Unité's younger residents. 'This book is both beautiful and important, because it goes to the heart of the family,' noted Le Corbusier in 1961, as he waited for the book to be published.[28] Rather than presenting the Radiant City simply as an example of the architect's work, the main aim of the book was to show the contented lives of the residents and thereby to promote the concept of a vibrant and successful building.

The illustrated article by René Burri for *Paris Match* in 1959, published seven years after the first residents moved in, is probably the best-known depiction of residential life in the Unité.[29] Burri was both an artist and a magazine photographer, and his combination of skills is clearly reflected in the way he treated the subject of a living building. For him, the purpose of photographing the Unité was, first and foremost, to present daily life there for the residents. Because he was writing and photographing for such a popular publication, it was clear to him that his treatment of the subject needed to be tackled from the point of view of those who lived in a building that had been so vigorously opposed at the time of construction. The article presents the spontaneous and evident joy of the children on the roof-top terrace, views of ordinary family life in the apartments, and chance meetings in the communal garden areas: direct and anecdotal in tone, the article commends the social success of the Unité to the public at large.

However, Burri's photographs are very different from Louis Sciarli's, for example, in which the architecture is almost invisible compared to the depiction of the daily lives of the residents. Burri understood how to combine the two subjects: architecture remains the focus of the article. It is significant that this successful representation did not come about through architectural photographers nor through the arts community, but from a photographer whose work was not commissioned by Le Corbusier, and yet who proved best able to show the kind of life the architect wanted for the residents as well as for the building itself.

Cover of the book *Les Maternelles* (Nursery Schools), with a photograph by Marseille Unité d'Habitation resident Louis Sciarli, who extensively documented life in the Unité and in its nursery school.

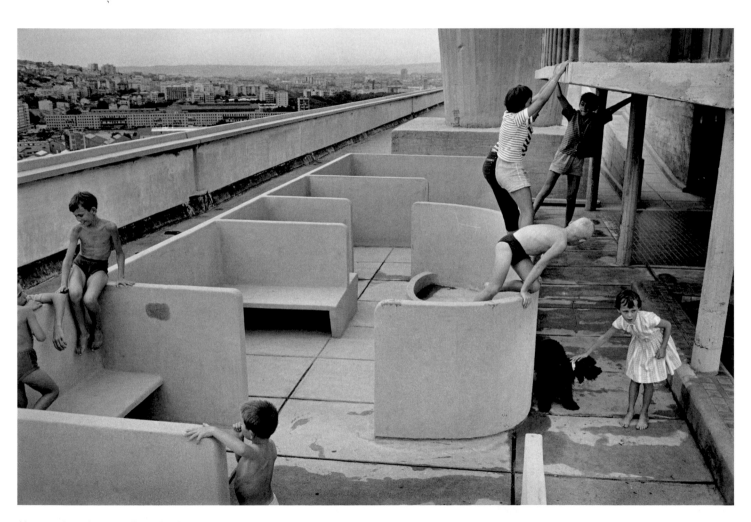

Above and overleaf, left: René Burri,
the roof-top terrace of the Radiant City, 1959.
When Burri photographed the Marseille Unité
d'Habitation, he took into account the building's
users and thus paid tribute not only to the
architecture but also to the people who had
made the construction their home.

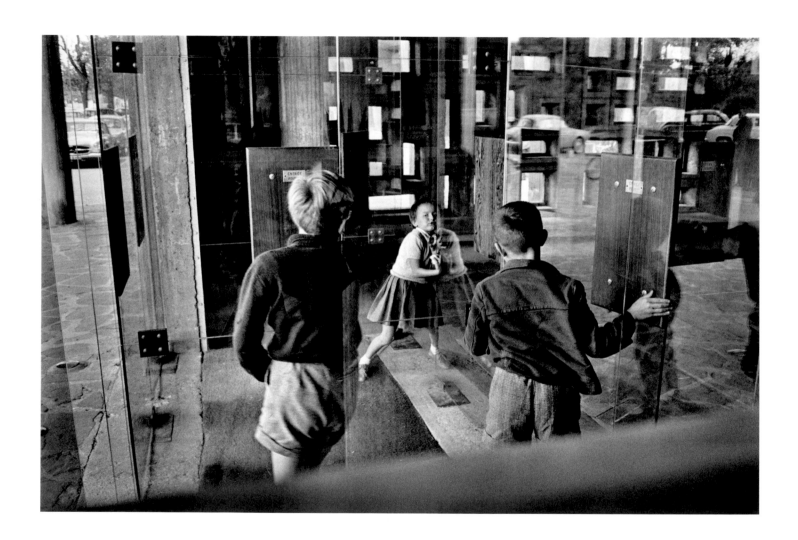

A PLACE IN
URBAN PLANNING THEORY

Pierre Kast, producer of the film *Le Corbusier, l'architecte du bonheur* (Le Corbusier: The Architect of Happiness, 1957),[30] had no intention of giving the leading role to the Unité and its residents. On the contrary, in September 1956 he promised Le Corbusier that he would, '…show to the widest possible audience the beauty, novelty and importance of Le Corbusier's creations',[31] adding that his film would be released in a large number of cinemas. Although the film clearly shows that the Radiant City was inhabited, it is presented primarily within the context of the architect's overall concept of urban planning and at a key moment in his oeuvre. The film was widely circulated and Le Corbusier used it as a key promotional tool from the moment it was released. He asked Hervé to generate positive coverage in the German press to support his Housing Unit project in Berlin – it was essential to raise the awareness of the German public by promoting excellent pictures of other units, as well as Kast's film.[32] Now that Le Corbusier's great crusade of the Marseille Unité d'Habitation had ended, this film signalled a new era – one that seamlessly blended the Unité into his overall work and theory. Although he continued to promote his major achievements through monographs, using the work of Hervé and other photographers (including Bernhard Moosbrugger,[33] Pierre Joly and Véra Cardot[34]), a visual media campaign on such a scale would never be seen again in Le Corbusier's career.

Above: Stills from the film *Le Corbusier, l'architecte du bonheur* (Le Corbusier: The Architect of Happiness) by Pierre Kast (1957), in which Le Corbusier discusses his urban projects and the Marseille Unité d'Habitation is filmed.

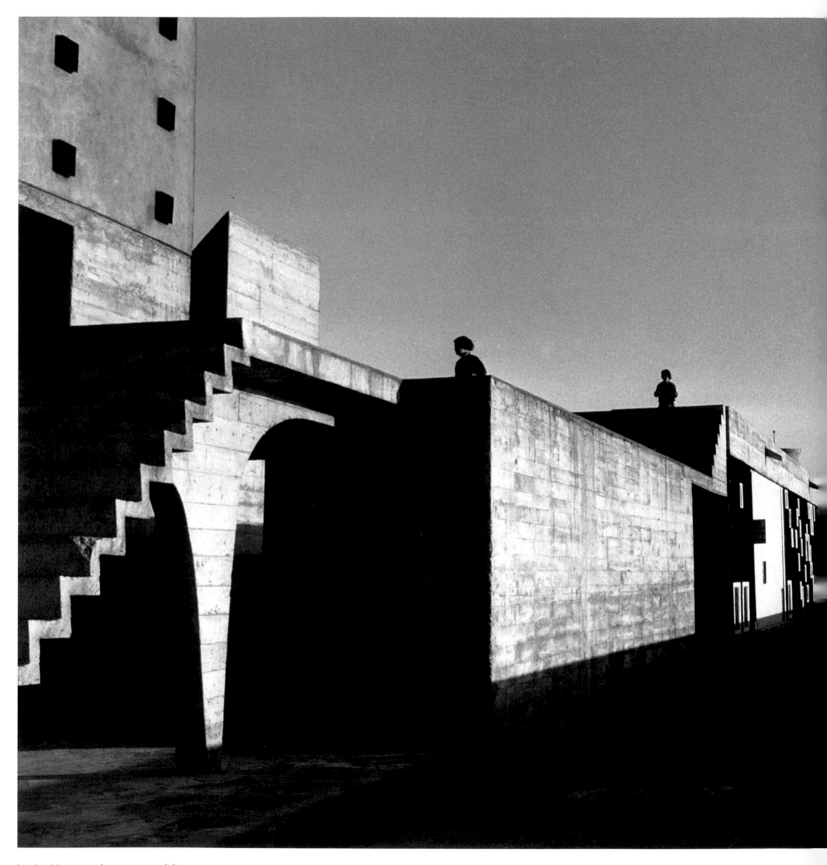

Lucien Hervé, roof-top terrace of the
Rezé-les-Nantes Housing Unit, 1954.

5

THROUGH MANY LENSES: CONTEMPORARY INTERPRETATIONS OF THE ARCHITECT'S WORKS

JEAN-CHRISTOPHE BLASER

Le Corbusier and photography ... the subject is vast. It includes photographs taken by the architect himself and images by photographers that he used to promote his projects and published in books and journals. Added to this are the many portraits of him that were commissioned from well-known photographers. The subject has been further extended recently due to the 'recycling' of his architecture in contemporary imagery. This article will examine the forms of this recycling and the various types of reinvention it may lead to. We will discover that if photographers take an interest in Le Corbusier's work, they do so less to reveal his intentions than to further their reflection on their own medium. What will be discussed here is the history of photography and not that of architecture.[1]

A brief reminder of some facts seems appropriate. Architectural photography can boast a rich tradition.[2] Berenice Abbott (1898–1991), Julius Shulman (1910–2009) and Ezra Stoller (1915–2004), to name but a few, are among architectural photography's main proponents. Members of the avant-garde, such as László Moholy-Nagy (1895–1946) and Albert Renger-Patzsch (1897–1966), although less specialized, have also made their contribution. For his part, Walker Evans (1903–1975) – and his interest in vernacular architecture – influenced generations of photographers and artists, including, among many others, Dan Graham (born 1942) and his sociological studies of the suburban houses of New Jersey, and Dieter Roth (1930–1998) and his project to photograph all the facades in Reykjavik.

Following these pioneering projects of the late 1960s and early 1970s, such documentation became commonplace, with numerous artists adopting similar approaches at some point in their career. The 'New Topographics' exhibition, organized by the George Eastman House Museum in Rochester, New York, in 1975, is particularly significant in this context and its influence has increased over the years. Dedicated solely to topographic photography, the exhibition showcased various views of unremarkable architecture and places without identity:[3] anonymous suburbs, utility buildings and prefabricated houses were presented according to a point of view that did not intend to be anything other than simple observation. Among the participants were artists who would later play a major role in the international scene, such as Bernd Becher (1931–2007) and Hilla Becher (born 1934), whose work – analytical and codified in the extreme – is similar to the highly polished style of architectural photography.[4] The 'New Topographics' exhibition and the Bechers contribute to our understanding of why the urban environment has become the predominant subject of contemporary photography and the crucial role played by architectural photography. The photographic mission of DATAR (the Delegation for Regional Planning and Action) in France in 1984 is also relevant, in that it influenced the definition of a new kind of topographic landscape.[5]

It is mainly in the light of these developments that it is interesting to analyse the representation of Le Corbusier's architectural work in contemporary photography, although the impact of such developments on architectural photography should not be neglected. The New Topographics tradition, without always being visible, will be used as a common thread in this essay, which will highlight the changes that have taken place in recent history from the perspective of a growing separation from architectural photography.[6]

FIRST SIGNS OF CHANGE

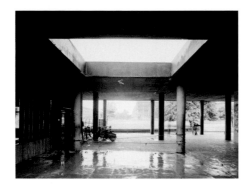

Thomas Flechtner, Jagat cinema entrance, Sector 17, Chandigarh, 1990.

Chandigarh in the rain... In Thomas Flechtner's work, such a choice betrays the need to establish new relationships with Le Corbusier's daunting legacy and, particularly, to guard against the temptation to 'monumentalize' his work.

Daniel Schwartz, bookshelves in the form of the Villa Schwob (Villa Turque), La Chaux-de-Fonds, 1990.

Historically, for photographers, architecture has been a fast track to abstraction. They could identify and isolate the motifs from which they derived compositions. Here the motif is the plan of the Villa Schwob, a complex design that Daniel Schwartz interprets as a pictorial sign.

Thomas Flechtner (born 1961) undertook a 'colour essay' via a series of photographs taken in Chandigarh, India, in 1990, at a time when colour was still used mainly for advertising.[7] For many years there was an almost unspoken acceptance among photographers that the use of black and white was essential for any artistic work that was to be exhibited and published. But the importance of the work of the pioneers of colour photography – such as William Eggleston (born 1939) from the United States, and Luigi Ghirri (1943–1992) from Italy – was beginning to be recognized in Europe. Flechtner (see p. 26 and pp. 158–63) not only challenged the domination of black and white photography, he also offered a highly innovative approach as a result of his broad understanding of his subject matter (which justifies the use of the word 'essay' with respect to his work in Chandigarh). Although he left substantial room for uncompromising architectural views, he also tried to 'contextualize' them through contemporary portraits. Flechtner's essay therefore contains images that highlight the buildings themselves and the points of view they offer. Some of the photographs also show personalities, such as the chief architect of Chandigarh or people who are living in buildings designed by Le Corbusier – the users of his architecture. Although not overwhelming, the intrusion of the portrait in such a subject is unusual: the human element is generally not welcome in architectural photography because it can interfere with the message; but when present, it is there to give an idea of scale or to create an atmosphere, in much the same way as furniture does. Like Ernst Scheidegger (born 1923) during the construction of Chandigarh in the 1950s,[8] Flechtner goes beyond this utilitarian concept to favour a sociological vision. His aim is to provide an account of life in the city, as well as a view of its formal organization. In a third set of images (in addition to the architectural views and the portraits), the photographer's eye focuses on the streets and squares of the capital of Punjab flooded by the monsoon. The effect of the 'New Topographics' exhibition is immediate. In the rain or in the mud, the great architecture of Chandigarh is no longer highlighted, nor even really visible – it is reduced to a 'non-place', an ordinary and anonymous urban environment.[9] This downgrading is sometimes pushed to the extreme, to desecration, when buildings and facades are made to appear dull and dirty.

The work of Daniel Schwartz (born 1955) at Villa Schwob (Villa Turque) in La Chaux-de-Fonds dates from the same era as that of Flechtner in Chandigarh (see pp. 182–85).[10] The photographer's objective in this project was to explore the iconic building, which was constructed at the beginning of Le Corbusier's pre-war work (his 'second period'). His inventory of the place included a number of detailed views, as would be expected in a project of this nature. These show, once again, the strong potential for abstraction in architectural photography and the ambition of photography in general to highlight a world organized by underlying geometric structures. Throughout history, the visual arts have used architecture to explore abstraction, and photography is no exception to this rule. Today, however, the issue seems particularly relevant: does abstraction represent a way out for topographic photography, which is often a victim of its own success? Will abstraction attract renewed interest? Another aspect of Schwartz's work that is worth noting and is echoed in contemporary photography relates to the 'whiteness' of certain views of Villa Schwob. In recent years, photographers have shown increased enthusiasm for desaturated tones, to the extent that these are one of the hallmarks of current style. Images have become increasingly pale and

translucent. Collectors of photography have had to adapt to this shift towards evanescence, even though, until recently, they had based their standards of assessment on the density of black tones. In retrospect, the choices made by Schwartz at Villa Schwob can be seen to presage a period of transition: they illustrate the appetite for clarity and transparency that has gradually emerged in photography since the 1990s.[11] Similarly, the contrasts between black and white have gradually lost their appeal. At Villa Schwob, the use of chiaroscuro, so prominent in the work of in Lucien Hervé (1910–2007), has been abandoned: the whole drama constructed by this photographer, one of Le Corbusier's main collaborators, has given way to an atmosphere of peace and tranquillity. Schwartz clearly gives the impression that he wanted to create a space that was lit in a consistent way, avoiding spotlights and discontinuity, as is often the case in architectural photography. Such moderation and classicism are not far from the neutrality claimed by the Bechers. Although their origins differ, they reflect a similar desire for restraint and sobriety.

DENYING ARCHITECTURE

Flechtner's vision of Chandigarh appears unorthodox compared to the approach of architectural photography – iconoclastic, even, in the few images in which the buildings are made to appear like ruins overrun by vegetation. Flechtner is not the only one to have distanced himself somewhat from tradition: other photographers have also not been fearful of finding paradoxical effects that sometimes blur the representation of architecture. Olivo Barbieri (born 1954) is among the photographers who have disrupted the apparent order of Le Corbusier's constructions (see pp. 144–49). Like his compatriots Ghirri (whose pioneering work with colour has already been mentioned), Guido Guidi (born 1941) and Gabriele Basilico (born 1944),[12] this Italian photographer has engaged in a detailed reflection on architecture and urban planning.[13] For several years he has led a major project to create portraits of large cities – Mexico City, Rio de Janeiro, Chicago, Detroit and Bangkok are the subjects of his most recent studies. Some of his early books, published twenty years ago, reflect the spirit of the 'New Topographics' exhibition,[14] which is hardly surprising considering, on the one hand, Barbieri's proximity to this American school and, on the other, the significant influence he has had on the genre of landscape photography in Italy. Since the 1990s, Barbieri's work has been notable for its radical use of light, including artificial light at night. At Le Corbusier's chapel of Notre-Dame-du-Haut at Ronchamp, where Barbieri worked by day in 1996, both the extreme brightness of his images and the luminosity of the colours are striking. Light in particular attracts the viewer's attention – its use sometimes seems counter-productive. In one view of the inside of the chapel (taken against the light), the light streams through the windows, invading and transforming the space and making it difficult to see the wall structure (left).

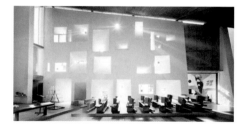

Olivo Barbieri, Ronchamp, 1996.

The white sky is one of the methods used by contemporary photographers to signify a certain artistic neutrality. Contrary to popular belief, they do not cultivate expressiveness or 'demonstrativeness' at all costs: trying to move the viewer or to convey a message is not a priority.

In his Chandigarh series (1999), Barbieri's approach is equally unconventional. His range of colour is even more limited, consisting mainly of two or three extremely light colours and a few bright marks that sometimes punctuate the image. Most disconcerting, however, is the technique developed by Barbieri whereby, in setting and modifying the focus, the image is divided into three, with areas on the edges that are out of focus (top and bottom or left and right). This has the effect of destabilizing the perception of the viewer, who first thinks the photograph is of a model. By choosing such a strategy, Barbieri challenges traditional working methods: experimentation within the photographic medium takes precedence over

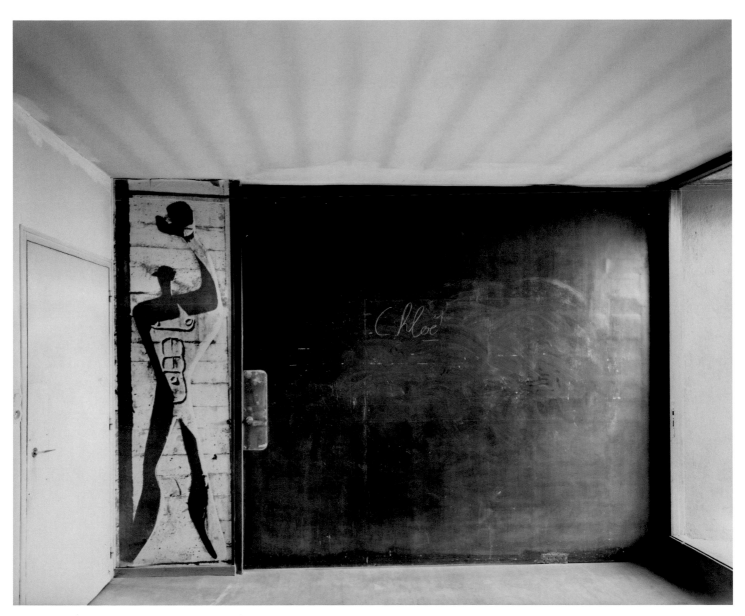

Guido Guidi, Duval factory, Saint-Dié-des-Vosges, 2003.

Guido Guidi uses light to reflect the passage of time. He looks for imperfections in textures and details that, over time, can arise in very geometric spaces. His photography is an attempt to overcome the general and formalistic views that sometime dominate architectural photographs (see pp. 168–71).

Hiroshi Sugimoto, chapel of Notre-Dame-
du-Haut I, Ronchamp, 1998.

elucidating the architectural spaces. Photography liberates itself from its subject, which it then addresses very freely. But in so doing, it also denies it.

A series of photographs by Hiroshi Sugimoto (born 1948) entitled *Architecture* is devoted to the architectural icons of the 19th and 20th centuries.[15] Commissioned by the Museum of Contemporary Art in Chicago, the series was produced between 1997 and 2003. Among the landmark structures by great architects that are featured in the anthology are Le Corbusier's chapel at Ronchamp (opposite) and his Villa Savoye (pp. 186–87). These views offer a romantic evocation of the story of Modernism. Sugimoto is known for working with very long exposure times. His series of photographs of old cinemas was what first brought him considerable attention: the film was exposed only to the violent light reflected from the screen throughout the film's projection. The difference between this work and his *Architecture* series is particularly noticeable, however, with the long exposure times yielding opposite results: the details of the cinemas were shown with great precision, whereas the details of the architectural monuments are not visible because they are out of focus. Hence this interpretation of the artist's goals: the passage of time and its capture by photography have long been one of Sugimoto's main interests, but in his collaboration with the Museum of Chicago he has explored and tried to reflect the effects of time on architecture specifically. In his ghostly images, the masterpieces of Modernism appear eroded, as they would be after one or two centuries of existence. What remains of them is their general form, reduced to essentials. Like memories, they are fading away. Unlike Sugimoto, most photographers who are interested in architecture seldom explore blurring effects. Even rarer are those who, like Milo Keller (born 1979), experiment with the effects of atmospheric conditions on architecture, in this case, a light winter mist at night (see pp. 172–73).

Photographers' attempts to blur the vision of architecture do not stop there. In Barbieri's and Sugimoto's work, the canons of architectural photography were abandoned in favour of photographic and artistic considerations. After them, the path was clear for those who were eager to push the limits of this approach still further, as can be seen in the work of Stéphane Couturier (born 1957), one of the pioneers who wanted to move beyond a classical representation of Le Corbusier's work (see p. 7 and pp. 150–55). In *Chandigarh Replay* (2006–7)[16] – a title that clearly indicates the photographer's desire to redefine the rules of the game – Couturier was not afraid to confront both the architectural and the painted works of Le Corbusier, who was one of the founders of the post-Cubist school of painting known as Purism. Couturier has often presented the cities whose landscapes he analyses through the various strata that composed them. (He adopted this approach early in his career, and it is shown particularly well in some of his images of construction sites.) Did this vision of sedimentary layers play a role in the development of *Chandigarh Replay*, in which photographs of paintings, frescoes and tapestries by Le Corbusier were superimposed on photographs of his buildings?[17] In the process of asking such a question, it is worth considering whether it is architecture or painting that is the substratum of the resulting compositions. Common sense and observation would suggest that architecture is indeed this substratum. But the opposite hypothesis cannot be excluded. In some images (notably that of the High Court of Justice, p. 7), the ambiguity is certainly strong enough to make us doubt what we are seeing: are they decorative projects in which architecture has been painted, or collages in which the layout of the architectural structure is superimposed onto various

Matthieu Gafsou, Firminy-Vert, 2009.

Topographic photography serves as a reference for many young photographers. Matthieu Gafsou is part of a generation of photographers who were strongly influenced by the American school of 'New Topographics' and have used it as a solid starting point in all their research.

coloured patterns? Once again, the problem is expressed in terms of space within the photograph rather than space within architecture.

Matthieu Gafsou (born 1981) belongs to a younger generation of photographers who were deeply influenced by the 'New Topographics' exhibition. It is impossible for him to leave this tradition aside. For young photographers like him, it represents a framework for experimentation and inevitable confrontation. The philosophy of Lewis Baltz, Stephen Shore and other proponents of a new approach to landscape in the 1970s made essential contributions to Gafsou's education. Traces of this influence can be found in the commission Gafsou undertook at Firminy-Vert in 2009 (see pp. 164–67).[18] The general views of the neighbourhood, the housing unit, partly hidden by vegetation, and even the stadium, tend to support the concept of landscape as suburban – somewhat appealing but also without any particular interest. There is no indication in Gafsou's images that Firminy-Vert was the largest housing project undertaken by Le Corbusier after Chandigarh. However, Gafsou's approach changes in his treatment of the church of Saint-Pierre and of the roof-terrace of the Housing Unit, where he rediscovers the practices of architectural photography (tight shots, attention to detail and to lines and volumes, and so on). What can we infer from this return to tradition? Does it announce a return to order? Without going that far, it is reasonable to assume that photographers influenced by the New Topographics 'school' are generally more comfortable with humble subjects than with lofty ones, and can appear rather awkward when they switch from vernacular to grand architecture.

In the eyes of Gafsou, the landscape of the New Topographics, with its focus on the commonplace and the unremarkable, has the advantage that it can counter the dangers of the 'belle image' (the beautiful image), to which architectural photography is particularly exposed due to its inclination to formalism. For others – such as Cemal Emden (born 1967; see pp. 156–57), Jean-Michel Landecy (born 1959; see pp. 174–77) and Alexey Naroditsky (born 1974; see pp. 178–81) – its interest is limited to providing an additional point of view on a subject that has been photographed so often that it is not always easy to offer a new approach.[19]

MAJOR CONSEQUENCES

The reader may well be confused by the place allocated to Le Corbusier in this essay, in which he serves primarily to illuminate the discussion of contemporary photography; and possibly also disturbed and surprised by the fact that the New Topographics plays the leading role. The interpretive framework has superseded the subject under review.

However, an overview of the type undertaken here can help qualify the widely held and somewhat impulsive reading of contemporary photography as 'colour imagery': appealing, but also relatively undifferentiated and superficial. The examples discussed here reveal a great variety, even though the photographers often share some common principles. Schwartz, Barbieri, Flechtner, Couturier … their approaches clearly differ in terms of concept; their experimental methods are never the same; and the issues at stake vary from one photographer to the next. Examining these specific cases has helped to clarify the manner in which Le Corbusier's legacy has been received by contemporary photography.[20] It confirms, as evident from recent history, that architectural photography

Cemal Emden, Mill Owners, Ahmedabad, 2011.

has been appropriated and overwhelmed by many elements of urban and suburban landscape photography. This development has had major consequences: the codes of architectural photography have been widely applied and have contaminated contemporary photography with a somewhat cold and distant approach (the influence of Bernd and Hilla Becher has also been key in this respect). It is likely that the relative decline of humanist photography is largely due to this phenomenon. For these two disciplines could not be more opposed: architectural photography, with its desire for clarity and readability, its rejection of chaos and its distrust of the human dimension; and humanist photography and its search for emotion, communion and compassion.

Contemporary photography has received as a legacy from architectural photography a certain slightly static aspect and a tendency to ignore living beings, to eliminate excessive human presence. It has also received significant support in a period in which it has finally imposed itself as an art form in its own right. This recognition is inseparable from the success achieved by topographic photography. There is no doubt that the anonymous landscapes of big cities played a major role in this process of legitimation, as their bright colours, enhanced by digital techniques, and their monumental formats assured them unparalleled visibility in exhibitions. As for the collectors and the market, needless to say, they quickly understood the benefits of supporting such a trend.

OLIVO BARBIERI

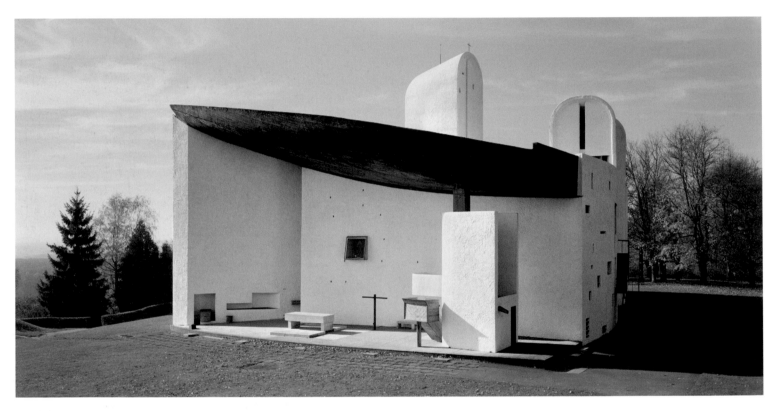

Olivo Barbieri, Ronchamp, 1996.

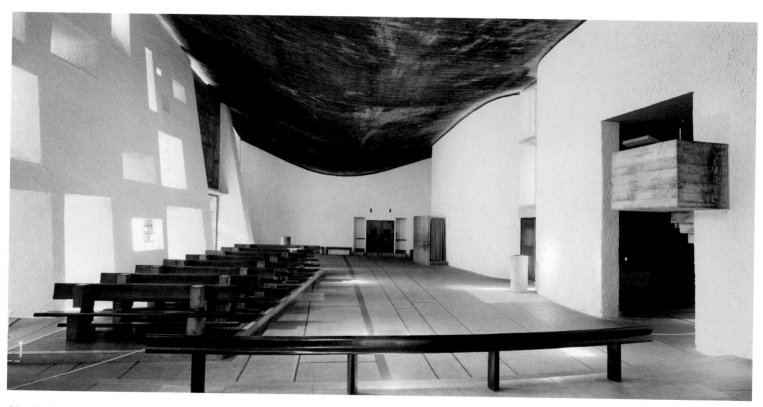

Olivo Barbieri, Ronchamp, 1996.

Olivo Barbieri, Chandigarh, 1999.

Olivo Barbieri, Chandigarh, 1999.

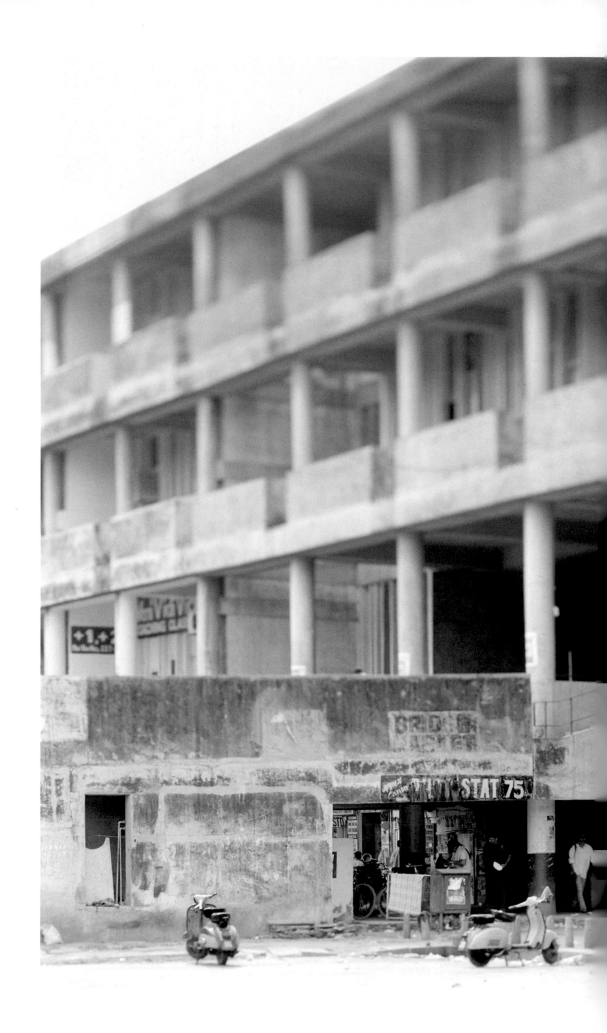

Olivo Barbieri, Chandigarh, India, 1999.

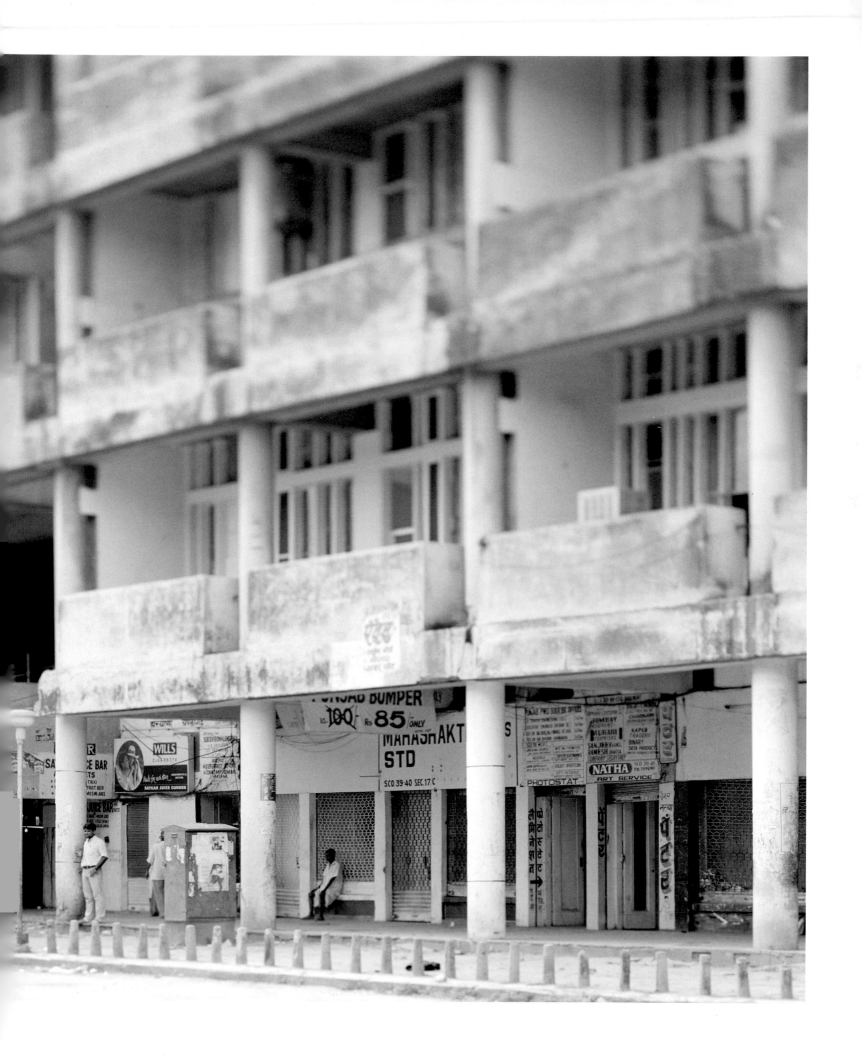

STÉPHANE COUTURIER

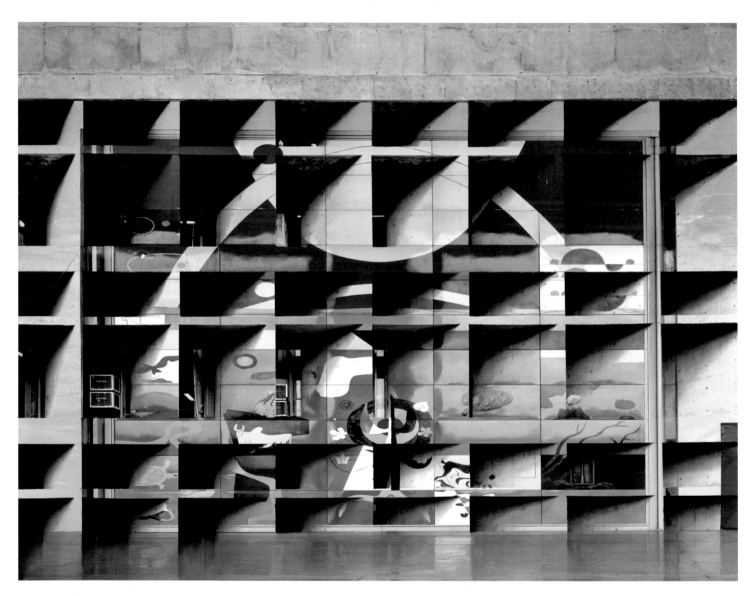

Stéphane Couturier, Assembly no. 1, from
the series *Chandigarh Replay*, 2006–7.

Opposite: Stéphane Couturier, Monastery of
La Tourette, Eveux-sur-l'Arbresle, Photo no. 1,
from the series *Melting Point*, 2009–10.

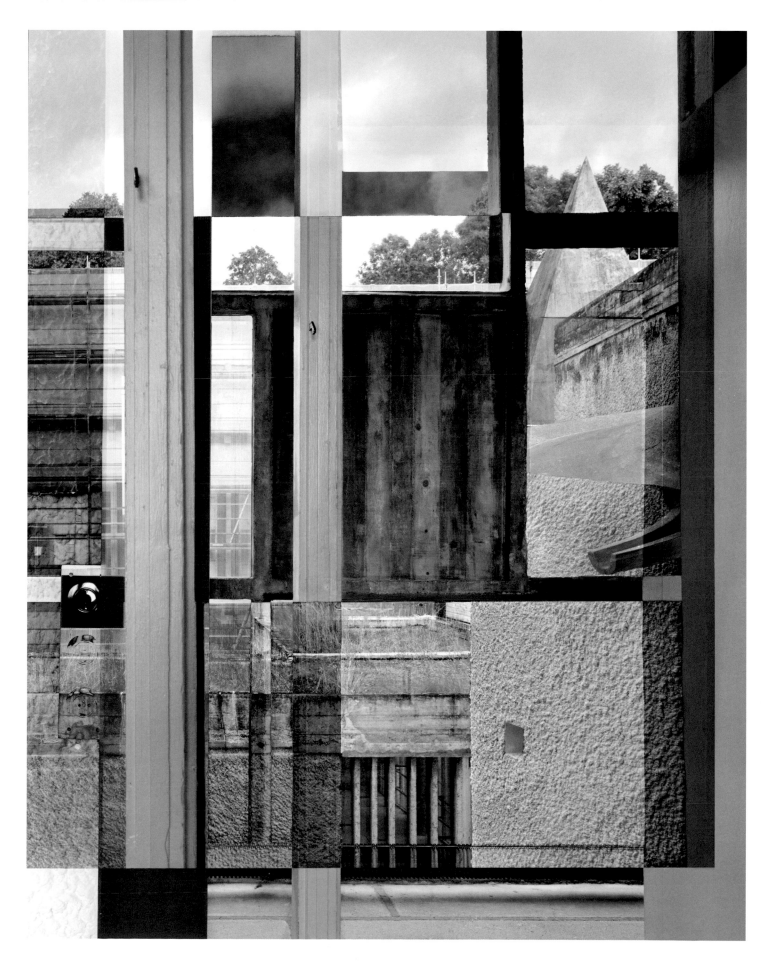

151 Jean-Christophe Blaser

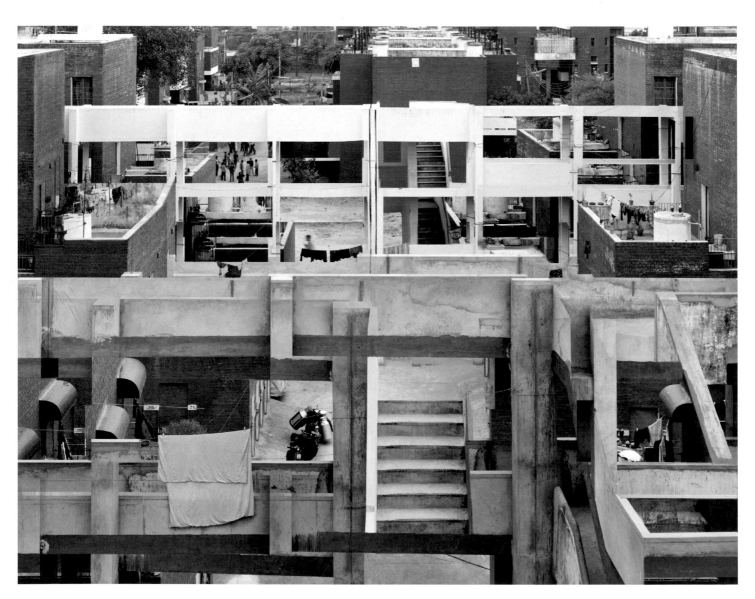

Stéphane Couturier, Sector 44, Photo no. 1,
from the series *Chandigarh Replay*, 2006–7.

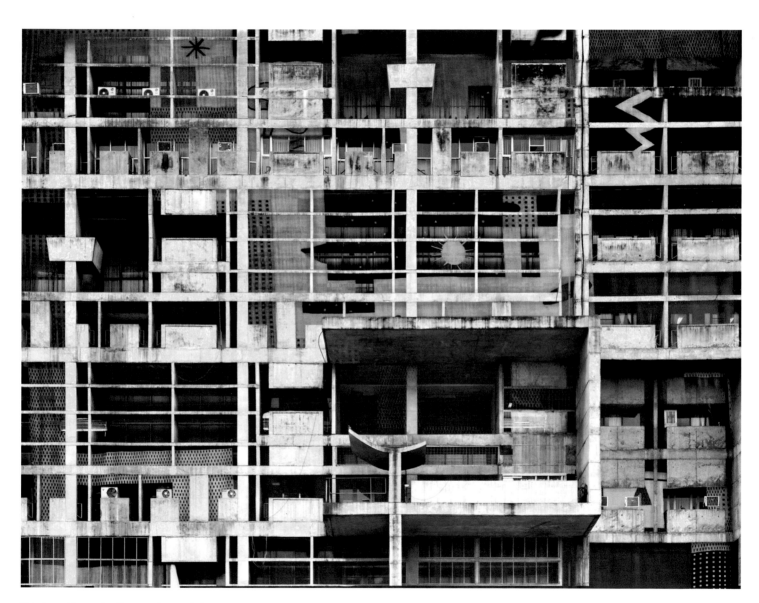

Stéphane Couturier, Secretariat no. 1, from
the series *Chandigarh Replay*, 2006–7.

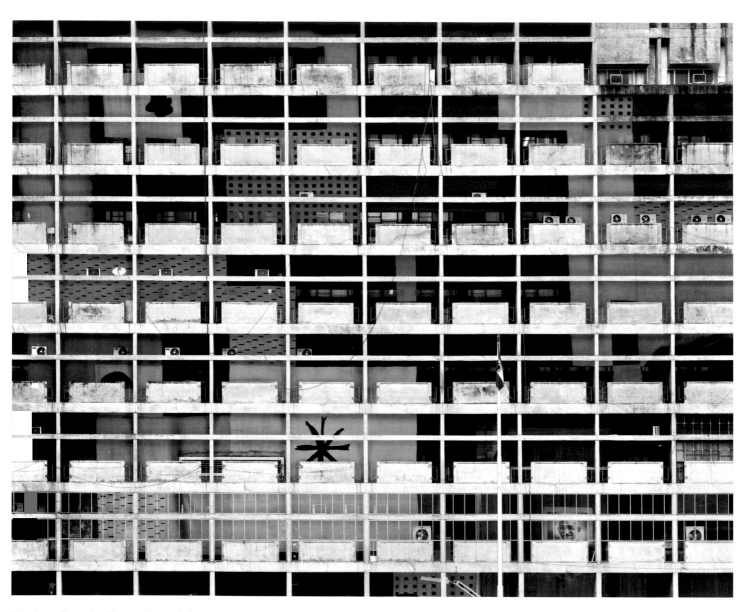

Stéphane Couturier, Secretariat no. 2, from
the series *Chandigarh Replay*, 2006–7.

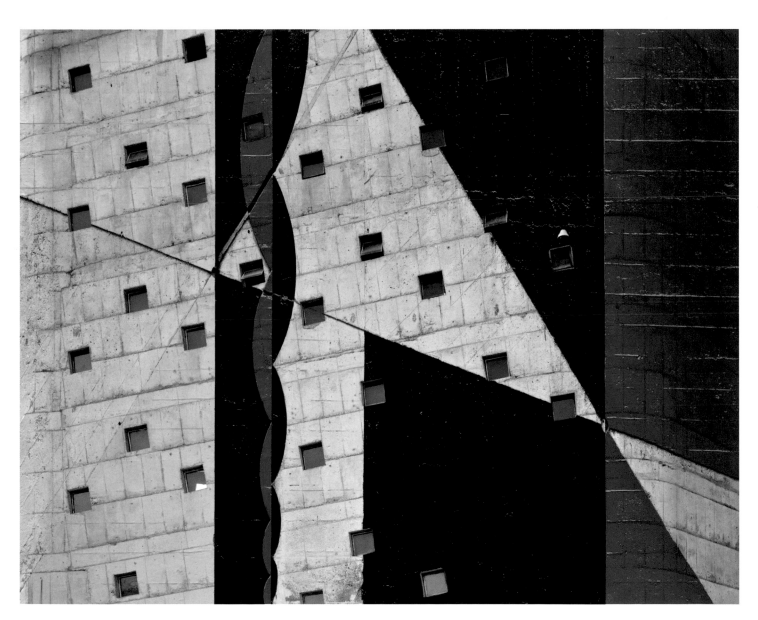

Stéphane Couturier, Secretariat no. 3, from
the series *Chandigarh Replay*, 2006–7.

CEMAL EMDEN

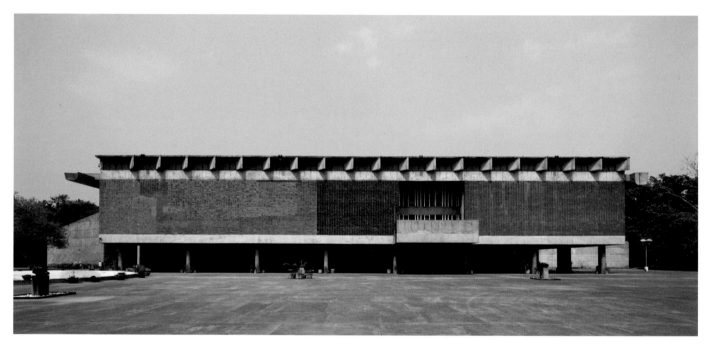

Cemal Emden, Museum 1, Chandigarh, 2011.

Cemal Emden, Sector 17, Chandigarh, 2011.

THOMAS FLECHTNER

Thomas Flechtner, Restaurant at the Bus
Terminus, Sector 17, Chandigarh, 1990.

Thomas Flechtner, Neighbours, Sector 23,
Chandigarh, 1990.

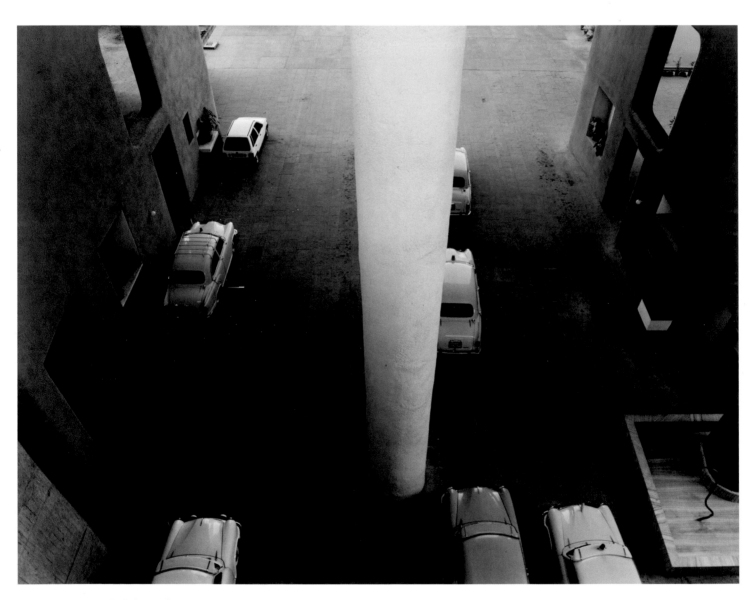

Thomas Flechtner, High Court, Capitol
Complex, Chandigarh, 1990.

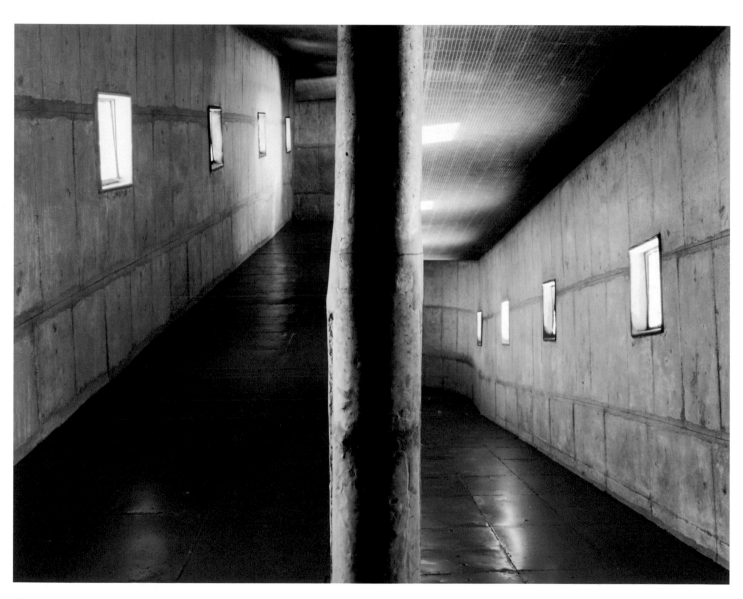

Thomas Flechtner, Ramp, Sector 1,
Chandigarh, 1990.

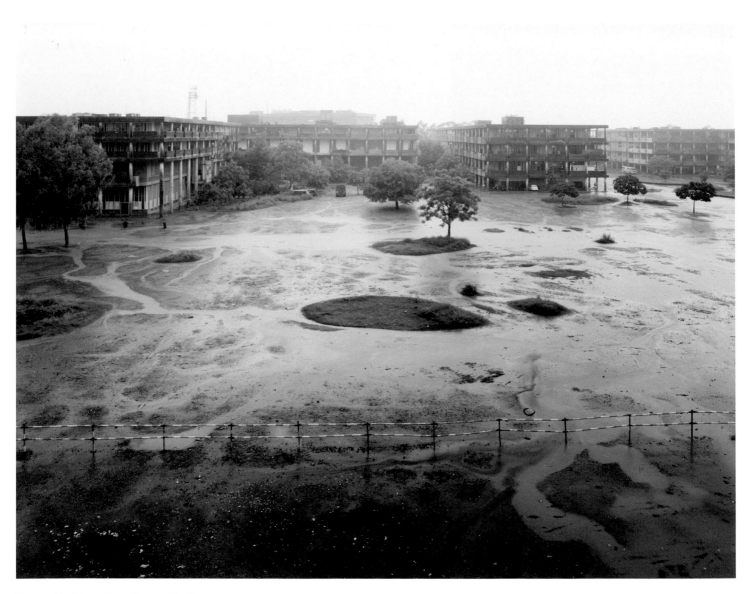

Thomas Flechtner, Open Space, City Centre,
Sector 17, Chandigarh, 1990.

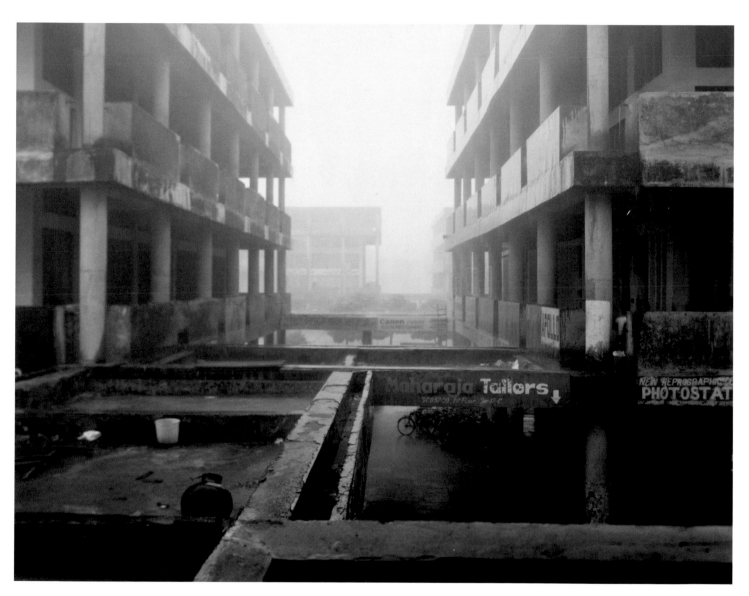

Thomas Flechtner, City Centre,
Sector 17, Chandigarh, 1990.

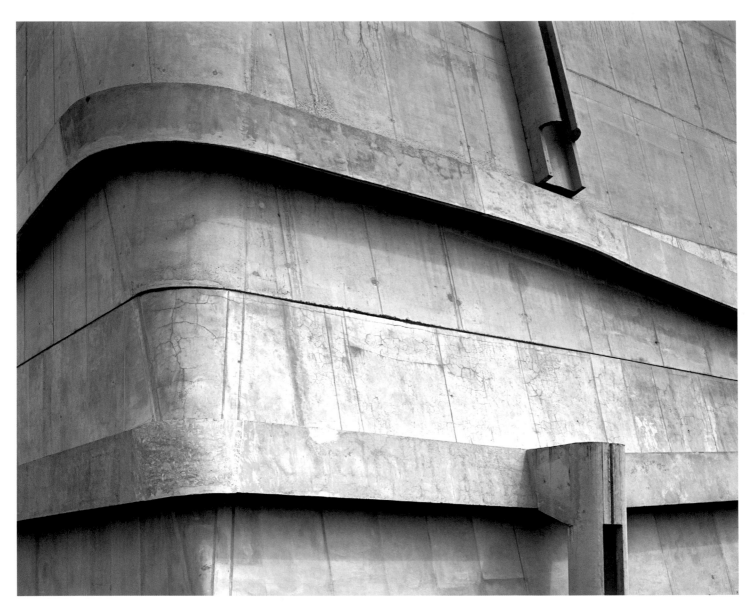

Matthieu Gafsou, Saint-Pierre Church, Firminy, 2009.

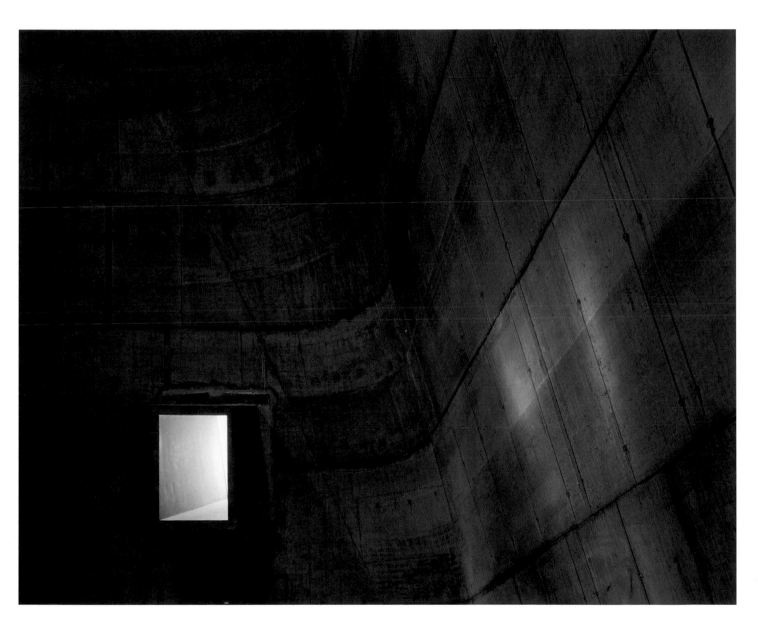

Matthieu Gafsou, Saint-Pierre Church, Firminy, 2009.

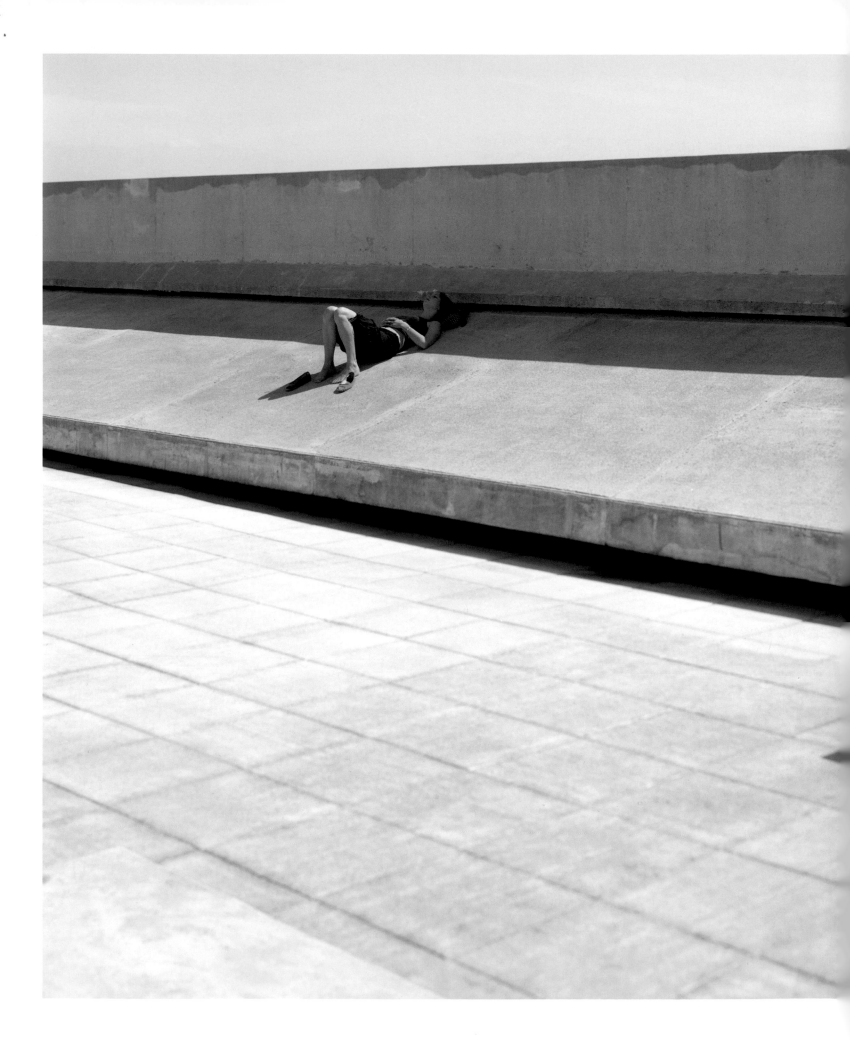

Matthieu Gafsou, Housing Unit, Firminy, 2009.

GUIDO GUIDI

Guido Guidi, Duval Factory, Saint-Dié-des-Vosges, 2003.

Opposite: Guido Guidi, The Salvation Army,
Cité de Refuge, Paris, 2003.

Jean-Christophe Blaser

Guido Guidi, Villa La Roche, Paris, 2003.

Guido Guidi, Villa La Roche, Paris, 2003.

Guido Guidi, Villa La Roche, Paris, 2003.

Guido Guidi, Duval Factory, Saint-Dié-des-Vosges, 2003.

MILO KELLER

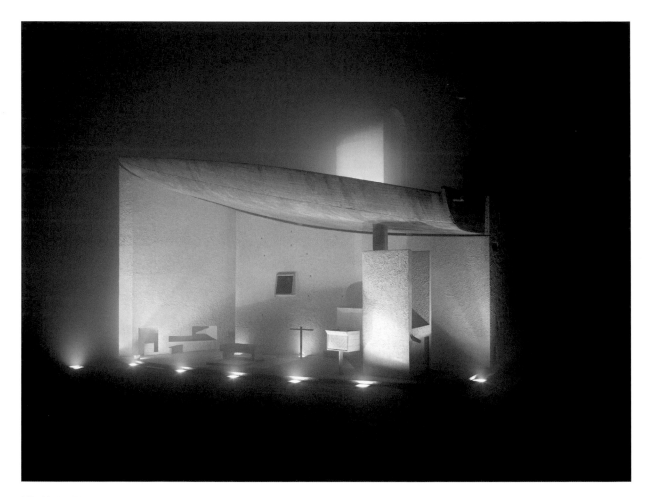

Milo Keller, Ronchamp, 2011.

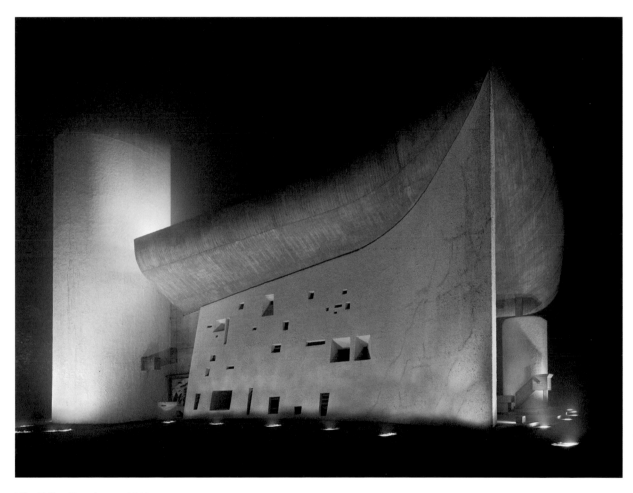

Milo Keller, Ronchamp, 2011.

JEAN-MICHEL LANDECY

Jean-Michel Landecy, Villa Savoye, Poissy, 1990.

Jean-Michel Landecy, Monastery of La Tourette,
Eveux-sur-l'Arbresle, 2004.

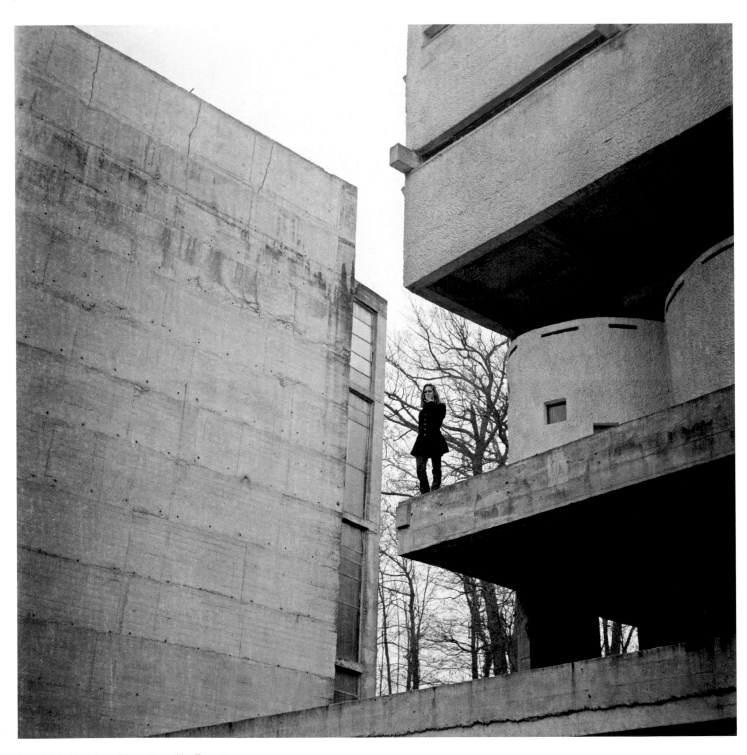

Jean-Michel Landecy, Monastery of La Tourette,
Eveux-sur-l'Arbresle, 2004.

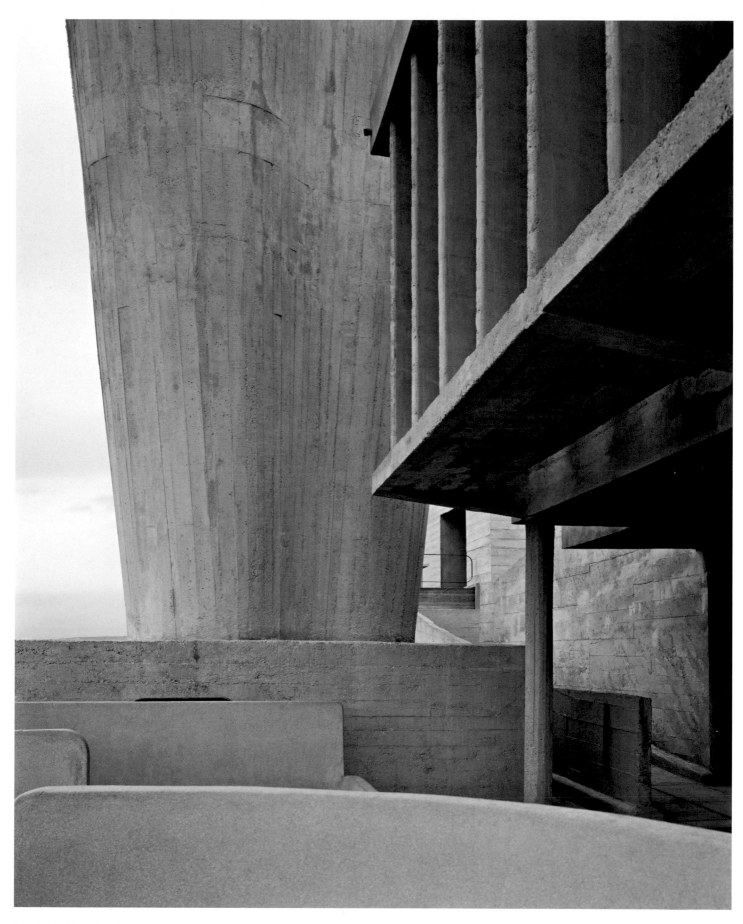

Jean-Michel Landecy, Unité d'Habitation,
Marseille, 2007.

ALEXEY NARODITSKY

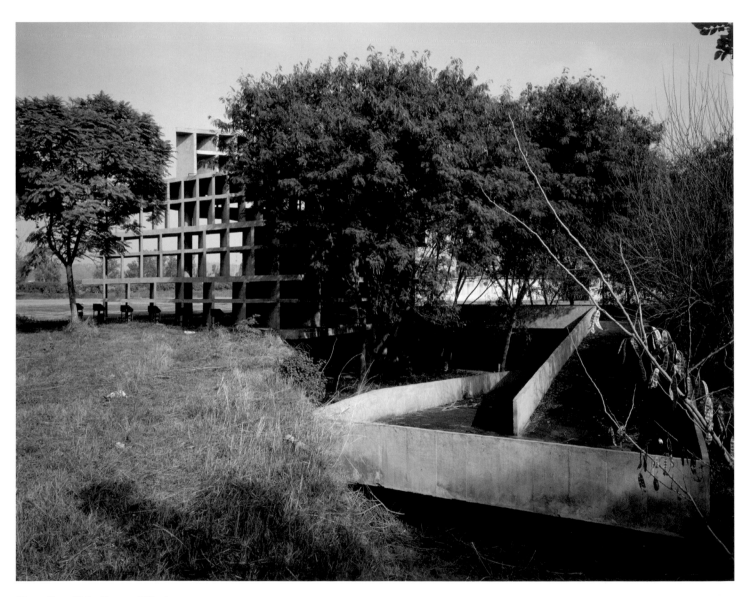

Alexey Naroditsky, Tower of Shadows,
Chandigarh, 2011.

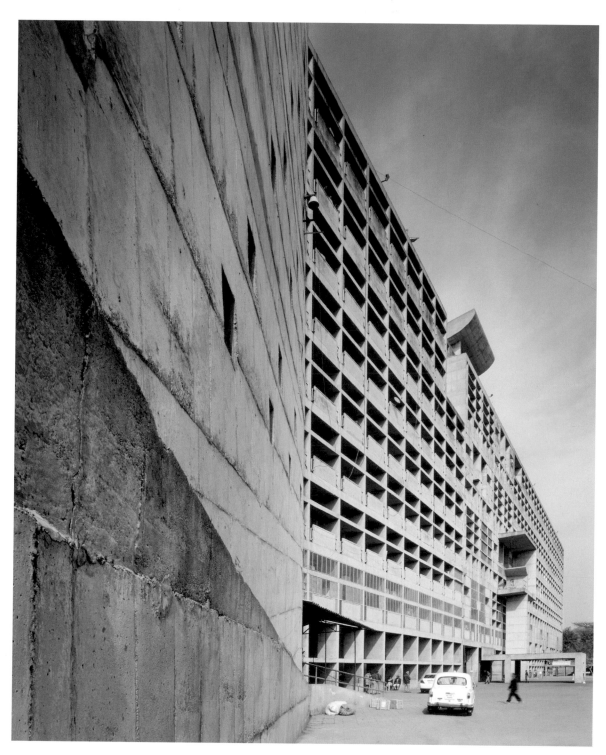

Alexey Naroditsky, Secretariat, Chandigarh, 2011.

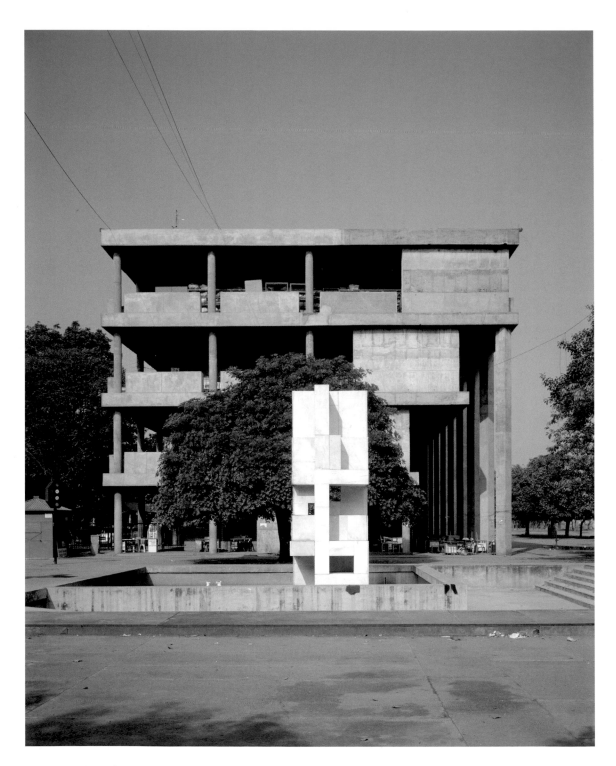

Alexey Naroditsky, Sector 17, Chandigarh, 2011.

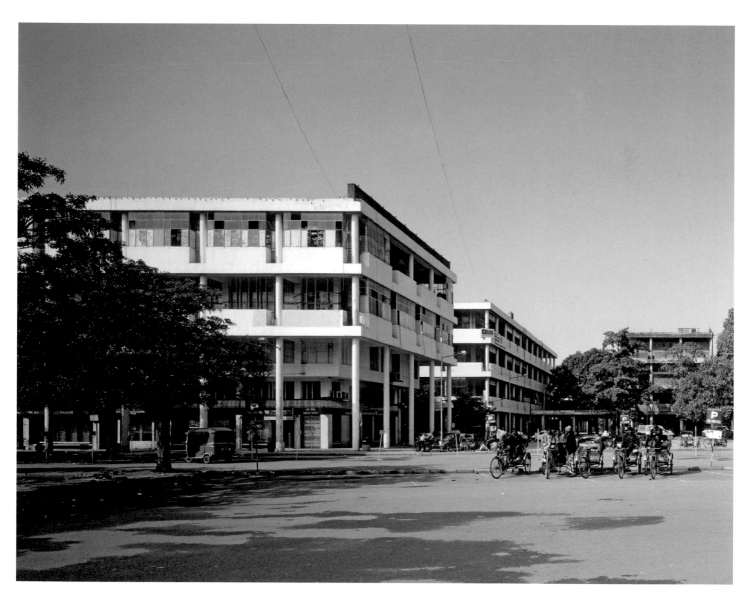

Alexey Naroditsky, Sector 17, Chandigarh, 2011.

DANIEL SCHWARTZ

Daniel Schwartz, Balcony (detail), Villa Schwob
(Villa Turque), La Chaux-de-Fonds, 1990.

Daniel Schwartz, Brasilia Room: Ceiling (detail), Villa
Schwob (Villa Turque), La Chaux-de-Fonds, 1990.

Daniel Schwartz, Central Hall: Library, Villa Schwob
(Villa Turque), La Chaux-de-Fonds, 1990.

Daniel Schwartz, Central Hall: Balcony (detail) and Moucharaby,
Villa Schwob (Villa Turque), La Chaux-de-Fonds, 1990.

HIROSHI SUGIMOTO

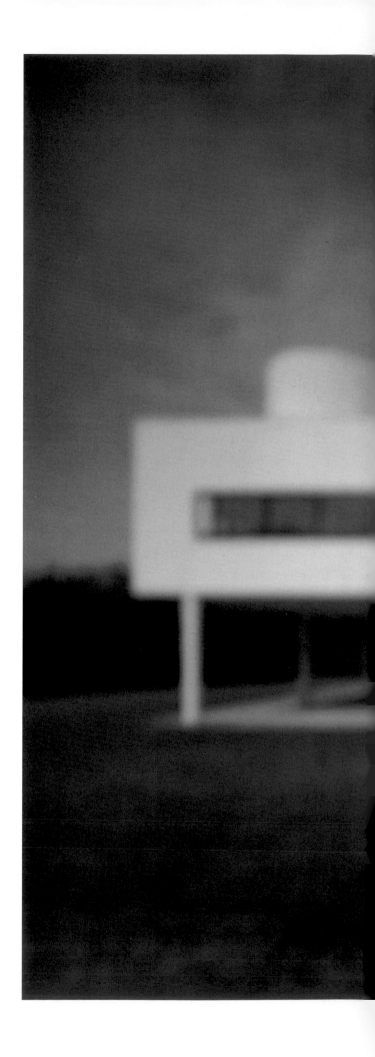

Hiroshi Sugimoto, Villa Savoye, Poissy, 1998. **186**

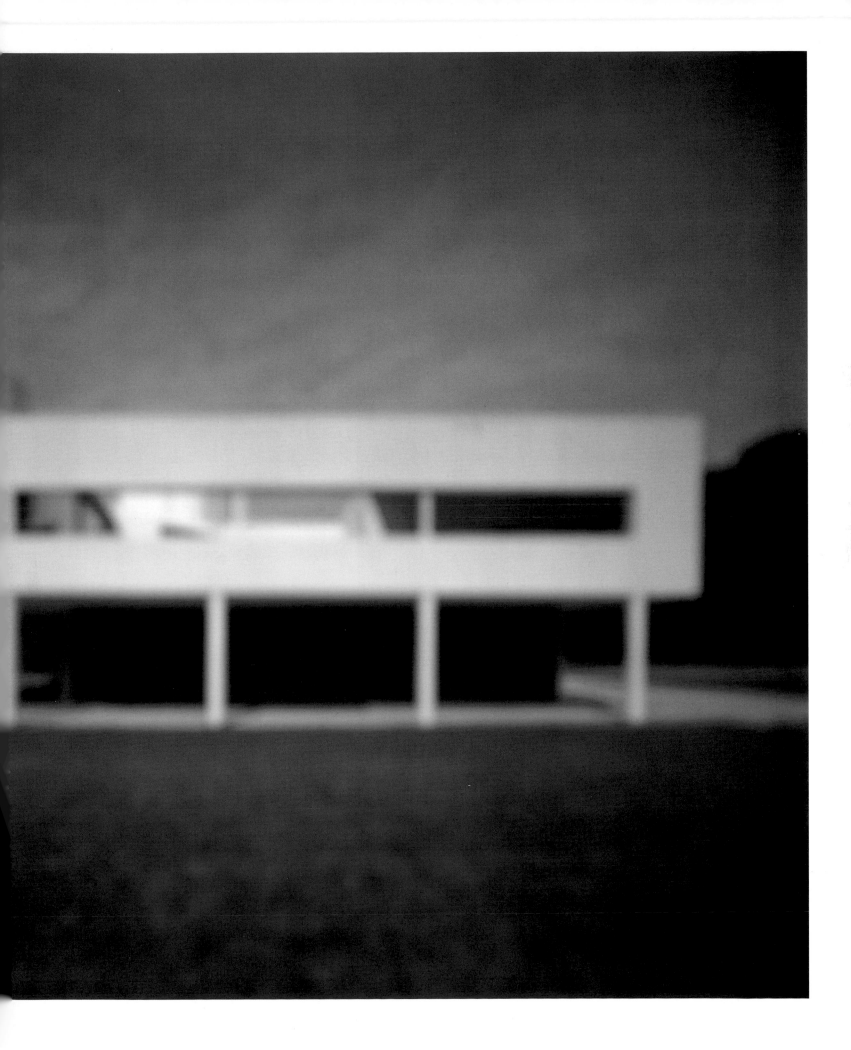

6

CAPTURING
LE CORBUSIER'S IMAGE

KLAUS SPECHTENHAUSER

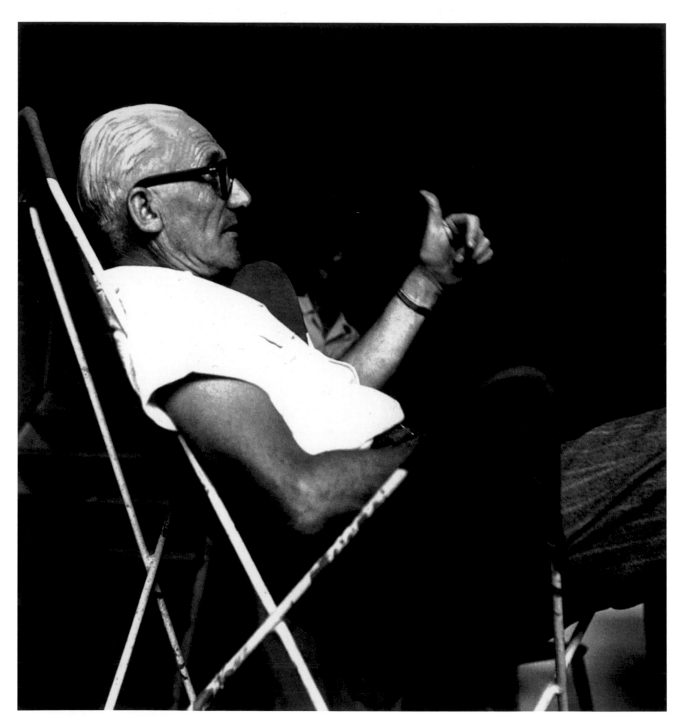

Le Corbusier at the Marseille Unité d'Habitation,
c. 1952–55. Photograph by Lucien Hervé.

A book that examines the subject of Le Corbusier and photography cannot exclude images that show the life of the great artist and architect. This essay therefore acts as a visual biography: the focus is not on the targeted use of photography and film by Le Corbusier himself, but on the depiction of his active life and career.

The majority of the images shown here are by unknown photographers: they include both snapshots and photographs in which Le Corbusier is seen striking poses. Also included are images by renowned photographers (Lucien Hervé, Robert Doisneau and René Burri) that not only represent the architect's work but also capture important aspects of his personality.

The images have been grouped according to significant aspects of Le Corbusier's life. The architect is presented in various contexts: with friends and acquaintances; alongside his work; in significant locations; and as an 'icon of style', who was to exert immense influence long after his death. The aim of this arrangement is, above all, to offer fresh and stimulating insights into Le Corbusier's complex personality.

1

2

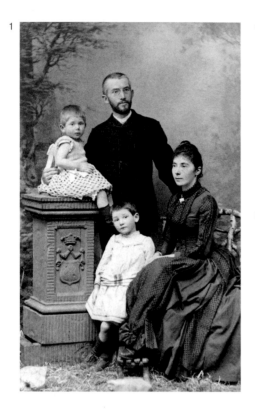

3

4

5

6

7

8

9

10

Le Corbusier was anything but narrow-minded when it came to media attention and used every means possible to present his ideas to the public. He may even have been the first architect to understand the power of the mass media and how it could be exploited for promotional purposes. However, he insisted on the strict separation of his personal and professional lives and largely kept his private world hidden from view: only rarely did he allow photographers access to it.

11

13

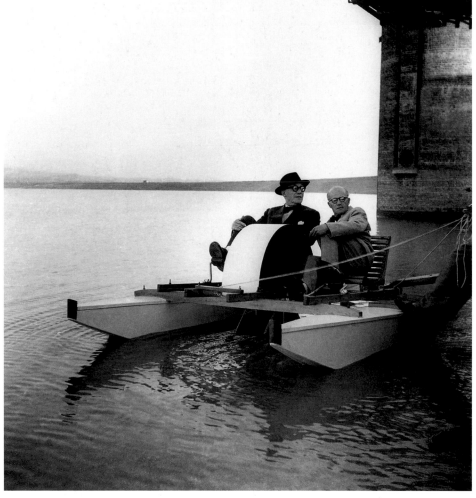

12

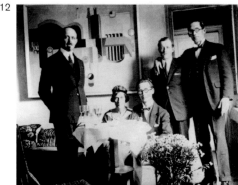

1. The Jeanneret-Perret family: Charles-Edouard (sitting on column), his brother, Albert, and their parents, December 1889.
2. The American author and journalist Marguerite Tjader Harris with her son Hilary in Vevey, 1932. She accompanied Le Corbusier as a 'muse' on his excursions in and around New York in November and December 1935.
3. Le Corbusier (left) with his cousin and office partner Pierre Jeanneret, 1920s. They shared the famous studio in rue de Sèvres, before going their separate ways in 1940. They later worked together again on plans for Chandigarh, the new capital of the Punjab, where Pierre lived from 1951 to 1965.
4. Le Corbusier and Yvonne with their schnauzer, Pinceau, 1930s.
5. Yvonne Gallis, later Le Corbusier's wife, in the apartment at 20 rue Jacob, Paris, 1920s. Yvonne was from Monaco and worked as a model and sales clerk in a Parisian fashion boutique. Le Corbusier met her in the early 1920s. The two would remain

together until Yvonne's death on 5 October 1957.
6. Yvonne at the window of the apartment at 20 rue Jacob, Paris, 1920s.
7. Charles-Edouard Jeanneret with his brother, Albert, in their room in the Villa Jeanneret-Perret, La Chaux-de-Fonds, August 1919. Albert Jeanneret, a musician and composer, lived in Paris from 1919 to 1939. Together with his wife, Lotti Rääf, and the Basel-born banker Raoul La Roche, he commissioned the Villa La Roche/Jeanneret, in which the Fondation Le Corbusier now has its offices. Photograph by Amédée Ozenfant (?).
8. Albert Jeanneret (left), Le Corbusier and their mother, Marie-Charlotte-Amélie, in front of the Villa Le Lac in Corseaux, near Vevey, 15 September 1959. Le Corbusier maintained a close relationship with his mother until her death at the age of 100 on 15 February 1960.
9. Le Corbusier (second from right), Yvonne (far right), Jean Badovici with a companion, and Thomas ('Roberto') Rebutato (in the

background), in front of 'L'Etoile de Mer', Roquebrune-Cap-Martin, 1949. This magical location, with its remarkable view of the Mediterranean, was Le Corbusier's preferred refuge after the Second World War. It was here, between 1951 and 1952, that he erected his Cabanon, a modest wooden holiday home.
10. Le Corbusier in his apartment in rue Jacob, Paris, c. 1930. Photograph by Charlotte Perriand or Pierre Jeanneret.
11. Le Corbusier (left) and Pierre Jeanneret in Chandigarh, 1956.
12. The wedding of Albert Jeanneret and Lotti Rääf, 26 June 1923. Left to right: Pastor Huguenin, Lotti Rääf, Albert Jeanneret, Pierre Jeanneret and Le Corbusier. On the wall is *Nature morte Indépendants* (Still Life Independents, 1922), Le Corbusier's wedding gift (now in the Moderna Museet in Stockholm).
13. Le Corbusier and Pierre Jeanneret on Sukhna Lake in Chandigarh, India, 1950s.

14. Yvonne Le Corbusier, 1949. Photograph by Lucien Hervé.
15. Le Corbusier and Yvonne in southern France, 1930s.
16. Le Corbusier, 1950s. Photograph by André Steiner.

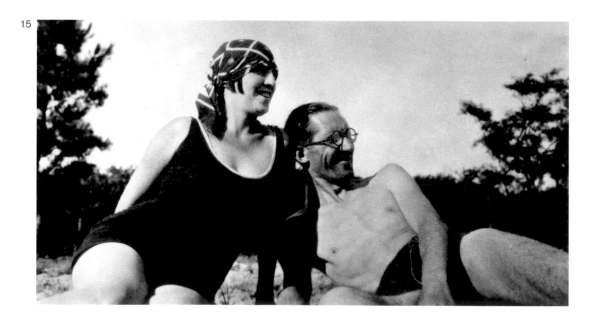

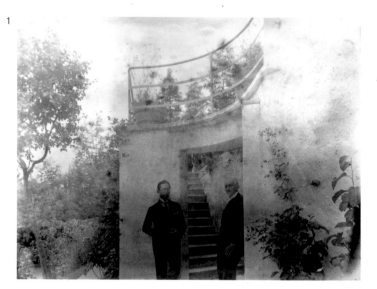

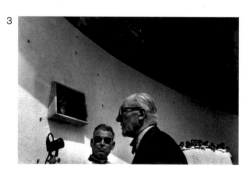

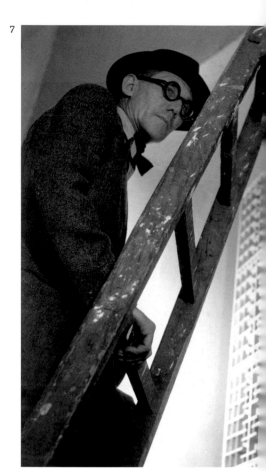

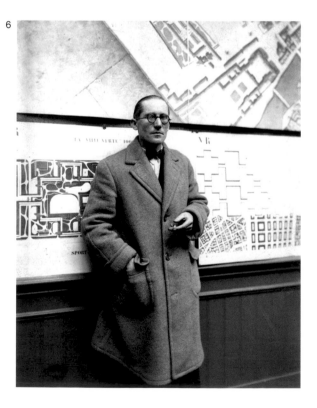

The photographs that show Le Corbusier alongside his work are very different: some make it seem that he was unaware of being photographed; others depict him looking earnestly or sometimes detachedly into the camera. And yet these images thrive on the interaction between the man and the work, shedding light on a particular context and depicting the circumstances under which the work was created.

9

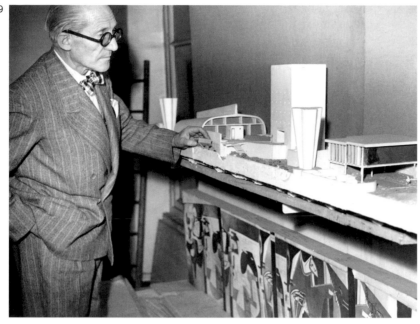

12

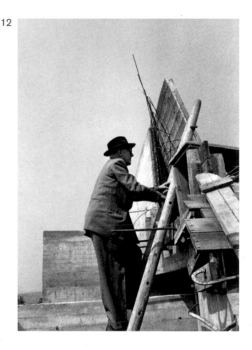

10

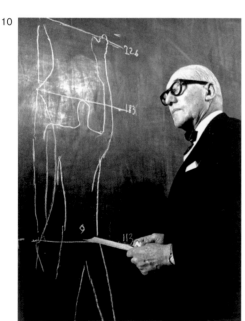

11

1. Charles-Edouard Jeanneret with his father, Georges-Edouard, in front of the stairs to the Chambre d'été of the Villa Jeanneret-Perret in La Chaux-de-Fonds (built 1912), c. 1915. With a few notable exceptions, Le Corbusier rarely referred to the considerable number of early works that he completed in La Chaux-de-Fonds up until 1917. Constructed in 1912 for his parents, the Villa Jeanneret-Perret (better known locally as Maison Blanche) was likewise never mentioned. Photograph by Albert Jeanneret (?).
2. Le Corbusier with a model of the Villa Savoye in the Museum of Modern Art in New York, 1935. Built between 1928 and 1931, the Villa Savoye was one of the buildings that would bring Le Corbusier world fame.
3. Le Corbusier speaking at the dedication of the Notre-Dame-du-Haut church in Ronchamp, 25 June 1955. This religious building is among his most famous works and is considered one of the architectural milestones of the 20th century. Photograph by René Burri.
4. Exhausted in the atelier, c. 1927. Photograph by Alfred Roth.
5. Le Corbusier in front of the Plan Voisin, 1925. Visionary projects such as this were needed in order to transform Paris into a true 20th-century capital – as were visionary architects like Le Corbusier, here dressed smartly in a white shirt, waistcoat and bow tie. The metal-rimmed glasses were the unmistakable accessory of the intellectual.
6. Le Corbusier in front of the plans for the Ville radieuse (Radiant City), c. 1933–35.
7. Le Corbusier in front of the model of the skyscraper 'Brise-soleil' for the city of Algiers (Project E, 1939), 1950s. He worked for ten years, from 1932 to 1942, on urban planning studies for Algiers. Photograph by Robert Doisneau.

8. Le Corbusier with his publication of 1935, La Ville radieuse (published in English as The Radiant City, 1967).
9. Le Corbusier in front of his model of the roof-top terrace of the Marseille Housing Unit, 1950s. Built between 1945 and 1952, the Unit is an enormous residential block for 1,600 inhabitants with shopping galleries, a hotel and roof-top terrace that houses a gym and kindergarten. Photograph by A. Scarnati.
10. Le Corbusier explains the Modulor, a system of measurement based on human proportions, c. 1960.
11. Le Corbusier in Venice at a discussion on his project for a new hospital in the city, 1965.
12. Le Corbusier at the construction site of the Dominican monastery La Tourette in Eveux-sur-l'Arbresle, near Lyon, 1959. Photograph by René Burri.

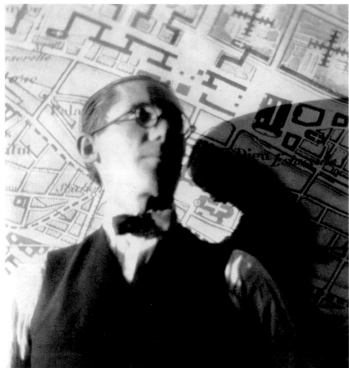

13

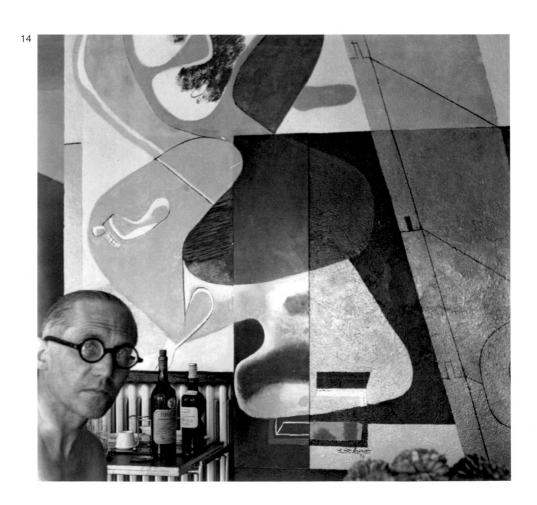

14

13. Le Corbusier in front of the Plan Voisin, 1925.
14. Le Corbusier in front of one of his murals
in the Villa E 1027 in Roquebrune-Cap-Martin,
owned by Eileen Gray and Jean Badovici,
c. 1938–40. The paintings were a 'present'
in acknowledgment of 'Bado' and Gray's
hospitality.
15. Le Corbusier in front of photographs of the
'Brise-soleil' skyscraper in Algiers (1939) and
of the competition project for the United Nations
headquarters in New York (1947), 1955.
Photograph by Franz Hubmann.

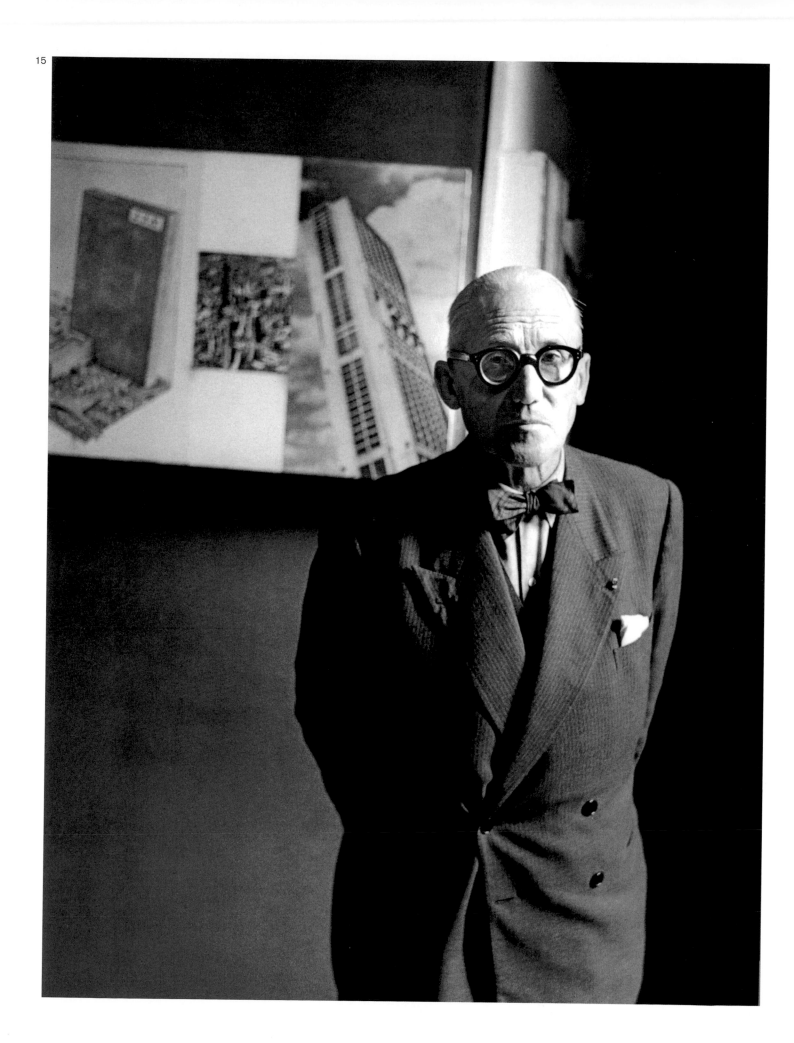

LE CORBUSIER'S WORLD

Le Corbusier lived in just two places in his life: from 1887 to 1917 in La Chaux-de-Fonds (as Charles-Edouard Jeanneret); and from 1917 to 1965 in Paris. But his various personal and professional pursuits (as architect, designer, painter and author) involved him in extensive travel. Many of the places he visited were a source of great inspiration to him, conjuring up new ideas and visions or stimulating him to conceive specific projects. Movement and change, discovering the new and the unknown while travelling – these were the essential elements on which Le Corbusier's 'recherche patiente' (patient research) flourished. Be it Paris, Moscow or Venice, Rio de Janeiro, Bogotá or New York – for Le Corbusier the world was a vast construction site and source of inspiration that consistently presented new challenges.

1

5

7

2

6

3

8

4

9

10

11

12

13

14

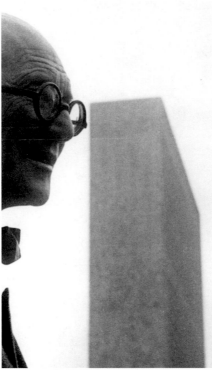

15

1. Charles-Edouard Jeanneret in the Parthenon, Athens, 1911. The structures of classical antiquity marked one of the highlights of Jeanneret's 'Voyage d'Orient', a journey of several months through the Balkan countries, Turkey, Greece and Italy. Photograph by August Klipstein.
2. Le Corbusier in St Peter's Square, Rome, August 1921. Photograph by Amédée Ozenfant.
3. Le Corbusier on a test drive on the roof of the Fiat factory in Lingotto, Turin, Italy, 1934. As with Citroën and Peugeot in France, the architect was unable to convince the company to collaborate with him.
4. At the fair, from left to right: August Klipstein and wife, Yvonne, Pierre Jeanneret and Le Corbusier, 1927.
5. Le Corbusier on board a DC-2 aeroplane (TWA from Chicago to Newark), 28 November 1935. In 1934 the U.S.-based Douglas Aircraft Company delivered the first DC-2s – the first aeroplane to demonstrate that passengers could travel comfortably, safely and reliably by air.
6. Stopover on the way to Moscow: Le Corbusier (right) with the Czech architect Jaromír Krejcar at Wilson station in Prague, October 1928.
7. Le Corbusier (left) and Nikolai Kolli at the construction site of the Centrosoyuz Building of the Central Union of Consumer Cooperatives, Moscow, March 1930.
8. Le Corbusier (right) and Dominik Cipera, member of the administrative board of the Bat'a company and mayor of Zlín, Zlín, April 1935. Both were jury members of the housing competition organized by Bat'a. Le Corbusier presented several potential projects to the company, but none of them came to fruition.
9. Fernand Léger (left) and Pierre Jeanneret with Le Corbusier (right) in Spain, 1930. Le Corbusier enjoyed taking long drives in his elegant Voisin and is shown here in a stylish driving outfit.
10. Le Corbusier at the fourth CIAM congress held on the cruise liner *Patris II*, between Marseille and Athens, August 1933. Sigfried Giedion, a historian of architecture, is shown left.
11. Le Corbusier (right) with Alfred Roth at the seventh CIAM congress in Bergamo, Italy, 1949.
12. On the road… Le Corbusier behind the steering wheel of his Voisin.
13. Le Corbusier in front of his Voisin, c. 1930.
14. Le Corbusier at the fourth CIAM congress on the cruise liner *Patris II*, August 1933. Behind him, from the left to right: Fernand Léger (cropped), Christian Zervos (concealed), Yvonne Zervos. Photograph by László Moholy-Nagy.
15. Le Corbusier in New York, 1959. In the background is the United Nations headquarters, designed by Wallace K. Harrison and built between 1947 and 1952. Many aspects of Harrison's project were based on Le Corbusier's design.

Le Corbusier at the Zurich-Kloten airport, Switzerland, just after arriving via an Air India Super Constellation, autumn 1960. He was visiting Zurich to view the future construction site of his pavilion for Heidi Weber on Zürichhorn. Photograph by René Burri.

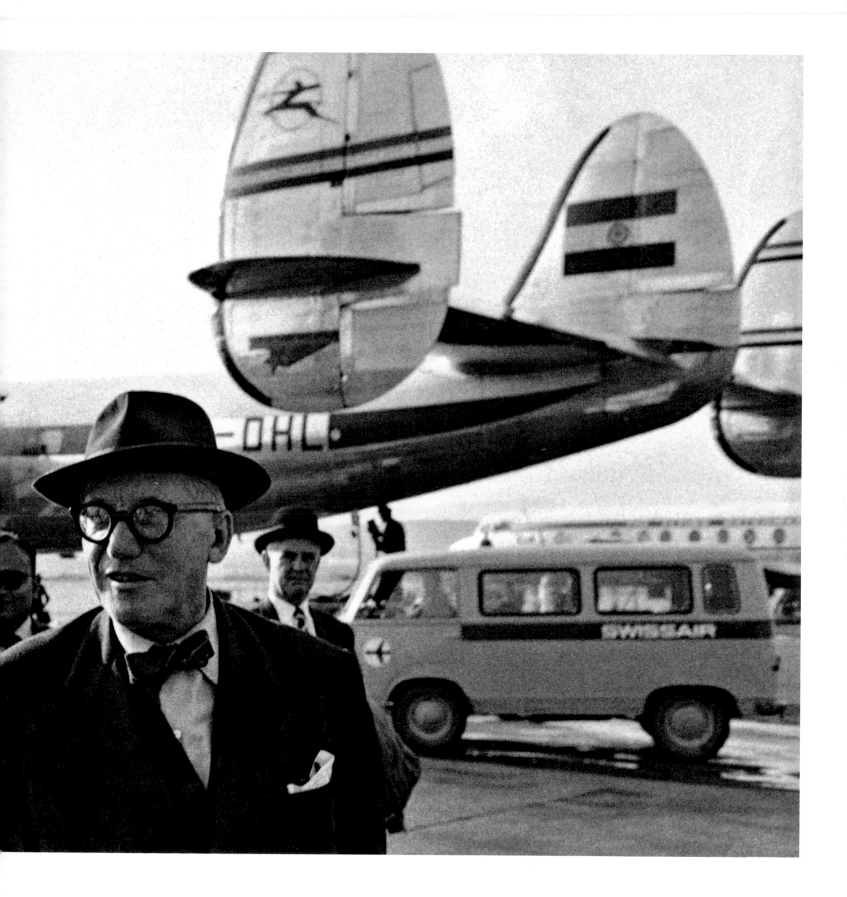

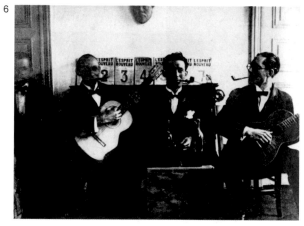

1. Octave Matthey (left), Charles-Edouard Jeanneret (centre) and Louis Houriet (right) working on the 'sgraffito' decoration of the Villa Fallet, La Chaux-de-Fonds, 1907. The decoration, in the 'Style sapin' (a local interpretation of the Art Nouveau movement), was a collective work by students from the Ecole d'Art. Jeanneret developed the plans for the project with the local architect René Chapallaz.
2. Le Corbusier (right) with Amédée Ozenfant in Rome, August 1921. Ozenfant was an entrepreneur, art connoisseur, intellectual and painter and became one of the most influential proponents of Le Corbusier's ideas.
3. Charlotte Perriand and Le Corbusier

in the 'Bar sous le toit' (bar under the roof), Paris, 1927. In the background is Percy Scholefield, Perriand's first husband. From 1927 Perriand worked in the studio in rue de Sèvres and played an essential role in the development of Le Corbusier's famous tubular-steel furniture.
4. In the atelier in rue de Sèvres, 1928. Left to right: Ernest Weissmann, Le Corbusier, Nikolai Kolli, Albert Frey, Vladimir Barkov, Charlotte Perriand, Pierre Jeanneret.
5. Left to right: Amédée Ozenfant, Albert and Charles-Edouard Jeanneret in the studio of the Villa Jeanneret-Perret, La Chaux-de-Fonds, August 1919.

6. Left to right: Pierre Jeanneret (?), Amédée Ozenfant, Albert Jeanneret and Le Corbusier, 1921. The first issues of the magazine *L'Esprit nouveau* (The New Spirit) are shown in the background. The magazine's agenda was to initiate a comprehensive cultural reform based on the establishment of an aesthetic harmony between industry and art.
7. Le Corbusier (left) with the architect Ludwig Mies van der Rohe in the grounds of what one year later would become the Weissenhof-Siedlung housing estate in Stuttgart, 21 November 1926. Le Corbusier designed two groundbreaking residential buildings for the complex.

8

Le Corbusier came into contact with countless prominent individuals in the course of his lengthy career: colleagues, artists or other players in the world of culture, industrialists, politicians and influential statesmen. He would sometimes develop longstanding friendships from what were, initially, purely professional contacts. Many of the images showing Le Corbusier with these individuals offer glimpses of his chameleon-like ability to adapt his behaviour and clothing according to the person he was with or the circumstances in which he found himself. They also often capture his unique sense of humour.

9

12

8. Left to right: Nikolai Kolli, Yvonne, Le Corbusier and Pierre Jeanneret in the apartment in rue Jacob, Paris, early 1929. Kolli, a Russian architect, was an important go-between in Le Corbusier's design of the Centrosoyuz Building of the Central Union of Consumer Cooperatives in Moscow. The building was not completed until 1936, under Kolli's direction. Photograph by Sigfried Giedion.
9. Le Corbusier in southern France, summer 1927.
10. At the fair, from left to right: Le Corbusier, Sigfried Giedion, Pierre Jeanneret, Yvonne, early 1929.
11. Carnival at the first CIAM congress in La Sarraz, Switzerland, July 1928. Le Corbusier is shown centre (with glasses), Pierre Jeanneret to the far right, Gabriel Guévrékian to the far left and next to him, André Lurçat.
12. Le Corbusier (right) with Walter Gropius in Paris, 1930.
13. On their way to the Weissenhof-Siedlung in Stuttgart, Pierre Jeanneret and Le Corbusier stopped off at the estate belonging to the parents of the Swiss architect Alfred Roth in Wangen an der Aare, October 1927. Left to right: Pierre Jeanneret, Le Corbusier, Friedrich T. Gubler (director of the Schweizerischer Werkbund) and Sigfried Giedion. Roth was working in Le Corbusier's atelier at the time and was construction manager for both buildings in the Weissenhof-Siedlung. Photograph by Alfred Roth.

10

11

13

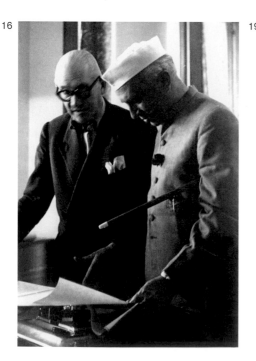

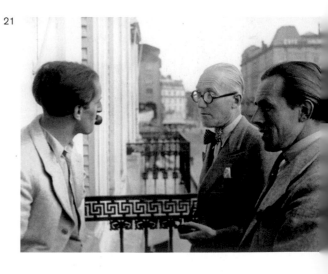

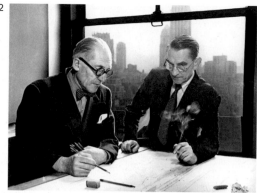

22

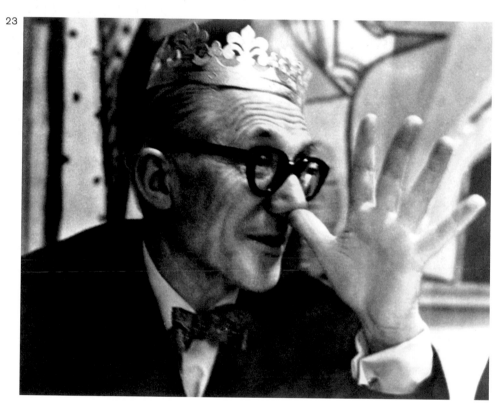

23

14. Le Corbusier with the dancer and singer Josephine Baker (centre) and her friend Pepito Abatino (far right) on the ocean liner *Lutetia*, 1929.
15. Getting in the car…
16. Le Corbusier with the Indian Prime Minister Jawaharlal Nehru, 1950s. It was Nehru who commissioned Le Corbusier to take charge of the overall planning of Chandigarh, the new capital of the Punjab.
17. Le Corbusier with Yvonne Gallis (his wife-to-be), Fernand Léger and his wife, Jeanne Lohy, 1925.
18. Le Corbusier with his schnauzer, Pinceau, 1930s.
19. Left to right: Fernand Léger, Charlotte Perriand, Le Corbusier, Albert and Pierre Jeanneret and Matila Ghyka at the fourth CIAM congress in Athens, 1933.
20. Le Corbusier (right) with Fernand Léger.
21. Le Corbusier (centre) with Willy Boesiger (editor of the *Oeuvre complète*) and the architect Alfred Roth (right), Zurich, 1938. Photograph by Bodé.
22. Le Corbusier with the Russian-born engineer Vladimir Bodiansky in New York, 1947. Le Corbusier was a member of the five-person committee for the planning of the United Nations headquarters in New York. His project '23A' was not well received, but nevertheless served as a template for Wallace K. Harrison's design.
23. Always up for some fun…
24. Le Corbusier and Albert Einstein in Princeton, USA, 1946.
25. Le Corbusier (centre) presents André Malraux (left) with the master plan for Chandigarh, 1952.

24

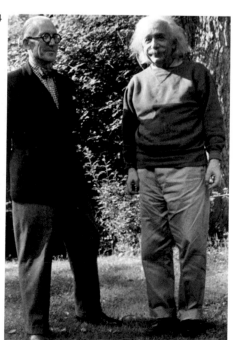

25

26. Le Corbusier discussing the construction plans with monks at the construction site of the Dominican monastery La Tourette in Eveux-sur-l'Arbresle, France, 1959. Photograph by René Burri.
27. Le Corbusier as a member of the advisory council for the construction of the UNESCO building in Paris, 1952. Left to right: Ernesto Rogers, Walter Gropius, Bernard Zehrfuss, Le Corbusier, Benjamin Wermiel, Marcel Breuer, Sven Markelius.
28. Le Corbusier and Pablo Picasso at the construction site of the Marseille Unité d'Habitation, 1949.

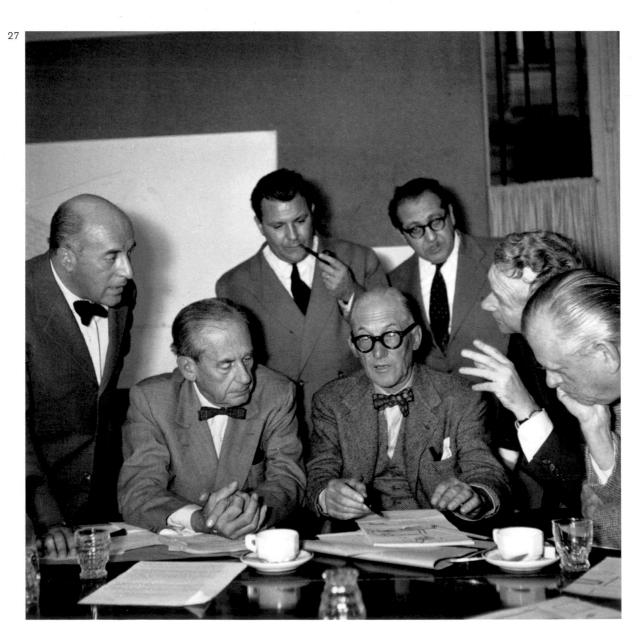

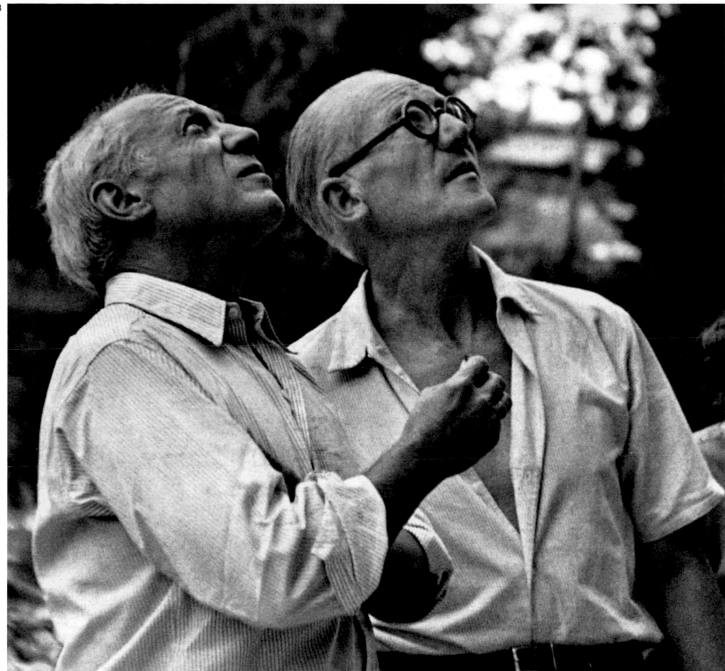

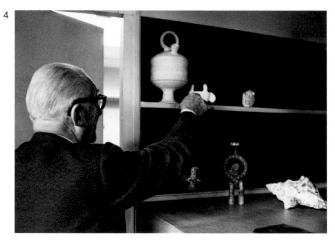

1. Charles-Edouard Jeanneret in front of the farmhouse Le Couvent near La Chaux-de-Fonds, Switzerland, where he lived for a short time after his 'Voyage d'Orient', 1911–12.

2. Charles-Edouard Jeanneret in his room in Berlin, April 1911. He worked for five months in 1910 to 1911 in the offices of the architect and designer Peter Behrens in Neubabelsberg.

3. Villa Le Lac (Petite maison), Corseaux, near Vevey, Switzerland, designed by Le Corbusier and Pierre Jeanneret in 1923–24. The small residential building, with a remarkable view of the mists over Lake Geneva towards the Grammont mountains, was conceived as a new home for Le Corbusier's parents. This photograph shows a view of Lake Geneva from the garden, 1953.

4. Le Corbusier with objects from his 'Collection particulière' in the apartment in rue Nungesser et Coli, 1959–60. From 1934 onwards, he and his wife, Yvonne, lived in the top storey of the apartment house that he designed in Paris-Passy. Photograph by René Burri.

5. Relaxing on the terrace of 'L'Etoile de Mer' bar, owned by Thomas ('Roberto') Rebutato in Roquebrune-Cap-Martin, France, c. 1950.

6. Le Corbusier in his apartment in rue Nungesser et Coli, 1959–60. The kitchen is shown in the background; left of the foreground is *Les mains* (The Hands), a sculpture he made in collaboration with the sculptor Joseph Savina in 1956. Photograph by René Burri.

7. Le Corbusier in his atelier in rue de Sèvres, Paris, 17 March 1955. Behind him are the architects Roger Aujame and Jerzy Sołtan (right).

8. Inside the Cabanon, the vacation home built by Le Corbusier between 1951 and 1952 in Roquebrune-Cap-Martin. Photograph by Lucien Hervé.

9. Le Corbusier with architect José Oubrerie in the atelier in rue de Sèvres in Paris, 1959–60. Photograph by René Burri.

10. In Le Corbusier's atelier at 35 rue de Sèvres, Paris, 24 January 1927. The design team in front of the plans for the competition project for the Palace of Nations in Geneva. Left to right: Ernst Schindler, Hans Neisse, Walter Schaad, Alfred Roth, Jean-Jacques Dupasquier, Zvonimir Kavurič, Pierre Jeanneret and Le Corbusier.

11. Le Corbusier bathing in the Mediterranean, Roquebrune-Cap-Martin, 1950s.

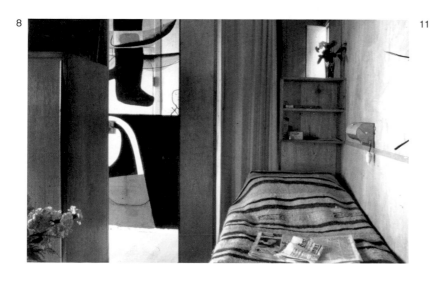

Living and working spaces played a key role in Le Corbusier's life. While his studios and offices were infused with an atmosphere of vibrant creativity, his apartments and private spaces were havens that offered stability, identity and comfort, as well as a context for relaxed contemplation or gatherings with friends. These private spaces reflect not only the intellectual biography of the architect but also his personality, sensibilities and passions.

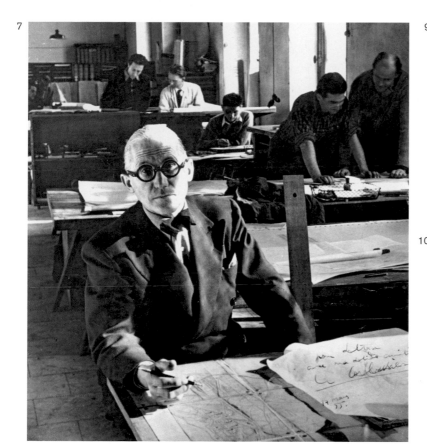

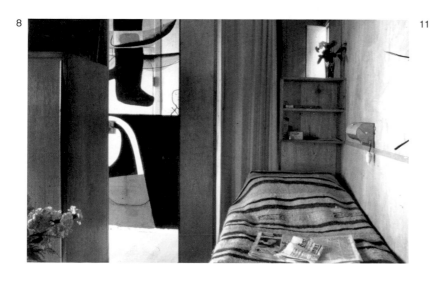

Klaus Spechtenhauser

12. Le Corbusier in his apartment in rue Jacob
in Paris, 1931. The photographer Brassaï was
astonished by the 'old-fashioned' atmosphere
in which Le Corbusier lived. Photograph
by Brassaï.
13. Le Corbusier's atelier in rue de Sèvres
in Paris, 1950s. Photograph by Robert Doisneau.
14. Le Corbusier in the Cabanon, summer 1952.
Photograph by Lucien Hervé.

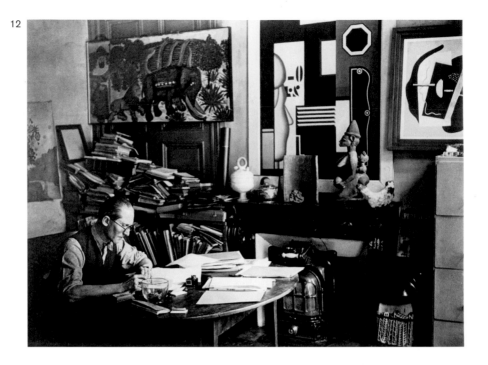

12

13

ARCHITECT, ARTIST, ICON

1 & 3. Le Corbusier lecturing in Zurich, 1938.
Photograph by Gotthard Schuh.
2. Le Corbusier in his attic studio in rue Jacob
in Paris, *c.* 1920.
4. Le Corbusier, 1930.
5. Le Corbusier among friends at the seventh
CIAM congress in Bergamo, Italy, 1949.
6. Amédée Ozenfant and Le Corbusier (left),
Paris, June 1923.
7. Le Corbusier in front of an Air France Super
Constellation heading to India, *c.* 1960.
8. Le Corbusier, 1950s.
9. Le Corbusier on the way to the construction
site of La Tourette monastery in Eveux-sur-
l'Arbresle, 1959. On the train from Paris to Lyon
he made notes in his sketchbook, which he always
carried with him. Photograph by René Burri.
10. Le Corbusier, 1950s. Photograph by
Robert Doisneau.

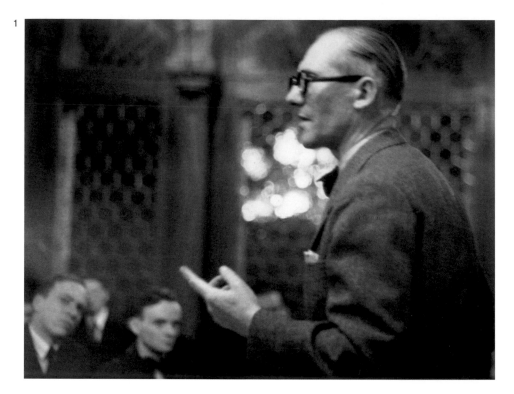

6

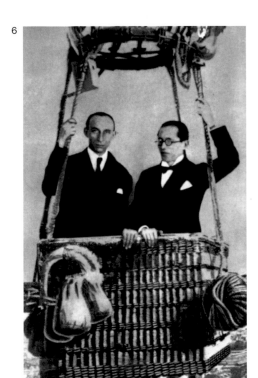

7

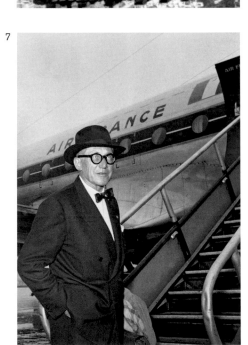

8

Very few personalities leave behind an impression of themselves that endures for generations. Even in his early years Le Corbusier began to cultivate a look that extended beyond his own personality to almost represent the identity of the architect: suit, white shirt and bow tie; round metallic or (later) horn-rimmed glasses; and often a pipe or cigarette in his mouth.

Le Corbusier was a master at fulfilling the expectations placed upon him as a public figure. He always looked dashing, even in the black and white American wool shirt that he frequently wore while working in his painting studio in rue Nungesser et Coli in the suburbs of Paris. His expression is generally focused or meditative and always serious. But in his later years he is often shown smiling and exudes a sense of composure, even serenity. It is tempting to see in such images an awareness of the unmatched influence he was to have on 20th-century architecture.

9

10

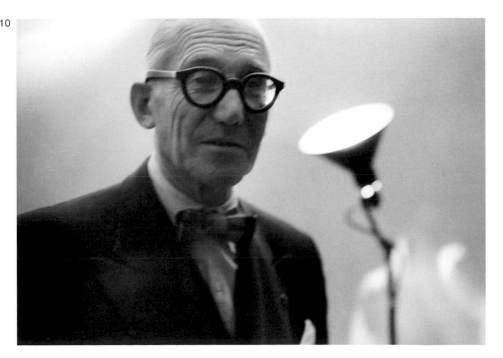

11. Le Corbusier in his sturio in rue Nungesser
et Coli, 1959–60. Photograph by René Burri.
12. Le Corbusier, 1932. Photograph by
Studio Limot.
13. Le Corbusier in a restaurant in Zurich, 1960.
Photograph by René Burri.
14. Le Corbusier in Zurich, 1938. Photograph
by Bodé.

11

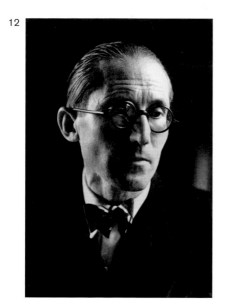

12

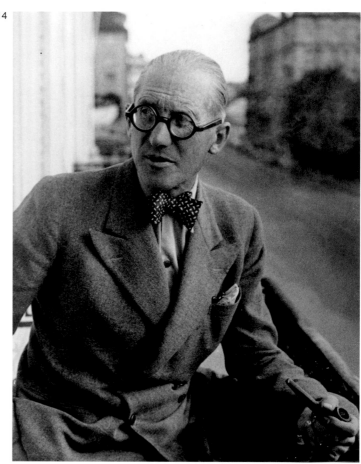

14

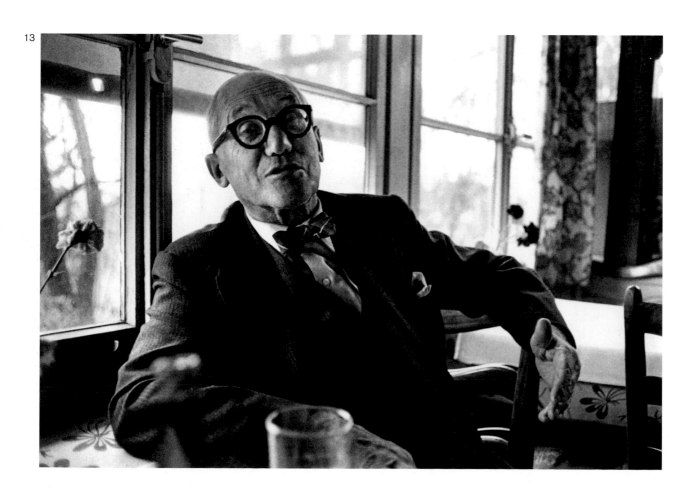

13

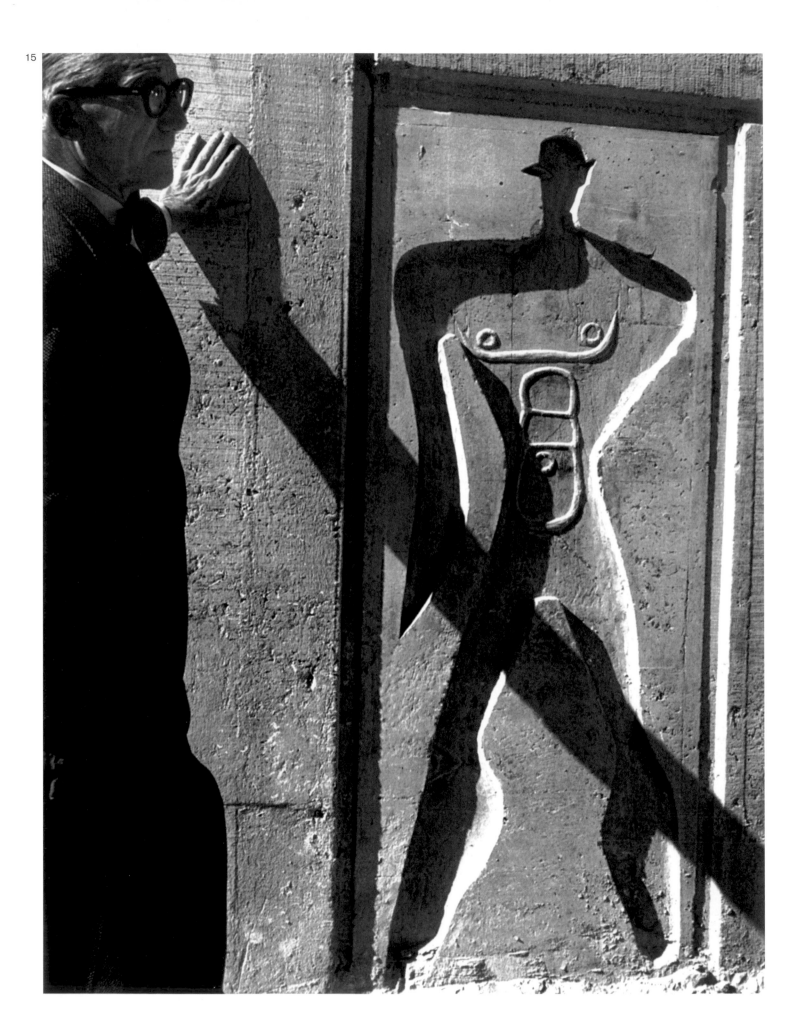

15. Le Corbusier on the day of the dedication of the Marseille Unité d'Habitation, 14 October 1952. Photograph by Lucien Hervé.
16. Le Corbusier in his studio in rue Nungesser et Coli, 1959–60. Photograph by René Burri.
17. Le Corbusier in his studio in rue Nungesser et Coli working on the painting *Plougrescant*, 1938. Photograph by Paul Almásy.

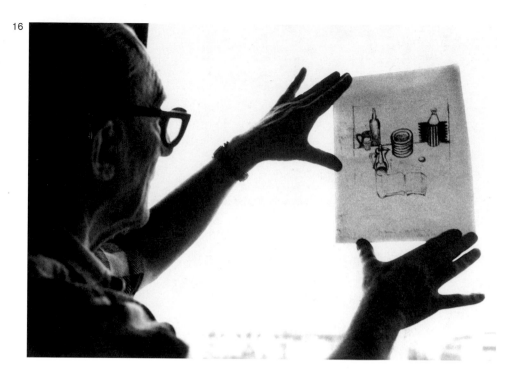

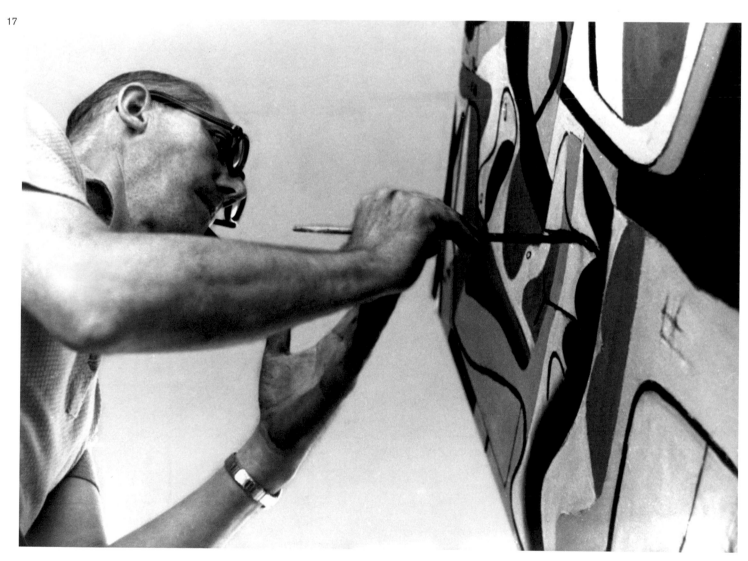

Le Corbusier in his 'studiolo' in the rue de Sèvres, Paris, 1959–60. Photograph by René Burri.

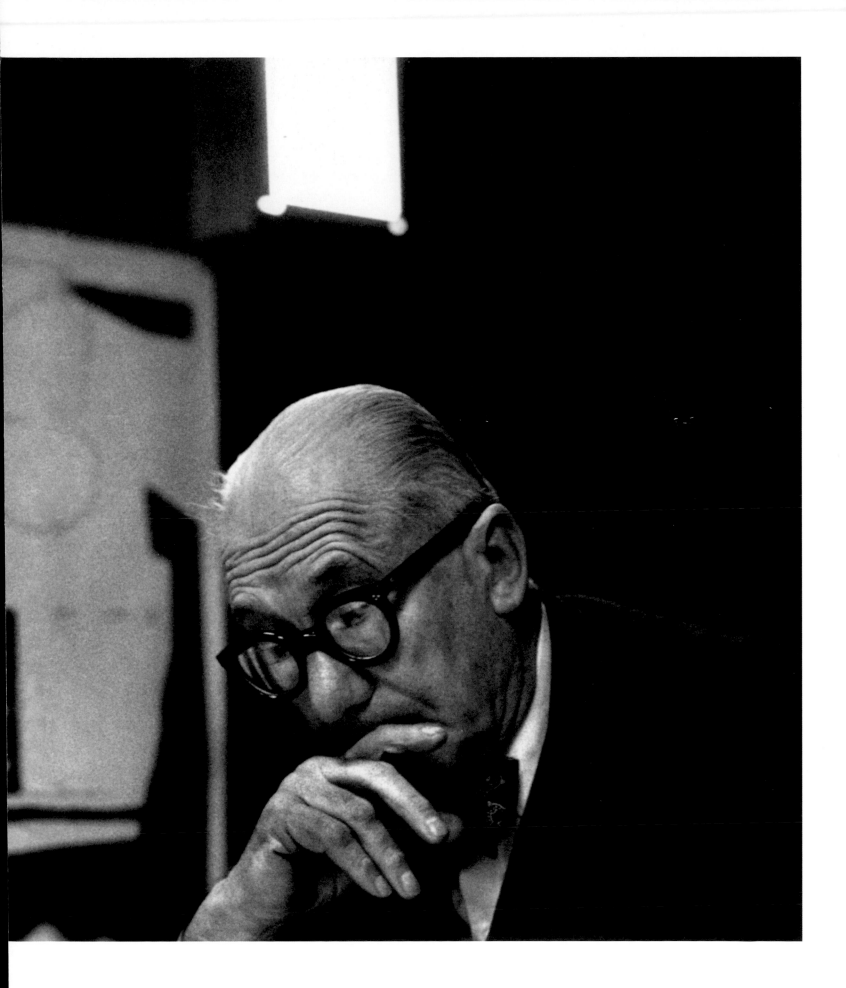

NOTES
AND
SELECT BIBLIOGRAPHY

1

LE CORBUSIER'S
SECRET PHOTOGRAPHS

TIM BENTON

Le Corbusier's Secret Photographs
Tim Benton

1. From what remains of the 18 reels of film, we have 21 minutes of film, of which 4 minutes 7 seconds are composed of 5,931 still photographs; the rest are film sequences.

2. See Le Corbusier, *Des canons, des munitions? Merci! des logis... s.v.p.*, Boulogne-sur-Seine: Editions de L'Architecture d'Aujourd'hui, coll. 'L'équipement de la civilisation machiniste', 1938. The layout for these pages is held by the Fondation Le Corbusier (FLC, L2(13)172); see Catherine de Smet, *Vers une architecture du livre*, Baden: Lars Müller, 2007, p. 264.

3. Stanislaus von Moos attributes Le Corbusier's interest in cinema to his fascination with the books of Rodolphe Töpffer (see Stanislaus von Moos, 'Voyage en zigzag' in *Le Corbusier before Le Corbusier: Applied Arts, Architecture, Painting and Photography 1907–1922*, Stanislaus von Moos and Arthur Ruegg (eds), publication for the Bard Graduate Center for Studies in the Decorative Arts, Design and Culture, New York, with the Langmatt Museum, Baden, Switzerland, New Haven: Yale University Press, 2002). Töpffer's approach to montage is closer to traditional cartoon sequencing than to film editing, but it is precisely in this sense that Le Corbusier understood film-making.

4. Jean-Louis Cohen, *Le Corbusier et la mystique de l'URSS: théories et projets pour Moscou, 1928–1936*, Bruxelles/Liège: Pierre Mardaga Editeur, 1987, pp. 48–49.

5. The film *Architecture d'aujourd'hui* was commissioned by the newly founded journal of the same name and introduced the public to the architecture of Auguste Perret and Le Corbusier (Pessac, Villa Stein, Villa Church, Villa Savoye and the Plan Voisin). *Bâtir* showed a more conventional building site (as the steel frame was later covered with a traditional stone facade), which contrasted with the modern architecture of Auguste Perret, Robert Mallet-Stevens and Le Corbusier and Pierre Jeanneret (see Alessandra Redivo, *Bâtir, L'Architecture d'aujourd'hui. Costruire l'architettura moderna 1930. Il contributo di due film di Pierre Chenal*, Venice: Istituto Universitario di Architettura di Venezia, 2001).

6. Manuscript of an article intended for the journal *Prélude*, founded in 1933 by Le Corbusier, Dr Pierre Winter, François de Pierrefeu and Herbert Lagardelle (FLC, E1(11)253).

7. Lucien Pierron, 'La prise de vues Pathé-Baby' in *Le Cinéma chez soi*, no. 35, 1929, pp. 14–15.

8. 'Questions d'économies' in *Le Cinéma chez soi*, no. 31, 1929, p. 2.

9. FLC, F3(6)3, p. 13 recto. Just prior to this, he had made a note to ring Chenal, perhaps on the same subject, on 28 February 1936 (FLC, F3(6)2).

10. The Kinamo movie camera, invented by the Russian engineer Emanuel Goldberg in 1921, was developed into several later models under the name Kinamo or Zeiss Ikon Movikon, between 1923 and 1933. Goldberg directed the Internationale Camera Aktiengesellschaft company, a subsidiairy of Zeiss, which was united with four other companies in 1926 to create Zeiss Ikon. The Dutch film-maker Joris Ivens, who knew Goldberg, used the Kinamo for his early documentary films such as *De Brug, Zuiderzee* (1930), *Borinage* (1933) and *Philips Radio* (1931).

11. Agenda used between April 1936 and February 1937 (FLC, F3(6)3 p. 28). On page 27 recto, Le Corbusier had already indicated the train schedules for Frankfurt, and the departure time of the Graf Zeppelin.

12. This page (p. 28 recto) is in the agenda, two pages after the note on the departure of the Zeppelin from Frankfurt on 8 July 1936, among the last annotations on the preparations before the trip.

13. Sequence 1 05775 (the file name given to the new scan of the film).

14. Fifteen yellow Kodak boxes, originally containing 50-foot (15.25-metre) reels of film, have survived at the Fondation Le Corbusier. Unfortunately, the film has been removed from the boxes and spliced together into a big reel, after cutting off the tops and tails of the films. One box carries the inscription: 'Eté 36, 24 Nungesser et Coli peinture; tableau cordage T100 film (avec pied); sport stade Jean Bouin; Trois os film; Corbu sur voûte et pelouse luzerne' (Summer 36; 24 Nungesser et Coli paintings; rope painting T100 film (with tripod); sport Jean Bouin stadium; three bones film; Corbu on the roof and lucerne lawn), so this film must have been shot before his departure to Brazil in July 1936. The fact that four of the other films shot in his apartment at 24 rue Nungesser et Coli are of the same period is confirmed by the season and by the film emulsion numbers. Three films, including two shot in Brazil, carry the number 61022 whereas another has the number 61015. None of the other films has batch numbers beginning with 610.

15. Jürgen Lossau, *Der Filmkamera-Katalog: 16mm 9,5mm 8mm Single-8 Super-8 Doppel-Super-8*, Hamburg: Atoll Medien, 2003. I would like to thank Sophie Vantieghem for leading me to this important document.

16. *Le Corbusier: il viaggio in Toscana*, a cura di Giuliano Gresleri, Venezia: Cataloghi Marsilio, 1987 and *Le Corbusier, Viaggio in Oriente: gli inediti di Charles-Edouard Jeanneret fotografo e scrittore*, Giuliano Gresleri (ed.), Venezia/Paris: Marsilio/Fondation Le Corbusier, 1985.

17. Reproduced as the frontispiece of the chapter 'Le sentiment déborde', Le Corbusier, *Urbanisme*, Paris: Editions Crès & Cie, 1925, p. 29.

2

'BEWARE PRINTER!':
PHOTOGRAPHY AND THE
PRINTED PAGE

CATHERINE DE SMET

18. See Françoise Véry, 'Athènes', in *Le Corbusier: le passé à reaction poétique*, Pierre Saddy and Claude Malécot (eds), trans. Marianne Brausch and Gérard Cladel, Paris: Caisse nationale des monuments historiques et des sites, Ministère de la culture et de la communication, 1988, pp. 54–59.

19. From an interview in the 1960s with Jacques Barsac. See Leo Schubert 'Jeanneret, the City and Photography' in *Le Corbusier before Le Corbusier, op. cit.* (note 3), p. 55.

20. See Roland Barthes, 'La chambre claire. Note sur la photographie' (1979; *Camera Lucida: Reflections on Photography*, 1981) in Roland Barthes, *Oeuvres complètes*, vol. 5, Paris: Editions du Seuil, 2002, pp. 785–890.

21. See Stanislaus von Moos, 'Les femmes d'Alger' in *Le Corbusier et la Méditerranée*, Marseille: Parenthèses/Musées de Marseille, 1987, pp. 191–209.

22. Le Corbusier often spent his holidays at Le Piquey. He was there with Yvonne in September 1936, writing to the publisher Picard on 8 September 1936 from the Hôtel Chanteclerc (FLC, B1(14)343). It was also on this occasion that he left a statement in the visitor's book (see note 25, below) (FLC, E2(8)109).

23. In his book *Aircraft* (London: The Studio, 1935, p. 116), Le Corbusier makes the explicit connection between his observations of natural forces from the air and a sense of destiny:
"[With Durafour across the Atlas (Algiers – Ghardaïa) March 18, 1933.]
The earth:
A bony structure (rocks) product of matter in fusion cooled on the surface and having undergone shrinkage, contraction, splitting and tearing apart, etc...
And above:
The immemorial play of water – water vapour. Rivers or erosion or infiltration.
[...] Annihilation of wealth or creation of wealth.
Thus God, looking down on things from above, is assured of having delivered Earth to fate – to its fate."

24. Le Corbusier, *Une maison – un palais: à la recherche d'une unité architecturale*, Paris: Editions Crès & Cie, coll. 'L'Esprit nouveau', 1928, p. 160.

25. Note by Le Corbusier in the visitor's book at the Hôtel Chanteclerc, Le Piquey, in September 1936 (FLC, E2(8)109).

26. At this time, in Germany, photographers join the Neue Sachlichkeit (New Objectivity) movement. Photography becomes the instrument of a Neues Sehen (New Vision). Liberated from the pictorial model, photography is defined first and foremost as a medium with its own technical, optical and formal laws. Hence a new aesthetic, in which objects are seen in a new or unusual way.

27. Le Corbusier, *L'Art décoratif d'aujourd'hui*, Paris: Editions Crès & Cie, 1925.

28. Tim Benton, *The Rhetoric of Modernism: Le Corbusier as a Lecturer*, Boston, MA: Birkhaeuser, 2009.

'Beware Printer!':
Photography and the Printed Page
Catherine de Smet

1. Le Corbusier created the 'Esprit nouveau' series (as a continuation of the magazine of the same name) for his books published by Crès & Cie, and subsequently the 'Equipement de la civilisation machiniste' series from 1935 with the publishers Editions de L'Architecture d'Aujourd'hui. Note that the term 'Esprit nouveau' appears in various forms: as the series mentioned above; as a general concept (esprit nouveau); and as the magazine (*L'Esprit nouveau*).

2. I exclude from this *Oeuvre complète*, for which, despite his claims to the contrary, Le Corbusier did not handle the editing or the page layout; he simply provided the material, including the photographs. Concerning the physical and visual concepts for his publications, see my book, *Vers une architecture du livre. Le Corbusier, édition et mise en pages, 1912–1965,* Baden: Lars Müller Publishers, 2007, and my shorter essay on the subject, *Le Corbusier Architect of Books*, Baden: Lars Müller Publishers, [2005] 2007.

3. The *Bulletin Thomas* (no. 1) also served as a catalogue for the Jeanneret and Ozenfant exhibition that was organized, at the end of 1918, in Germaine Bongard's fashion house in the rue de Penthièvre in Paris, renamed 'Galerie Thomas' for the occasion. On this subject, see Françoise Ducros, *Amédée Ozenfant*, Paris: Editions du Cercle d'Art, 2002, also the author of an essay on photography that looks at the work of Ozenfant and *Le Corbusier: La Photographie pure. Modernisme, culture, tekhnê, 1800–1930*, Thèse d'habilitation (Habilitation thesis), Université de Paris IV-Sorbonne, 2007, pp. 144–160.

4. Promotional document published by Editions Crès & Cie, 1923 (FLC, B2(15)17).

5. Elie Faure, 'La Ville radieuse' in *L'Architecture d'aujourd'hui*, no. 11, 1935, pp. 1–2.

6. Le Corbusier, *Vers une architecture*, Paris: Editions Crès & Cie, 1923, pp. 64–65.

7. Le Corbusier, *L'Art décoratif d'aujourd'hui*, Paris: Editions Crès & Cie, 1925, pp. 194–95. Ripolin was the name of a brand of paint. Le Corbusier always recommended the use of white paint: '...each citizen must replace his wall coverings, his damask, his wallpaper, his stencils, with a layer of pure white Ripolin.' (*L'Art décoratif d'aujourd'hui*, Arthaud, 1980, p. 191.) There is also a moral dimension to this: 'the love of purity!' (Ibid.)

8. Le Corbusier, *La Ville radieuse*, Boulogne-sur-Seine: Editions de L'Architecture d'Aujourd'hui, coll. 'L'équipement de la civilisation machiniste', 1935, p. 343.

9. Le Corbusier, *Des canons, des munitions? Merci! des logis... s.v.p.*, Boulogne-sur-Seine: Editions de L'Architecture d'Aujourd'hui, coll. 'L'équipement de la civilisation machiniste', 1938, p. 41.

10. This photomontage can be seen on a billboard, in a picture of the exhibition in the Pavillon des Temps Nouveaux on p. 66 and then, isolated, at the bottom of the same page (p. 66), and also on p. 142, in the form of a drawing of the book *La Ville radieuse*.

11. On this topic see my books, *Vers une architecture du livre* and *Le Corbusier Architect of Books*, op. cit. (note 2).

12. This popular French magazine, founded in 1833, ran for over one hundred years. It took the form of a highly illustrated encyclopaedia and contained information on a vast range of topics, from science, philosophy and history to industry and travel.

13. In particular see Beatriz Colomina, 'Le Corbusier et la photographie' in *Esprit Nouveau: Le Corbusier et l'industrie, 1920–1925*, Stanislaus von Moos (ed.), Zurich/Berlin: Museum für Gestaltung/Ernst und Sohn, 1987, p. 38.

14. Le Corbusier, *Vers une architecture*, op. cit. (note 6), p. 225 and Le Corbusier, *L'Art décoratif d'aujourd'hui*, op. cit. (note 7), p. 98. 'Innovation' was the brand name of the trunk.

15. Le Corbusier, *L'Art décoratif d'aujourd'hui*, op. cit. (note 7), p. 15.

16. See Stanislaus von Moos., 'Le Corbusier et Loos', in *L'Esprit nouveau: Le Corbusier et l'industrie*, op. cit. (note 13), p. 125, and Beatriz Colomina, *La publicité du privé: de Loos à Le Corbusier* [1994], trans. Marie-Ange Brayer, Orléans: HYX, 1998, pp. 139–48.

17. Le Corbusier, *Urbanisme*, Paris: Editions Crès & Cie, 1925, p. 38.

18. 'Complete page reserved for a picture of the lighthouse made by the former Etablissements Sautter-Harlé/16, Avenue de Suffren, Paris', in *L'Art décoratif d'aujourd'hui*, op. cit. (note 7), p. 108.

19. Le Corbusier, *Croisade*, Paris: Editions Crès & Cie, 1933, p. 72.

20. See Gustavs Klucis, 'Le photomontage, nouvel art de propagande' [1931], in exhib. cat. *Gustavs Klucis*, Musées de Strasbourg, 2005, pp. 125–28; Marie-Hélène Joyeux, 'Le photomontage politique à travers les couvertures de *Vu*: 1928–1936' in *Les Cahiers du Musée national d'art moderne*, no. 84, July 2003, pp. 49–65.

21. Le Corbusier, *Aircraft*, London: The Studio, 1935.

22. Le Corbusier consulted, among others, Antoine de Saint-Exupéry and a number of acquaintances (including Colonel P. Vauthier in France and Colonel G. Fiorini in Italy) in order to acquire suitable photographic material. See Le Corbusier's letters between March and June 1935 (FLC, B3(14)50 to 61).

23. Letter from Le Corbusier to the publishers, The Studio, 7 May 1935 (FLC, B3(14)21).

24. Moï Ver, *Paris*, Paris: Editions Jeanne Walter, 1931. Le Corbusier was probably familiar with this book: his friend Fernand Léger had written the introduction, and Jeanne Walter was the co-editor (with Philippe Lamour) of the review *Plans*, to which he had contributed significantly.

25. Letter from Le Corbusier to Picard (through whom he dealt with Plon), 8 September 1936 (FLC, B1(14)343).

26. Erich Mendelsohn, *Erich Mendelsohns's Amerika : 82 photographs*, New York: Courier Dover Publications, 1993, p. 24.

27. Le Corbusier, *Quand les cathédrales étaient blanches: voyage au pays des timides*, Paris: Plon, 1937, p. 325.

28. Le Corbusier, *Destin de Paris*, Paris and Clermont-Ferrand: Sorlot, 1941.

29. See the letter from Sorlot to Le Corbusier, 3 November 1940 (FLC, A3(8)29). The photomontage was part of one of the friezes exhibited in the Pavillon des Temps Nouveaux, which, in 1938, had already served as the cover for *Logis et loisirs* (Boulogne-sur-Seine: Editions de l'Architecture d'Aujourd'hui, 1937). It included pictures of various Paris monuments, such as the Eiffel Tower and the Arc de Triomphe, and was accompanied by a detail from the *Marseillaise* by sculptor François Rude.

30. See the highly critical article by Gisèle Freund: 'La photographie à l'exposition' in *Arts et métiers graphiques*, no. 42, 1938, pp. 37–41 (found also in Dominique Baqué, *Les documents de la modernité: anthologie de textes sur la photographie 1919 à 1939*, Nîmes: Editions Jacqueline Chambon, 1993, pp. 485–89).

31. See, for example, László Moholy-Nagy, *Malerei, Fotografie, Film*, Munich: Albert Langen, 1925, no. 8 in the Bauhausbücher series, pp. 117–19 – a book that formed part of Le Corbusier's personal library.

32. Le Corbusier, *L'Atelier de la recherche patiente*, Stuttgart: Hatje, 1960.

33. Le Corbusier, *Les Plans de Paris, 1956–1922*, Paris: Editions de Minuit, 1956.

34. *L'Architecture d'aujourd'hui*, special Le Corbusier edition, 1948, pages 78 and 88.

35. Le Corbusier, *New World of Space*, New York: Raynal & Hitchcock, 1948.

36. André Malraux, *Le Musée imaginaire* [1947], Paris: Gallimard, coll. 'Folio', 1996.

37. Mock-up for *Une petite maison* (FLC, B2(19) folder no. 2).

38. Mock-up for *L'Atelier de la recherche patiente*, first run (FLC, B1(10), p. 269).

39. Mock-up for *L'Architecture d'aujourd'hui*, special Le Corbusier edition, 1948 (FLC, A3(16), corresponding to page 91).

40. Mock-up for *L'Atelier de la recherche patiente* (FLC, B1(9)5).

41. Le Corbusier, *Ronchamp*, Stuttgart: Hatje, 1957.

42. Le Corbusier, *Une petite maison*, Zurich: Girsberger, 1954, p. 59.

43. Le Corbusier, *Ronchamp*, op. cit. (note 41), p. 127.

44. Handwritten note from Le Corbusier, 1951 (FLC, B2(19)155).

45. Letter from Le Corbusier to Hans Girsberger, 3 May 1954 (FLC, F3(20)129). Concerning Le Corbusier's collaboration with Claudine Peter, and in particular regarding his approach to pictures and photography, see Daniel Naegele, *Le Corbusier's Seeing Things: Ambiguity and Illusion in the Representation of Modern Architecture*, PhD, University of Pennsylvania, 1996. See also Barbara Mazza, *Le Corbusier e la fotografia: la vérité blanche*, Florence: Firenze University Press, 2002.

46. Letter from Le Corbusier to Claudine Peter, 18 May 1954 (FLC, T1(2)248).

3

MONUMENTAL PHOTOGRAPHS

ARTHUR RÜEGG

Monumental Photographs
Arthur Rüegg

1. Walter Benjamin, 'Paris, the Capital of the Nineteenth Century (Exposé of 1935)' in Walter Benjamin, *The Arcades Project*, trans. Howard Eiland and Kevin McLauglin, Cambridge, MA: Belknap Press of Harvard Univ. Press, 2002, p. 9.
2. See Arthur Rüegg, 'Autobiographical Interiors: Le Corbusier at Home' in Alexander von Vegesack et al., *Le Corbusier: The Art of Architecture*, exhib. cat., Weil am Rhein: Vitra Design Museum, 2007, p. 123.
3. 'Entretien avec Le Corbusier' in Georges Charbonnier, *Le Monologue du peintre*, vol. 2, Paris: Julliard, 1960, p. 103.
4. Ibid., p. 101.
5. They were intended to interact with ceilings painted grey or white and brown or green linoleum floors. Cf. the reconstruction of the colour combinations in Jan de Heer, *The Architectonic Colour: Polychromy in the Purist Architecture of Le Corbusier*, Rotterdam: 010 Publishers, 2009, pp. 182–83.
6. FLC, J 1(8)19 to 28, 1 August 1931.
7. See the text by Ivan Zaknic in Echelle-1 and Fondation Le Corbusier (eds), *Le Corbusier Plans, 1929–1933*, Paris: Codex Images International, 2005; and Ivan Zaknic, *Le Corbusier, Pavillon Suisse: The Biography of a Building/Biographie d'un bâtiment*, Basel: Birkhäuser, 2004, although the photo collage is mentioned only briefly in the latter.
8. 'Entretien avec Le Corbusier' in Georges Charbonnier, *op cit.* (see note 3), p. 106.
9. On the curved wall, there is a photograph printed in negative (stack of wood, top row to the left of centre). Le Corbusier occasionally used the effect of inversion in his books as well.
10. 'Entretien avec Le Corbusier' in Georges Charbonnier, *op cit.* (see note 3), p. 107.
11. Charlotte Perriand, *Charlotte Perriand: A Life of Creation*, New York: Monacelli, 2003, p. 49.
12. Le Corbusier himself started to photograph with a film camera again around 1936 (see the essay by Tim Benton in the present volume); it may be that the photographs taken up to 1933 are by Pierre Jeanneret. The relevant archives are lost.
13. Le Corbusier mentioned this store in the context of new interior decoration after the war; Le Corbusier to Pierre Jeanneret, 27 September 1948 (FLC, J 1(8)162).
14. The photographs in question are *Equerres ordonnées*, and *Empilement de tuiles*, see Jacques Barsac, *Charlotte Perriand and Photography: A Wide-Angle Eye*, Milan: Editions 5 Continents, 2011, pp. 158–60, figs on p. 206 (bottom), p. 213 (variation), and p. 124.
15. Le Corbusier, *Les tendances de l'architecture rationaliste en rapport avec la collaboration de la peinture et de la sculpture*, Rome: Reale Accademia d'Italia, 1937-XVI, p. 14.
16. See Stanislaus von Moos, *Le Corbusier: Elements of a Synthesis*, Cambridge, MA: MIT Press, 1982, p. 303.
17. 1939; FLC, E 1(5)34.
18. See Michel de Frizot and Cedric de Veigy, *Vu: Le magazine photographique, 1928–1940*, Paris: Editions La Martinière, 2009.
19. See Jean Barsac, *Charlotte Perriand and Photography, op cit.* (see note 14), pp. 264–77. The photomontage was reconstructed in colour for the exhibition 'Charlotte Perriand: Entwerferin, Fotografien, Akivistin' at the Museum für Gestaltung Zürich, 2010 (curators: Andres Janser and Arthur Rüegg; advisers: Pernette Perriand and Jacques Barsac).
20. See the standard work on the subject: Romy Golan, *Muralnomad: The Paradox of Wall Painting, Europe 1927–1957*, New Haven, CT: Yale Univ. Press, 2009.
21. On the planning history, see Danilo Udovicki-Selb, 'Les engagements de Charlotte Perriand pour l'Exposition de 1937 à Paris: Le Corbusier, "Les Jeunes 37" et le Front populaire', in *Charlotte Perriand*, exhib. cat., Paris: Centre Georges Pompidou, 2005, pp. 41–62. The most thorough reproduction of the pavilion is in Ivan Rumenov Schumkov, 'Architecture and Revolution: Pavillon des Temps Nouveaux by Le Corbusier and Pierre Jeanneret at the International Exposition of 1937 in Paris', PhD, Universitat Politècnica de Catalunya, 2009. See also Joan Ockman, 'Lessons from Objects: Perriand from the Pioneer Years to the "Epoch of Realities"' in Mary McLeod, *Charlotte Perriand: An Art of Living*, New York: Harry N. Abrams and the Architectural League of New York, 2003, pp. 154–81.
22. See the *Contrat de principe* of the architects, Le Corbusier and Pierre Jeanneret, with the artists involved, 1 February 1937, Archives Charlotte Perriand, Paris.
23. Congrès Internationaux d'Architecture Moderne (International Congresses of Modern Architecture).
24. See the monograph on the pavilion: Le Corbusier, *Des canons, des munitions? Merci! des logis... s.v.p.*, Boulogne-sur-Seine: Editions de l'Architecture d'Aujourd'hui, coll. 'L'Equipement de la civilisation machiniste', 1938.
25. Le Corbusier, *Le Lyrisme des temps nouveaux et l'urbanisme*, Colmar: Le Point, 1939, p. 94.
26. This part of the collage was used (reversed!) for the cover of the official book for the fifth CIAM congress of 1937: *Logis et loisirs: 5e congrès CIAM Paris, 1937; Urbanisme*, Boulogne-sur-Seine: Editions de L'Architecture d'aujourd'hui, 1938.
27. I am grateful to Ivan Rumenov Shumkov for sending me his extensive dissertation, *op cit.* (see note 21), in which this drawing is illustrated.
28. Le Corbusier, *Des canons, des munitions?*, *op cit.* (see note 24), p. 110.
29. Ibid., p. 110.
30. Le Corbusier, 'The Quarrel with Realism: The Destiny of Painting' in J.L. Martin et al. (eds), *Circle: International Survey of Constructive Art*, London, 1937 [1971], pp. 67–74.
31. Le Corbusier (transcript of his talk) in Jean Lurçat et al., *La querelle du réalisme*, Paris: Editions sociales internationales, 1936, pp. 89–90.

32. 'Entretien avec Le Corbusier' in Georges Charbonnier, *op cit.* (see note 3), p. 106.

33. Le Corbusier, *Le Modulor*, Boulogne-sur-Seine: Editions de L'Architecture d'Aujourd'hui, 1950, p. 155.

34. Stanislaus von Moos, 'Art, Spectacle and Permanence: A Rear-Mirror View of the Synthesis of the Arts' in Vegesack, *Le Corbusier, op. cit.* (see note 2), p. 69.

35. Reprinted in Jean Petit (ed.), *Le Poème électronique Le Corbusier*, coll. 'Forces vives', Paris: Editions de Minuit, 1958, p. 13.

36. Ibid., p. 209.

37. The Tritrous were 'an ingenious arrangement whereby beams of light very sharply defined in character ended by projecting figures or coloured spots on various parts of the wall. These effects were achieved by means of film strips with each frame entirely opaque except for three holes (from which the word 'tritrous' is derived) in which the colours were introduced in accordance with a pre-determined lighting plan' (*Discovery: a magazine of scientific progress*, vol. 20, 1959, p. 123).

38. Bart Lootsma, 'Poème electronique: Le Corbusier, Xenakis, Varèse' in Andreas Vowinckel and Thomas Kesseler (eds), *Le Corbusier: Synthèse des Arts; Aspekte des Spätwerks, 1945–1965*, Berlin: Ernst & Sohn, 1986, pp. 111–50, esp. pp. 141–42.

39. On this, see the detailed analysis in the excellent monograph by Marc Treib, *Space Calculated in Seconds: The Philips Pavilion/ Le Corbusier/Edgard Varèse*, Princeton, NJ: Princeton Univ. Press, 1996, pp. 98–167.

40. Jean Petit, *Le Poème électronique, op. cit.* (see note 35), pp. 33–91. Petit translated the sequences of images projected in the pavilion into an evocative sequence of montages superimposed with patches of colour and colourful tracing paper.

41. An archaic Greek statue of a young woman, standing and clothed in long loose robes.

42. *Carnet L 46*, p. 13 (3 February 1957), Fondation Le Corbusier, Paris. Apparently, Le Corbusier originally wanted to end *Le Poème électronique* with a pessimistic apotheosis ('et non sur apothéose optimiste').

43. See Marc Treib, *Space Calculated in Seconds, op. cit.* (see note 39), p. 114, and Bart Lootsma, 'Poème électronique', *op. cit.* (see note 38), p. 131.

44. In the two last versions of the 'minutage' for *Le Poème électronique* there is a list of books from which Le Cobusier took some of the visual material (according to Bart Lootsma, 'Poème électronique', *op. cit.* (see note 38), p. 131).

45. Jean Petit, *Le Poème électronique, op. cit.* (see note 35), p. 93.

46. Le Corbusier was referring to the exhibition 'L'Art dit primitif dans la maison d'aujourd'hui', which was held in his apartment in 1935; see *Le Corbusier and Pierre Jeanneret: Oeuvre complète, 1934–1938*, Zurich: Girsberger, 1939, p. 157.

The Promise of the Radiant City: The Visual Media Campaign for the Unité d'Habitation in Marseille
Veronique Boone

1. Le Corbusier, 'Notice for the Use of Photographers' (undated circular), FLC, T1(1)484.

2. Ibid.

3. Letter from Le Corbusier to Lucien Hervé, 15 December 1949 (FLC, E2(04)219).

4. Lucien Hervé guarded his independence fiercely, preserved his right to photograph other projects and was never contracted exclusively to Le Corbusier. During the pre-war period, for a number of years, other photographers – including Charles Gérard, Marius Gravot, Georges Thiriet, and Albin Salaün – took pictures of works by Le Corbusier.

5. Le Corbusier, *Modulor 2: Let the User Speak Next*, Cambridge: Harvard University Press, 1958, p. 233. Originally published as *Le Modulor 2* (Boulogne-sur-Seine: Editions de l'Architecture d'Aujourd'hui) in 1955. 'Modulor' refers to two different things in this essay: the book, as above, *Modulor 2*; and the concrete bas-relief, 'the Modulor', at the entrance to the Unité d'Habitation.

6. The show flat was installed during the summer of 1949 and photographed by Marcel de Renzis, a photographer working for the MRU (Ministère de la Reconstruction et de l'Urbanisme) based in Marseille. (Letter from Le Corbusier to Marcel de Renzis, 6 December 1949, FLC, T1(15)509.)

7. René Zuber trained as an engineer and was a follower of the Neue Sachlichkeit (New Objectivity) movement, a style of photography that began in Germany in the 1920s.

8. Correspondence between Le Corbusier's studio and rue Michelet between 13 October 1948 and 5 December 1949 (FLC, B3(10)59 to 64). The role that Le Corbusier had in mind for René Zuber was similar to that of Lucien Hervé and it is quite probable that Le Corbusier thought he had found an artistic accomplice in Zuber, although this relationship never really developed, and Le Corbusier never publicly stated as much, which he did with Lucien Hervé.

9. Circular from André Wogenscky to suppliers of the Marseille Unité d'Habitation site, 14 April 1948 (FLC, B3(10)75).

10. Not concerned by any of the controversies surrounding the Marseille Unité d'Habitation, French newsreels seemed eager to toe the official government line, since the State was a sleeping partner in this project. Episodes that refer to the Unité d'Habitation prior to its inauguration include: 'Le Corbusier's skyscraper', *Les Actualités Françaises*, 1 September 1949; 'Home 50', *Eclair Journal*, 2 March 1950; 'Le Corbusier présente les ouvrages consacrés à la maison de verre' (archived without the soundtrack), television newscast, 11 December 1950; 'Reconstructions à Marseille', *Les Actualités Françaises*, 1 March 1951.

11. For example, *Un Aperçu de la Reconstruction* by André Michel (1948).
12. 'Home 50', Eclair Journal, 2 March 1950.
13. For example, *Architecture d'Aujourd'hui* by Pierre Chenal (1931), *Les Mains de Paris* by Alexandre Alexander (1934), and *Les Bâtisseurs* by Jean Epstein (1938).
14. Frédéric Pottecher was guided by Le Corbusier around the show flat. 'Radiodiffusion française' broadcast on 11 January 1950.
15. Fourth Edinburgh International Film Festival, 20 August to 10 September 1950.
16. Venice Festival of Cinematographic Art, 20 August to 10 September 1950.
17. Fourth BAFTA (British Academy of Film and Television Art) Awards ceremony, 1951.
18. Lucien Hervé appears in the film credits.
19. Handwritten note from Le Corbusier, 29 April 1952 (FLC, B3(10)214).
20. Other examples include: a view of the interior paths; a sequence of photos of the kitchen, which were used in *Oeuvre Complète*, vol. 5; and a view perpendicular to the gardens, which appeared in *L'Architecture d'aujourd'hui*, no. 46, 2/1953. These shots were re-used for the film, but sequences were also shot at the same time as the pictures.
21. 'Unité d'habitation de Le Corbusier à Marseille', *L'Architecture d'aujourd'hui*, no. 46, February 1953, pp. 12–21.
22. The words for the film were written by Albert Camus in December 1952. After shooting had ended, Le Corbusier spoke about 'a hell of a drama, that would be the spine of the whole thing'. (Letter from Le Corbusier to Albert Camus, 2 August 1952, FLC, B3(10)220.) As for the music, Le Corbusier wrote to Jean Sacha that he intended to 'discuss the music about which I have some very strong opinions'. (Letter from Le Corbusier to Jean Sacha, 15 October 1952, FLC, B3(10)232.)
23. 'Note for M Tenoudji', 2 August 1952 (FLC, B3(10)221 to 223).
24. *Architecture d'aujourd'hui*, Pierre Chenal, 1931.
25. Letter from Le Corbusier to E. Tenoudji, 8 October 1953 (FLC, G2(15)213).
26. Le Corbusier, *Les Maternelles vous Parlent*, Paris: Denoël-Gonthier, 1968. The first draft of the work was available in 1956–57, but it was only published in 1968, after Le Corbusier's death.
27. Louis Sciarli, photographer and a resident of the Radiant City between 1963 and 1983. His photographs of the Unit taken 'as is' are the only ones that he produced of Le Corbusier's architectural work. Sciarli was also a photographer for the French magazine *Elle*.
28. Letter from Le Corbusier to Jean Petit (Editions de Minuit), 16 January 1961 (FLC, U3(1)169).
29. The photographs are reproduced in René Burri and Arthur Rüegg, *Moments in the Life of a Great Architect*, Basel: Birkhauser Publishers, 1999. René Burri, a member of Magnum, produced numerous illustrated articles with Le Corbusier, depicting situations in everyday life and at work, for example in La Tourette, at 35 rue de Sèvres, or at 24 rue Nungesser et Coli.
30. *Le Corbusier, L'Architecte du Bonheur*, Pierre Kast, 1957. Pierre Kast was a member of the Groupe des Trente, who defended the art of the short film in France, and is often regarded as a representative of the New Wave (Nouvelle Vague), a group of film-makers in France at the end of the 1950s and 1960s who argued for a rejection of classical cinematic form.
31. Letter from Jean-Marie Vivet to Le Corbusier, 26 September 1956 (FLC, B3(10)263).
32. 'There is likely to be a huge hullabaloo in the daily, weekly and monthly press surrounding our unit in Dreieck. We need a positive and effective story, with a small number of excellent photographs. We may even need to offer films. The one by Tenoudji [*La Cité radieuse*, Jean Sacha, 1952] is hopeless, but there is the one by Pierre Kast.' Letter from Le Corbusier to Lucien Hervé, 25 September 1957, FLC, E2(4)404.
33. Bernhard Moosbrugger photographed, among others, La Tourette and the chapel at Ronchamp, published in the series 'Les Cahiers Forces Vives' by Jean Petit (*Un Couvent de Le Corbusier*, 'Les Cahiers des Forces vives' no. 15, 1961).
34. Pierre Joly, art critic, and Véra Cardot, photographer, have photographed Le Corbusier's work from 1961 onwards.

**Through Many Lenses:
Contemporary Interpretations of the
Architect's Works**
Jean-Christophe Blaser

1. If this text should serve one purpose only, I hope that it will be to contribute to a better understanding of the new phase that research has entered in recent years. Photography is no longer regarded merely as a set of tools designed to support other activities (such as architecture, medicine, botany) for the purposes of documentation, but as a medium that can also be used to inspire studies of which photography itself is the subject.

2. One can trace this tradition to the Heliographic Mission (a project to catalogue France's architectural heritage through photography) undertaken in 1851, although it was specifically designed to establish an inventory of historical monuments. On the history of architectural photography in general, see: Robert Elwall, *Building with Light: The International History of Architectural Photography*, London: Merrell Publishers, 2004. Antoine Baudin (ed.), *Photography and Modern Architecture. Alberto Sartoris Collection*, exhib. cat., Lausanne: Presses polytechniques et universitaires romandes, 2003. *L'Architecture et son image. Quatre siècles de représentation architecturale. Oeuvres tirées des collections du Centre Canadien d'Architecture*, exhib. cat., Montreal: Canadian Centre for Architecture, 1989. On Le Corbusier and photography more specifically, see: Andrzej Piotrowski, 'Le Corbusier and the Representational Function of Photography' in Andrew Higgott and Timothy Wray (eds), *Camera/Constructs: Photography, Architecture and the Modern City*, Aldershot: Ashgate Press, 2011. Alexandra Lange, 'Le Corbusier Before Le Corbusier: Applied Arts, Architecture, Painting, and Photography, 1907–1922' in *The Journal of the Society of Architectural Historians*, vol. 62, issue 4, 2003, pp. 516–18. Daniel Naegele, 'Object, Image, Aura: Le Corbusier and the Architecture of Photography' in *Harvard Design Magazine*, issue 6, 1998, pp. 35–40. David Naegele, 'Le Corbusier and the Space of Photography: Photo-Murals, Pavilions and Multi-media Shows', in *History of Photography*, issue 22, 1998, pp. 127–38.

3. William Jenkins (ed.), *New Topographics: Photographs of a Man-Altered Landscape*, exhib. cat., Rochester: George Eastman House International Museum of Photography and Film, 1975. A new edition by Britt Salvesen was published in 2009 for the new version of the exhibition. This is simply entitled *New Topographics* (Britt Salvesen, *New Topographics*, Göttingen: Steidl, 2009).

4. The other photographers included in this exhibition were: Robert Adams, Lewis Baltz, Joe Deal, Frank Gohlke, Nicholas Nixon, John Schott, Stephen Shore and Henry Wessel Jr.

5. The photographic mission of DATAR (Delegation for Regional Planning and Action) was to create an exact overview of the French landscape. This public commission initially included 12 photographers, but this was eventually extended to 28, two of whom (Lewis Baltz and Frank Gohlke) took part in the 'New Topographics' exhibition.

6. I would like to thank the historian Julie Noël, who worked at the Canadian Centre for Architecture (CCA), for her advice and her help. I also wish to thank Lydia Dorner for editing the French version of this text.

7. See the series of photographs published in Peter Edwin Erismann (ed.), *Indien Sehen. Kunst, Fotographie, Literatur*, exhib. cat., Bern: Schweizerische Landesbibliothek, 1997. Flechtner's series on Chandigarh was first published by the Musée de l'Elysée in the exhibition catalogue dedicated to the 700th anniversary of the Swiss Confederation: 'Une utopie suisse au Pendjab' in C.-H. Favrod, P. Lambelet and A. Rouvinez (eds), *Voir la Suisse autrement*, exhib. cat., Fribourg: Musée d'art et d'histoire de Fribourg, coll. 'La Fête des quatre cultures', 1991. This project was an assignment from the Musée de l'Elysée. Flechtner is also the author of an influential book on La Chaux-de-Fonds, Le Corbusier's hometown: Thomas Flechtner, *Snow*, Baden: Lars Müller, 2002.

8. Ernst Scheidegger, *Chandigarh 1956*, Stanislaus von Moos (ed.), Zürich: Scheidegger & Spiess, 2010.

9. Marc Augé, *Non-lieux. Introduction à une anthropologie de la surmodernité*, Paris: Editions du Seuil, coll. 'La librairie du XXe siècle', 1992.

10. Daniel Schwartz, *Le Corbusier – Villa Turque: photographies*, La-Chaux-de-Fonds: Editions Glasnost, 1990.

11. And they also relate to a major concern of 20th-century architecture: dematerialization through light. This kind of dematerialization can also be found, as a contemporary artistic strategy, in art installations and environments.

12. Each of these photographers has produced numerous publications. The following selection represents the most recent and those that are relevant to the subject under discussion. Paolo Costantini (ed.), *Luigi Ghirri/Aldo Rossi. Des choses qui ne sont qu'elles-mêmes*, exhib. cat., Montreal/Milan: Canadian Centre for Architecture/Electa, 1996. *It's beautiful here, isn't it… Photographs by Luigi Ghirri*, New York: Aperture, 2008. Rosa Tamborrino (ed.), *Le Corbusier, scritti, photographs by Guido Guidi*, Torino: Giulio Einaudi, 2003. Guido Guidi, *Carlo Scarpa's Tomba Brion*, Ostfildern: Hatje Cantz, 2011. Gabriele Basilico, *Porto di mare*, Art & Udine, 1990. Gabriele Basilico, *L'esperienza dei luoghi. Fotografie 1978–1993*, Udine: Arti Grafiche Friulane, 1995. Gabriele Basilico, *Carnet de travail 1969–2006*, Arles: Actes Sud, 2006.

13. Olivo Barbieri, *Illuminazioni artificiali*, Milano: Federico Motta Editore, 1995. Paola Tognon (ed.), Olivo Barbieri: *Virtual Truths*, exhib. cat., Lugano: Galleria Gottardo, 2001.

14. Olivo Barbieri, *Paesaggi in miniatura. Viaggio nell'architettura cinese*, Bozen: Ar/Ge Kunst, 1991.

15. Francesco Bonami (ed.), *Sugimoto: Architecture*, exhib. cat., Chicago: Museum of Contemporary Art, 2003. See also Eckhard Schneider (ed.), *Hiroshi Sugimoto: Architecture of Time*, exhib. cat., Bregenz: Kunsthaus, 2002.

16. Stéphane Couturier, *Chandigarh Replay*, Paris: Ville Ouverte, 2007.

17. He used a process similar to that of the Monastery of Sainte-Marie de La Tourette. See *La Tourette 1959–2009. Le cinquantenaire: rencontre Le Corbusier/ François Morellet*, Paris: Bernard Chauveau, 2009.

18. Matthieu Gafsou, *Ce rêve étrange: Le Corbusier à Firminy*, Paris: Gallimard, 2009.

19. Cemal Emden, *Visual Log: A Gaze at Le Corbusier's Oeuvre*, İhsan Bilgin and Burcu Kütükçüoğlu (eds), exhib. cat., Istanbul: Santralistanbul, 2011.

20. In brief, architectural photography may have been responsible for bringing a certain type of humanist photography to an end – one in which the image is full of agitation and 'noise', with people everywhere, looking you straight in the eye, trying to challenge you.

SELECT BIBLIOGRAPHY

Compiled by Klaus Spechtenhauser

The present compilation is based on the theme of Le Corbusier and photography. This is particularly the case in the first part of the list, which comprises works of Le Corbusier and authorized publications. The second part of this list provides an overview of the life and work of Le Corbusier, while the third part describes the literature related to topics discussed in this present book. The fourth and final part of this list presents the literature on specific aspects of the context.

Publications by Le Corbusier and collected work authorized by Le Corbusier

L'Architecture d'aujourd'hui, vol. 19, 1948, special Le Corbusier edition (2e numéro spécial)

Badovici, Jean (ed.), *L'Architecture vivante. Le Corbusier et P. Jeanneret*, 1st to 7th series, Paris: Morancé, 1927–36

Boesiger, Willy (ed.), *Le Corbusier et Pierre Jeanneret. Œuvre complète*, Erlenbach / Zurich: Girsberger / Les Editions d'Architecture Artemis – Basel: Birkhäuser, 1930–70ff., 8 vols., titles and editions vary: vol. 1, 1910–29; vol. 2, 1929–34; vol. 3, 1934–38 (ed. Max Bill); vol. 4, 1938–46; vol. 5, 1946–52; vol. 6, 1952–57; vol. 7, 1957–65; vol. 8, 1965–69

Le Corbusier, *Vers une architecture*, Paris: Editions Crès & Cie, 1923; trans. Frederick Etchells as *Towards a New Architecture*, New York: Payson and Clarke / London: Rodker, 1927; trans. John Goodman as *Toward an Architecture*, Introduction by Jean-Louis Cohen, Los Angeles, CA: Getty Research Institute, 2007

Le Corbusier, *Urbanisme*, Paris: Editions Crès & Cie, 1925; trans. Frederick Etchells as *The City of Tomorrow and its Planning*, London: Rodker, 1929

Le Corbusier, *L'Art décoratif d'aujourd'hui*, Paris: Editions Crès & Cie, 1925; trans. James I. Dunnett as *The Decorative Art of Today*, London: The Architectural Press, 1987

Le Corbusier, *Une maison – un palais*, Paris: Editions Crès & Cie, coll. 'L'Esprit nouveau', 1928

Le Corbusier, *Croisade ou le crépuscule des académies*, Paris: Editions Crès & Cie, 1933

Le Corbusier, *Aircraft*, London / New York: The Studio, 1935

Le Corbusier, *La Ville radieuse*, Boulogne-sur-Seine: Editions de L'Architecture d'Aujourd'hui, coll. 'L'équipement de la civilisation machiniste', 1935; trans. Pamela Knight, Eleanor Levieux and Derek Coltman as *The Radiant City*, London: Faber & Faber, 1967

Le Corbusier, *Les tendances de l'architecture rationaliste en rapport avec la collaboration de la peinture et de la sculpture*, Rome: Reale Accademia d'Italia, 1937-XVI

Le Corbusier, *Quand les cathédrales étaient blanches. Voyage au pays des timides*, Paris: Plon, 1937; trans. Francis E. Hyslop as *When the Cathedrals Were White. A Journey to the Country of the Timid People*, New York: Reynal & Hitchcock, 1947

Le Corbusier, *Des canons, des munitions? Merci! des logis... s.v.p.*, Boulogne-sur-Seine: Editions de L'Architecture d'Aujourd'hui, coll. 'L'équipement de la civilisation machiniste', 1938

Le Corbusier, *Le lyrisme des temps nouveaux et l'urbanisme*, 1939 (*Le Point*, special issue)

Le Corbusier, *Destin de Paris*, Paris / Clermont-Ferrand: Sorlot, 1941

Le Corbusier, *New World of Space*, New York: Reynal & Hitchcock, 1948

Le Corbusier, *Le Modulor. Essai sur une mesure harmonique à l'échelle humaine applicable universellement à l'architecture et à la mécanique*, Boulogne-sur-Seine: Editions de L'Architecture d'Aujourd'hui, 1950; trans. Peter de Francia and Anna Bostock as *The Modulor. A Harmonious Measure to the Human Scale, Universally Applicable to Architecture and Mechanics*, Cambridge: Harvard University Press, 1954

Le Corbusier, *Une petite maison*, Zurich: Girsberger, 1954

Le Corbusier, *Modulor 2. 1955 (la parole est aux usagers), suite de 'Le Modulor' '1948'*, Boulogne-sur-Seine: Editions de l'Architecture d'Aujourd'hui, 1955; trans. Peter de Francia and Anna Bostock as *Modulor 2. Let the User Speak Next: Continuation of 'The Modulor', 1948*, London: Faber & Faber, 1958

Le Corbusier, *Les maternelles vous parlent / Kinder der strahlenden Stadt*, Stuttgart: Hatje, 1956 (text in French, English, and German); re-edition in French, Paris: Denoël-Gonthier, 1968

Le Corbusier, *Les plans de Paris 1956–1922*, Paris: Editions de Minuit, 1956

Le Corbusier, *Ronchamp*, Stuttgart / Zurich: Hatje / Girsberger, 1957

Le Corbusier, *L'Atelier de la recherche patiente – Textes et planches*, Paris: Vincent Fréal, 1960; trans. James Palmes as *My Work*, London: Architectural Press, 1960

Petit, Jean (ed.), *Le poème électronique Le Corbusier*, Paris: Editions de Minuit, coll. 'Forces vives', 1958

On Le Corbusier in general

Brooks, H. Allen (ed.), *Le Corbusier*, Princeton, NJ: Princeton University Press, 1987

Brooks, H. Allen, *Le Corbusier's Formative Years. Charles-Edouard Jeanneret at La Chaux-de-Fonds*, Chicago / London: University of Chicago Press, 1997

Cohen, Jean-Louis, *Le Corbusier. La planète comme chantier*, Paris: Editions Textuel / Zoé, 2005

Frampton, Kenneth, *Le Corbusier*, London / New York: Thames & Hudson, coll. 'World of Art', 2001

Frampton, Kenneth, *Le Corbusier. Architect of the Twentieth Century*, New York: Harry N. Abrams, 2002

Gauthier, Maximilien, *Le Corbusier ou l'architecture au service de l'homme*, Paris: Denoël, 1944

Le Corbusier. Architect of the Century, exhib. cat., Hayward Gallery, London, 1987

Le Corbusier. Le Grand, London / New York: Phaidon, 2008

Lucan, Jacques (ed.), *Le Corbusier. Une encyclopédie*, Paris: Centre Georges Pompidou, 1987

Moos, Stanislaus von, *Le Corbusier. Elemente einer Synthese*, Frauenfeld / Stuttgart: Huber, 1968; trans. and revised as *Le Corbusier. Elements of a Synthesis*, Cambridge, MA / London: MIT Press, 1979; trans. and revised, Rotterdam: 010 Publishers, 2009

Moos, Stanislaus von (ed.), *L'Esprit nouveau. Le Corbusier und die Industrie 1920–1925*, exhib. cat., Museum für Gestaltung Zürich / Bauhaus-Archiv, Museum für Gestaltung Berlin [etc.], Berlin: Ernst & Sohn, 1987; French ed. *L'Esprit nouveau. Le Corbusier et l'industrie 1920–1925*

Moos, Stanislaus von and Arthur Rüegg (eds), *Le Corbusier before Le Corbusier. Applied Arts, Architecture, Painting, Photography, 1907–1922*, exhib. cat., The Bard Graduate Center for Studies in the Decorative Arts, Design, and Culture, New York / Langmatt Museum, Baden, Switzerland, New Haven / London: Yale University Press, 2002

Saddy, Pierre (ed.), *Le Corbusier. Le passé à réaction poétique*, exhib. cat., Hôtel de Sully, Paris: Caisse nationale des monuments historiques et des sites / Ministère de la culture et de la communication, 1988

Vegesack, Alexander von, Stanislaus von Moos, Arthur Rüegg and Mateo Kries (eds), *Le Corbusier – The Art of Architecture*, exhib. cat., Nederlands Architectuurinstituut, Rotterdam – Vitra Design Museum, Weil am Rhein [etc.], Weil am Rhein: Vitra, 2007

Walden, Russell (ed.), *The Open Hand. Essays on Le Corbusier*, Cambridge, MA / London: MIT Press, 1977

Weber, Nicholas Fox, *Le Corbusier. A Life*, New York: Alfred A. Knopf, 2008

On Le Corbusier and photography, film, media

Beer, Olivier, *Lucien Hervé. Building Images*, Los Angeles, CA: Getty Research Institute, 2004

Benton, Tim, *The Rhetoric of Modernism – Le Corbusier as a Lecturer*, Basel / Boston / Berlin: Birkhäuser, 2009

Bergdoll, Barry, Veronique Boone, and Pierre Puttemans, *Lucien Hervé. L'œil de l'architecture*, exhib. cat., CIVA – Centre International pour la Ville, l'Architecture et le Paysage, Bruxelles, 2005

Boone, Veronique, 'La médiatisation cinématographique de l'Unité d'habitation de Marseille: de la promotion à la fiction' in *Massilia, 2004. Annuaire d'études corbuséennes*, pp. 192–199

Boone, Veronique, 'The Epic of the Marseilles Block through the Eye of the Camera' in *JSAH. Journal of the Society of Architectural Historians*, vol. 68, no. 1, 2009, pp. 125–28

Colomina, Beatriz, 'Le Corbusier and Photography' in *Assemblage*, no. 4, 1987, pp. 7–23

Colomina, Beatriz, *Privacy and Publicity. Modern Architecture as Mass Media*, Cambridge, MA / London: MIT Press, 1994

Colomina, Beatriz, 'Vers une architecture médiatique' in Alexander von Vegesack, Stanislaus von Moos, Arthur Rüegg, and Mateo Kries (eds), *Le Corbusier – The Art of Architecture*, exhib. cat., Nederlands Architectuurinstituut, Rotterdam – Vitra Design Museum, Weil am Rhein [etc.], Weil am Rhein: Vitra, 2007, pp. 247–73

de Smet, Catherine, *Le Corbusier. Architect of Books*, Baden: Lars Müller Publishers, 2005

de Smet, Catherine, *Vers une architecture du livre. Le Corbusier: édition et mise en pages, 1912–1965*, Baden: Lars Müller Publishers, 2007

Doisneau, Robert and Jean Petit, *Bonjour Monsieur Le Corbusier*, Zurich: Grieshaber, 1988

Fanelli, Giovanni with cooperation by Barbara Mazza, *Storia della fotografia di architettura*, Bari: Laterza, 2009, pp. 428–37 (chapter on Le Corbusier)

Faure, Elie, 'La Ville radieuse' in *L'Architecture d'aujourd'hui*, vol. 6, no. 11, 1935, pp. 1–2

Gresleri, Giuliano, *Le Corbusier. Viaggio in Oriente. Gli inediti di Charles-Edouard Jeanneret fotografo e scrittore*, Venezia: Marsilio, 1984 and 1985 (second edition); revised ed., *Le Corbusier. Viaggio in Oriente. Charles-Edouard Jeanneret, fotografo e scrittore*, 1995

Lootsma, Bart, 'Poème Electronique: Le Corbusier, Xenakis, Varèse' in Badischer Kunstverein Karlsruhe, Andreas Vowinckel, and Thomas Kesseler (eds), *Le Corbusier. Synthèse des Arts. Aspekte des Spätwerks 1945–1965*, exhib. cat., Badischer Kunstverein Karlsruhe, Berlin: Ernst & Sohn, 1986, pp. 111–47

Mazza, Barbara, *Le Corbusier e la fotografia. La vérité blanche*, Florence: Firenze University Press, 2002

Moos, Stanislaus von (ed.), *Chandigarh 1956. Le Corbusier, Pierre Jeanneret, Jane B. Drew, E. Maxwell Fry. Fotografien von / Photographs by Ernst Scheidegger. Mit Texten von / Texts by Maristella Casciato, Verena Huber Nievergelt, Stanislaus von Moos und / and Ernst Scheidegger*, Zurich: Scheidegger & Spiess, 2010

Naegele, Daniel, 'Intervista a Lucien Hervé / An Interview with Lucien Hervé' in *Parametro*, no. 206, 1995, pp. 71–83

Naegele, Daniel, *Le Corbusier's Seeing Things. Ambiguity and Illusion in the Representation of Modern Architecture*, PhD., University of Pennsylvania, 1996

Naegele, Daniel, 'Object, Image, Aura. Le Corbusier and the Architecture of Photography' in *Harvard Design Magazine*, no. 6, 1998, pp. 37–41

Naegele, Daniel, 'Fotografisk illusionisme og "rummets nye verden" / Photographic Illusionism and the "New World of Space"' in *Le Corbusier. Maler og arkitekt / Le Corbusier. Painter and Architect*, exhib. cat., Nordjyllands Kunstmuseum, Aalborg, 1995, pp. 83–117

Naegele, Daniel, 'Le Corbusier and the Space of Photography: Photo-Murals, Pavilions and Multi-media Spectacles' in *History of Photography*, vol. 22, no. 2, 1998, pp. 127–38

Redivo, Alessandra, *Bâtir, L'architecture d'aujourd'hui – Costruire l'architettura moderna 1930. Il contributo di due film di Pierre Chenal*, Venezia: Instituto Universitario di Architettura di Venezia, 2001

Rüegg, Arthur (ed.), *Le Corbusier. Photographs by René Burri / Magnum. Moments in the Life of a Great Architect*, Basel / Boston / Berlin: Birkhäuser, 1999

Rüegg, Arthur (ed.), *Pour Le Corbusier, René Burri, June 1962*, Baden: Lars Müller Publishers, 2006

Sbriglio, Jacques, with Introductions by Quentin Bajac and Béatrice Andrieux and a Preface by Michel Richard, *Le Corbusier & Lucien Hervé. The Architect & The Photographer – A Dialogue*, London: Thames & Hudson, 2011

Schubert, Leo, 'Jeanneret, the City, and Photography' in Stanislaus von Moos and Arthur Rüegg (eds), *Le Corbusier before Le Corbusier. Applied Arts, Architecture, Painting, Photography, 1907–1922*, exhib. cat., The Bard Graduate Center for Studies in the Decorative Arts, Design, and Culture, New York / Langmatt Museum, Baden, Switzerland, New Haven / London: Yale University Press, 2002, pp. 55–67

Schumacher, Thomas, 'Deep Space – Shallow Space' in *The Architectural Review*, vol. 181, no. 1079, 1987, pp. 37–42

Treib, Marc, *Space Calculated in Seconds. The Philips Pavilion / Le Corbusier / Edgar Varèse*, Princeton, NJ: Princeton University Press, 1996

Further publications

Barsac, Jacques, *Charlotte Perriand. Un art d'habiter*, Paris: Editions Norma, 2005

Barsac, Jacques, *Charlotte Perriand and Photography. A Wide-angle Eye*, Milan: Editions 5 Continents, 2011

Charbonnier, Georges, 'Entretien avec Le Corbusier' in Georges Charbonnier, *Le monologue du peintre*, vol. 2, Paris: Julliard, 1960

Cohen, Jean-Louis, *Le Corbusier and the Mystique of the USSR. Theories and Projects for Moscow 1928–1936*, Princeton, NJ: Princeton University Press, 1992

Coley, Catherine and Danièle Pauly (eds), *Quand l'architecture internationale s'exposait, 1922–1932. Actes du colloque Nancy 1926, le printemps du Mouvement moderne*, Lyon: Fage Editions, 2010

Congrès internationaux d'architecture moderne (eds), *Logis et loisirs. 5e Congrès CIAM Paris 1937*, Boulogne-sur-Seine: Editions de L'Architecture d'Aujourd'hui, 1938

Ducros, Françoise, *La photographie pure. Modernisme, culture, tekhnê, 1800–1930*, Thèse d'habilitation (Habilitation thesis), Université de Paris IV-Sorbonne, 2007

Elwall, Robert, *Building with Light. The International History of Architectural Photography*, London: Merrell, 2004

Freund, Gisèle, 'La photographie à l'exposition' in *Arts et métiers graphiques*, no. 42, 1938, pp. 37–41; republ. in Dominique Baqué, *Les documents de la modernité. Anthologie de textes sur la photographie de 1919 à 1939,*

Nîmes: Editions Jacqueline Chambon, 1993, pp. 485–89

Frizot, Michel and Cédric de Veigy, *Vu. Le magazine photographique 1928–1940*, Paris: Editions La Martinière, 2009

Golan, Romy, Muralnomad. *The Paradox of Wall Painting, Europe 1927–1957*, New Haven / London: Yale University Press, 2009

Gresleri, Giuliano (ed.), *Le Corbusier. Il viaggio in Toscana (1907)*, exhib. cat., Palazzo Pitti, Florence, Venice: Marsilio, 1987

Joyeux, Marie-Hélène, 'Le photomontage politique à travers les couvertures de *Vu*: 1928–1936' in *Les Cahiers du Musée national d'art moderne*, no. 84, 2003, pp. 49–65

Lienard, L. & L., 'Unité d'habitation Le Corbusier à Marseille' in *L'Architecture d'aujourd'hui*, vol. 24, no. 46, 1953, pp. 12–21

Lossau, Jürgen, *Der Filmkamera-Katalog / The Complete Catalog of Movie Cameras*, Hamburg: Atoll-Medien, 2003

Lurçat, Jean et al., *La querelle du réalisme*, Paris: Editions sociales internationales, 1936

Moholy-Nagy, László, *Malerei – Fotografie – Film*, Munich: Albert Langen, 1925

Moos, Stanislaus von, 'Les femmes d'Alger' in *Le Corbusier et la Méditerranée*, exhib. cat., Centre de la Vieille Charité, Marseille, Marseille: Editions Parenthèses / Musées de Marseille, 1987, pp. 191–209

Moos, Stanislaus von, 'Art, Spectacle and Permanence. A Rear-Mirror View of the Synthesis of Arts' in Alexander von Vegesack, Stanislaus von Moos, Arthur Rüegg, and Mateo Kries (eds), *Le Corbusier – The Art of Architecture*, exhib. cat., Nederlands Architectuurinstituut, Rotterdam – Vitra Design Museum, Weil am Rhein [etc.], Weil am Rhein: Vitra, 2007, pp. 61–99

Ockman, Joan, 'Lessons from Objects. Perriand from the Pioneer Years to the "Epoch of Realities"' in Mary McLeod (ed), *Charlotte Perriand. An Art of Living*, New York: Harry N. Abrams – The Architectural League of New York, 2003, pp. 154–81

Perriand, Charlotte, *A Life of Creation*, New York: Monacelli Press, 2003

Shumkov, Ivan Rumenov, *Architecture and Revolution. Pavillon des Temps Nouveaux by Le Corbusier and Pierre Jeanneret at the International Exposition of 1937 in Paris*, PhD, Universitat Politècnica de Catalunya, Barcelona, 2009

Udovicki-Selb, Danilo, 'Les engagements de Charlotte Perriand pour l'Exposition de 1937 à Paris: Le Corbusier, "Les Jeunes 37" et le Front populaire' in *Charlotte Perriand*, exhib. cat., Centre Georges Pompidou, Paris, 2005, pp. 41–61

Ver, Moï, *Paris*, Paris: Editions Jeanne Walter, 1931

Žaknič, Ivan, *Le Corbusier. Pavillon Suisse. The Biography of a Building / La biographie d'un bâtiment*, Basel / Boston / Berlin: Birkhäuser, 2004

CHRONOLOGY

KLAUS SPECHTENHAUSER
IN COLLABORATION WITH CLAIRE MARIE ROSE

CHARLES-EDOUARD JEANNERET/LE CORBUSIER: BIOGRAPHY AND WORKS

Buildings are listed under the year the project commenced or was completed. Unrealized projects are listed as 'Design for... or 'Project for...'. A majority of the buildings and projects from between 1922 and 1940 were developed in collaboration with Le Corbusier's cousin and office partner, Pierre Jeanneret. The collaboration of the two men expands and enters a new dimension from 1950, with the construction of Chandigarh.

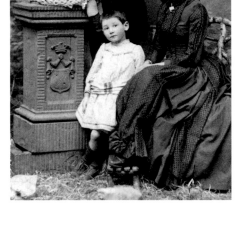

1887

Born Charles-Edouard Jeanneret on 6 October in La Chaux-de-Fonds, Switzerland, the son of Georges-Edouard Jeanneret, an engraver and enamellist, and of Marie-Charlotte-Amélie Jeanneret, born Perret, a piano teacher. His birthplace is 38 rue de la Serre.

1891

He and his brother Albert attend the Froebel-Kindergarten (Ecole Froebel), run by Louise Colin.

1894

Enters elementary school in La Chaux-de-Fonds.

1900

Enters the Ecole d'Art in La Chaux-de-Fonds (evening classes).

1902

Enters the professional class of the Ecole d'Art in La Chaux-de-Fonds, education in engraving and metal chasing. Beginning of a close relationship that lasts until 1912 with his teacher, Charles L'Eplattenier (1874–1946), an exponent of Swiss Art Nouveau.

1905

Enters the Cours Supérieur, one of the newly founded courses of study under Charles L'Eplattenier.

1906

Design of the music room in the Villa Matthey-Doret (destroyed in 1963) by students in the Cours Supérieur.

Villa Fallet in La Chaux-de-Fonds (1906–7), a collaboration with architect René Chapallaz and other students at the Ecole d'Art. Louis Fallet was a member of the commission of the School of Applied Arts in La Chaux-de-Fonds.

1907

First extended trip to Italy (Pisa, Florence, Siena, Padua, Ferrara, Verona, Venice, and Ravenna), which included visits to the Certosa del Galluzzo (which he subsequently referred to as 'Certosa d'Ema'), extended stay in Vienna.

Villa Stotzer and Villa Jaquemet in La Chaux-de-Fonds (1007–8) with René Chapallaz.

Acquisition of a camera: a Kodak model, 9 x 9 cm format. Moderate use during his educational travels in the following years. There are about 190 pictures made in Germany, France, Italy, and Switzerland dating from 1907–10. After 1912, he photographs the Villa Jeanneret-Perret. In 1916 he takes photographs in Switzerland. The majority of the negatives are held by the Bibliothèque de la Ville in La Chaux-de-Fonds (Fonds Le Corbusier).

1908

Trip from Vienna to Nuremberg, Munich, Nancy, first time in Paris. Contacts include Frantz Jourdan, Charles Plumet, Eugène Grasset and Henri Sauvage.

Work with Auguste Perret until spring of 1909 and first contact with reinforced concrete construction.

Regular visits to the Parisian museums and extensive travel through France.

1909

Returns to La Chaux-de-Fonds and co-founds the Ateliers d'Art Réunis (United Art Studios), a type of contracting firm that executes public and private commissions in close cooperation with the Ecole d'Art in La Chaux-de-Fonds.

1910

Extended stay in Germany (until 1911) for study purposes, including time in Munich and Berlin. Contact with Theodor Fischer, Hermann Muthesius, Heinrich Tessenow, Wolf Dohrn, and other advocates of the German reform movement. Five-month apprenticeship in Peter Behrens's office in Neubabelsberg, where both Walter Gropius und Mies van der Rohe had also worked.

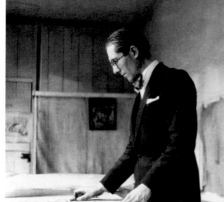

Becomes acquainted with William Ritter (1867–1955), Swiss writer and art and music critic, with whom he would maintain a close friendship until the 1940s.

Project for a building for the Ateliers d'Art Réunis (United Art Studios) in La Chaux-de-Fonds.

Work on the publications *Etude sur le mouvement d'art décoratif en Allemagne* and *La construction des villes*.

1911

Trip through Eastern Europe and the Balkans (Voyage d'Orient) as far as Istanbul with August Klipstein, an art history student in Berne at the time who later became an antiquarian. His return trip is through Athens, Mount Athos, Pompeii, Naples, Rome, Florence. The travelog is published in the newspaper *Feuille d'Avis de La Chaux-de-Fonds*.

Upon his return, he takes a lecture position on the subject of 'Composition décorative appliquée à l'architecture jusqu'aux plus petits objets' in the Nouvelle Section of the Ecole d'Art in La Chaux-de-Fonds.

At the beginning of the year, he purchases a Cupido 80 camera – an expensive, ambitious model – and uses it in Germany and on his Voyage d'Orient.

March to August, produces more than 160 glass plates, 9 x 12 cm format, as well as 155 roll-film negatives, 6 x 9 cm format.

Purchase of another camera in Naples, probably a Kodak Folding Brownie for roll film, 6 x 9 cm format. Takes 62 pictures during the Voyage d'Orient. Between 1912 and 1916, he takes pictures in Switzerland (Villa Jeanneret-Perret) and in France (Nancy, Versailles). Altogether more than 200 pictures are taken with this camera.

1912

Opens his own office at 54 rue Numa-Droz in La Chaux-de-Fonds, offering services as an architect, interior decorator and furniture designer.

Trip to Paris.

First exhibition of a series of sketches from his travels and watercolours, entitled 'Langage de pierres' (Language of Stones) in Neuchâtel and at the Salon d'Automne in Paris.

Villa Jeanneret-Perret (Maison Blanche), Jeanneret / Le Corbusier's first independent work of architecture, for his parents in La Chaux-de-Fonds.

Villa Favre-Jacot in Le Locle for the owner of the Zénith watch factory, Georges Favre-Jacot (1912–13).

Publishes *Etude sur le mouvement d'art décoratif en Allemagne*.

1913

Exhibition of 'Langage de pierres' (Language of Stones) in the Zurich Kunsthaus.

Several residential interiors and furniture designs in La Chaux-de-Fonds, primarily for members of the Ditisheim, Levaillant and (until 1923) Schwob families.

1914

Dissolution of the Nouvelle Section of the Ecole d'Art founded by L'Eplattenier in La Chaux-de-Fonds.

Visits the Werkbund exhibition in Cologne.

Project for the garden city Les Crêtets in La Chaux-de-Fonds.

1915

Studies at the Bibliothèque Nationale in Paris. The project for a publication about urban development, *La construction des villes*, comes to an end.

Competition entry for a bridge over the Rhône in Geneva (Pont Butin), in collaboration with engineer Max Du Bois.

Begins development of the Dom-ino concept (simple, serially manufactured constructions with skeletons of reinforced concrete) with Max Du Bois.

Various projects for Dom-ino houses.

1916

La Scala Cinema in La Chaux-de-Fonds (based on René Chapallaz's plans).

Villa Anatole Schwob in La Chaux-de-Fonds (1916–17).

Design for a villa on the sea for Paul Poiret (1916–17).

1917

Relocates to Paris and moves into an apartment at 20 rue Jacob in the Saint-Germain-des-Prés district, where he remains until 1934. Opens an office at 20 rue de Belzunce, later at 29 rue d'Astorg.

Begins his business career (until 1921) in conjunction with the Société d'application du béton armé (SABA), the Société d'entreprises industrielles et d'études (SEIE) and the Briqueterie d'Alfortville.

Workers' housing in Saint-Nicolas-d'Aliermont (partially realized).

Water reservoir in Podensac (partially realized).

Hydroelectric power plant in L'Isle-Jourdain.

1918

Collaborations with the painter Amédée Ozenfant (until 1925) and first joint exhibition at Galerie Thomas in Paris (December 1918–January 1919). The catalogue proclaims Purism to be a new movement in painting.

Becomes acquainted with Raoul La Roche, a banker and art collector from Basel.

Projects for slaughterhouses in Challuy, Garchizy and Bordeaux.

Oil painting *La Cheminée*, which Le Corbusier later refers to as 'ma première peinture' ('my first painting'). Is involved with visual arts until the end of his life (painting, graphic art and, starting in the 1940s, sculpture and tapestries).

Publishes *Après le cubisme* with Amédée Ozenfant.

1919

Project for the Maison Monol.

The *Actualités Gaumont* film the exhibition 'Ozenfant et Jeanneret' in Galerie Thomas in Paris.

1920

Begins using the pseudonym Le Corbusier. He takes it from 'Monsieur Lecorbésier', his maternal great-grandfather's name, though later he also attributes it to the French word for raven ('corbeau').

Founds the journal *L'Esprit nouveau* with Amédée Ozenfant and the poet Paul Dermée. The first issue is published in October.

Becomes acquainted with Yvonne Gallis (1892–1957), who later becomes his wife.

Becomes acquainted with Fernand Léger.

Preliminary studies for the Maison Citrohan.

Increasing use of photographs within *L'Esprit nouveau* creates a specific visual discourse.

1921

Increased contact with artists like Picasso, Braque and Léger. Advises Raoul La Roche in purchasing paintings at auctions.

Trip to Rome with Amédée Ozenfant and Germaine Bongard, owner of Galerie Thomas.

Exhibition of paintings in Galerie Druet in Paris.

Project for Villa Berque in Paris (1921–22, partially realized).

1922

Opens an architecture office with his cousin Pierre Jeanneret (1896–67). They work together until 1940.

Trip to Venice and Vicenza with Raoul La Roche.

First lecture at La Sorbonne in Paris.

Exhibitions at the Salon d'Automne and the Salon des Indépendants, in Paris.

Villa Besnus in Vaucresson (1922–23).

Project for the Immeubles Villas (apartment complex, 1922–25).

Project for the Ville contemporaine de trois millions d'habitants (Contemporary city of three million inhabitants), presentation at the Parisian Salon d'Automne.

1923

Painting exhibition with Amédée Ozenfant at the gallery L'Effort moderne in Paris.

Villa Le Lac (Petite Maison) for his parents in Corseaux, near Vevey, on Lake Geneva (1923–24).

Home and studio for the painter Amédée Ozenfant in Paris (1923–24).

Villa La Roche/Jeanneret in Paris (1923–25).

Home and studio for the sculptor Jacques Lipchitz in Boulogne-sur-Seine (1923–25).

Publishes *Vers une architecture*. In designing the layout, he refines his strategic use of photographs (as previously tested in *L'Esprit nouveau*) so that they further reinforce his message.

Charles Gérard begins photographing Le Corbusier and Pierre Jeanneret's work (collaborations until 1928).

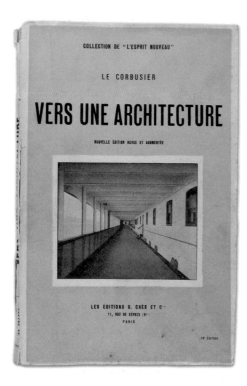

1924

Moves in to the legendary architectural studio at 35 rue de Sèvres in Paris, located in the corridor of a former Jesuit monastery.

Lectures in Geneva, Lausanne, Prague and Brno.

Workers' housing for the industrialist Henri Frugès in Pessac near Bordeaux (1924–26).

Georges Thiriet begins photographing Le Corbusier and Pierre Jeanneret's work (collaborations until 1930).

1925

Pavillon de l'Esprit Nouveau at the 'Exposition internationale des Arts décoratifs et industriels modernes' in Paris. His project for a Ville contemporaine de trois millions d'habitants and the Plan Voisin are displayed in the pavillion.

Projects for Villa Meyer (1925–26) and student housing in Paris.

Last issue of the journal *L'Esprit nouveau*.

Publishes *Urbanisme* and *L'Art décoratif d'aujourd'hui*.

Publishes *La peinture moderne* with Amédée Ozenfant.

Le Corbusier plans a film in the Pavillon de L'Esprit Nouveau.

1926

Death of his father on 11 April in Corseaux, Switzerland.

Palais du Peuple, building addition to the Salvation Army in Paris.

Villa Cook in Boulogne-sur-Seine (1926–27).

Villa Stein-de Monzie in Garches (1926–28).

Guiette House in Antwerp.

Publishes the *Almanach d'architecture moderne*.

Documentary by Fred Boissonnas on Villa La Roche/Jeanneret.

Competition entry for the Palace of the League of Nations in Geneva (1926–27).

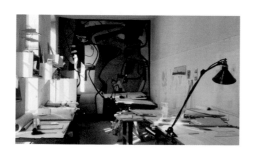

Contact with filmmakers who are shooting a film about the workers' housing in Pessac. Some sequences are later used in the film *Architecture d'aujourd'hui* by Pierre Chenal.

1927

Lectures in Madrid, Barcelona, Frankfurt, and Brussels.

The architect and designer Charlotte Perriand (1903–99) starts working in the studio on rue de Sèvres (October/November).

Designs for two houses as part of the Werkbund exhibition in Stuttgart-Weissenhof (construction supervisor Alfred Roth).

Villa Church in Ville-d'Avray (1927–30).

Wins first prize (*ex aequo*) in the competition for the Palace of the League of Nations in Geneva.

First publication of *Cinq points pour une architecture nouvelle*, in which he articulates his principles of design.

1928

Founding member of the Congrès internationaux d'architecture moderne (CIAM) at La Sarraz Castle in Switzerland.

Lectures in Prague and Moscow.

Villa Baizeau in Tunis-Carthage, Tunisia (1928–29).

Villa Savoye in Poissy (1928–31).

Building of the Central Union of Consumer Cooperatives (Centrosoyuz) in Moscow (1928–36, plans executed by Nikolai Kolli).

Studies for the Maison Loucheur (1928–29).

Project for the Mundaneum, conceived as a world museum in Geneva.

Publishes *Une maison – un palais*.

Meets with the Russian film pioneer Sergei Eisenstein during his stay in Moscow.

1929

Lecture series in Rio de Janeiro, Buenos Aires and Montevideo. During this trip he becomes acquainted with Josephine Baker.

Presents the tubular steel furniture he developed in collaboration with Charlotte Perriand and Pierre Jeanneret at the Salon d'Automne in Paris.

Floating homeless shelter (Asile flottant) on the Seine for the Salvation Army in Paris (1929–30).

Villa de Mandrot in Le Pradet, France (1929–31).

Penthouse de Beistegui on the Champs-Elysées, Paris (1929–31).

Cité de refuge, homeless shelter for the Salvation Army in Paris (1929–33).

Pavillon Suisse at the Cité Universitaire, Paris (1929–33).

1930

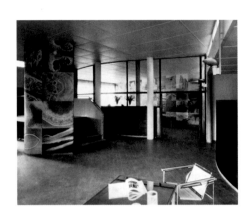

Contributions to the newly established journal *Plans*, which appeared in thirteen issues between 1931 and 1932.

Trip to Spain.

Obtains French citizenship (19 September) and marries Yvonne Gallis (18 December).

Immeuble Clarté in Geneva for the industrialist Edmond Wanner (1930–32).

Publishes *Précision sur un état présent de l'architecture et de l'urbanisme*, a compilation of his lectures in Latin America.

Publishes the first volume of his *Oeuvre complète* with Verlag Girsberger, a publishing house in Zurich. The eighth and final volume is published posthumously in 1970.

Marius Gravot begins photographing Le Corbusier and Pierre Jeanneret's work (collaborations until 1933).

Contact with Pierre Chenal, who shoots two films, *Architecture d'aujourd'hui* and *Bâtir* (1930–31), about Le Corbusier's architecture.

1931

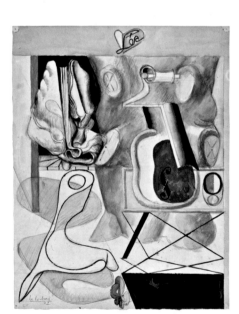

First trip to Algiers for a series of lectures. Preliminary sketches for urban renewal in the city. In the summer he makes a second trip to Algeria, this time with Pierre Jeanneret, by car via Spain and Morocco.

Immeuble Molitor, rue Nungesser et Coli, Paris (1931–34).

Competition entry for the Palace of the Soviets in Moscow (1931–32).

Coloured wallpaper collection for the Salubra company in Basel.

Brassaï visits and photographs Le Corbusier in the apartment on rue Jacob.

1932

Plan Obus for Algiers (1932–42).

Designs for apartment complexes at Zürichhorn and Hardturmstrasse in Zurich (both 1932–33).

1933

Attends the fourth CIAM conference on 'The Functional City' aboard the ship *Patris II* and in Athens. He subsequently plays a major role in drafting the conference's conclusions, published as *The Athens Charter* in 1943.

Lectures in Stockholm, Oslo, Gothenburg and Antwerp.

Awarded an honorary doctoral degree from the University of Zurich's Philosophy Faculty II.

Contributions to the journal *Prélude*, which appears in sixteen issues until 1936.

Introduces new plans for Algiers at the 'Exposition de la Cité Moderne' in Algiers.

Project for an administrative building for the Swiss Rentenanstalt in Zurich (1933–35).

Urban planning projects for Antwerp, Geneva and Stockholm.

Publishes *Croisade, ou le crépuscule des académies*. The layout of the book reflects Le Corbusier's increasing interest in photomontage.

Floor-to-ceiling photo fresco in the common area of the Pavillon Suisse made up of photographs by Pierre Jeanneret and Charlotte Perriand, among others.

1934

Moves into an apartment with studio space on the seventh floor of the Immeuble Molitor, where he resides for the rest of his life.

Lectures in Rome, Milan, Barcelona.

Villa Henfel in La Celle-Saint-Cloud (1934–35).

Urban planning project for the city of Nemours in Algeria.

Project for an apartment complex at the Kellerman Bastion in Paris (1934–35). Albin Salaün begins photographing Le Corbusier and Pierre Jeanneret's work (collaborations until 1948).

1935

Visits the Bat'a shoe factory in Zlín, Czechoslovakia. Develops several projects for Bat'a branches in Zlín and France that are never realized (until 1937).

On an invitation from the Museum of Modern Art in New York, he visits the United States and lectures in New York, Yale, Boston, Chicago, Philadelphia and other cities.

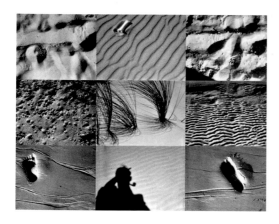

Travelling exhibition in the United States.

Exhibits 'Les Arts dits primitifs', organized by Louis Carré, in his apartment on rue Nungesser et Coli.

Villa Le Sextant in La Palmyre-Les Mathes.

Urban development concepts and regional planning studies for Zlín, Czechoslovakia.

Project for a contemporary art centre in Paris (1935–36).

Publishes *La Ville radieuse* and *Aircraft*. Aircraft celebrates the aeroplane as an icon of modern civilization, as well as an embodiment of the publisher's series' motto, 'The New Vision'.

1936

Trip to South America (in a Zeppelin) for a lecture series; contacts include Oscar Niemeyer, Lucio Costa and Affonso Eduardo Reidy in Rio de Janeiro.

Planning consultant for the Ministry of Health and Education in Rio de Janeiro (1936–45, realized by Lucio Costa and Oscar Niemeyer).

Project for a Bat'a company pavilion at the 'Exposition internationale des Arts et des Techniques dans la Vie moderne' in Paris (1936–37).

Design for a recreation centre and stadium with a 100,000-person capacity on the outskirts of Paris (1936–38).

In the summer he purchases a 16mm camera – possibly a Siemens Model B (1932) or C (1934) – that can also take still photographs. Between this point and 1938, he shoots 120 film sequences and takes almost 6,000 photographs (apartment on rue Nungesser et Coli, Villa Le Lac (Petite Maison), Villa E 1027, trip to Brazil, Bassin d'Arcachon/Le Piquey and others).

Begins designing large-scale photomontages and collages.

Charlotte Perriand – along with J. Bossu, E. Enri, G. Pollak and J. Woog – prepare the large-scale collage *La Grande misère de Paris* (3 x 16 m) for the Salon des Arts Ménagers. It criticizes the dismal living conditions for the lower class in Paris.

1937

Helps organize the fifth CIAM conference in Paris on the topic of 'Housing and Recreation'.

The French government awards him the title Chevalier de la Légion d'honneur.

Appointed member of the Regional Planning Commission in Algiers.

Charlotte Perriand leaves the studio at rue de Sèvres.

Pavillon des Temps Nouveaux at the 'Exposition internationale des arts et des techniques dans la vie moderne' in Paris.

Publishes *Quand les cathédrales étaient blanches. Voyage au pays des timides.*

With CIAM-France, impressive visual publicity for modern urban planning in the Pavillon des Temps Nouveaux. Le Corbusier also designs two large-scale photo collages, *Esprit de Paris* and *Habiter*.

1938

Exhibits paintings at the Zurich Kunsthaus and at the gallery Louis Carré in Paris.

Continues to work on plans for Algiers with the skyscraper project Quartier de la Marine.

Murals for Jean Badovici and Eileen Gray in the Villa E.1027 in Roquebrune-Cap-Martin in southern France.

Publishes *Des canons, des munitions? Merci! Des logis . . . s.v.p.* and *Œuvre plastique, peintures et dessins, architecture. Des canons, des munitions? Merci! Des logis… s.v.p.* is a documentation of the content and form of the exhibition in the Pavillon des Temps Nouveaux. The cover – a montage of photographic fragments and silhouette-like areas of colour – is one of Le Corbusier's most compelling works in the field of book design.

Uses part of the photo collage Esprit de Paris from the Pavillon des Temps Nouveaux for the cover of the publication for the fifth CIAM conference (*Logis et loisirs. 5e Congrès CIAM Paris 1937*, 1938).

1939

Studies for prefabricated houses in drywall construction (Maisons montées à sec, MAS, 1939–40). Publishes *Le Lyrisme des temps nouveaux et l'urbanisme* (special issue by *Le Point*).

1940

Closes the office at rue de Sèvres and he and his wife move to Ozon in the Pyrenees following the occupation of Paris by German troops on 14 June. He and Pierre Jeanneret separate.

Munitions factory near Aubusson
(partially realized).

Design for workers' housing in Lannemezan.

Designs for mobile schools (Ecoles volantes)
and club facilities with Jean Prouvé.

1941

Contacts with the Vichy Regime under Marshal
Pétain, whom he notifies of his interest in
contributing to the reconstruction of France
at the end of the war.

Exhibits gouache paintings at Willy Boesiger's
gallery in Zurich.

Publishes *Destin de Paris* and *Sur les quatre
routes*.

1942

First studies for the Modulor, a universal system
of measurement based on human proportions.

Plan Directeur for Algiers as a final design
variation on Plan Obus.

Publishes *Les Constructions 'Murondins'* and
La maison des hommes (in collaboration with
François de Pierrefeu).

1943

ASCORAL (Association des constructeurs
pour la rénovation architecturale) is founded as
a re-formation of CIAM's French national group.

Publishes *Entretien avec les étudiants des
écoles d'architecture* and *Urbanisme des
CIAM. La Charte d'Athènes* (published under
the auspices of the French CIAM group, with
an introduction by Jean Giraudoux).

1944

Plans for the reconstruction of Saint-Gaudens,
Saint-Dié-des-Vosges, and La Rochelle-La
Pallice (1944–46).

Reopens the office at rue de Sèvres in August.

Robert Doisneau photographs Le Corbusier
in his apartment on rue Nungesser et Coli.
In the years to come, he would make many
portraits of Le Corbusier.

1945

Elected chairman of the Urban Planning
Commission of the architectural association
Front national des architectes.

ATBAT (Atelier de bâtisseurs) is founded
as a planning office structured for multiple
fields in light of the upcoming work for the Unité
d'Habitation. Under Le Corbusier's leadership,
Vladimir Bodiansky and André Wogenscky take
directoral positions.

Trip to the United States in the company
of Eugène Claudius-Petit, André Sive, Pierre
Emery, Gerald Hanning and Vladimir Bodiansky.

Preliminary designs for the Unité d'Habitation,
a housing project in Marseille, as a commission
from Reconstruction Minister Raoul Dautry
(1945–52).

Publishes *Les trois établissements humains*
(group authorship).

1946

Trip to New York to prepare a project for the
United Nations headquarters. Meets Albert
Einstein in Princeton.

Textile factory Claude et Duval in Saint-Dié-
des-Vosges (1946–50).

Publishes *Manière de penser l'urbanisme*
and *Propos d'urbanisme*.

1947

Trip to Bogotá.

Beginning of construction of the Unité
d'Habitation in Marseille.

Designs for the United Nations headquarters
in New York. The structure, eventually built
by Wallace K. Harrison, incorporates
Le Corbusier's ideas.

Completion of the Grille CIAM, a system of wall
charts that serve as graphic illustrations of urban
development projects, in collaboration with
ASCORAL and additional contributors (1947–
49). They were presented at the sixth CIAM
conference in Bridgwater, England.

New emphasis on painting and first wooden
sculptures in collaboration with the Breton
cabinetmaker Joseph Savina.

Publishes UN Headquarters.

1948

Exhibitions of his work in the United States,
organized by the Institute of Contemporary
Art in Boston.

Unité d'Habitation in Rezé-lès-Nantes
(1948–55).

Project for a residential vacation complex Roq in Roquebrune-Cap-Martin, southern France (1948–50).

Mural in the studio on rue de Sèvres.

Mural in the foyer of the Pavillon Suisse at the Cité Universitaire, Paris.

Begins his serious engagement with tapestries.

Publishes *Grille CIAM d'Urbanisme. Mise en application de la Charte d'Athènes* and *New World of Space*.

In reorganizing the studio on rue de Sèvres (starting in 1948), he creates a 'studiolo' with a floor-to-ceiling, black-and-white reproduction ot his Purist oil painting *Verres, bouteille et livre* (1932).

Visual design for the publication *New World of Space* in the spirit of the aspiration for a 'synthèse des arts' ('synthesis of the arts'). Juxtapositions, details and deliberate shifts in scale are meant to demonstrate unified creative intention among his various artistic disciplines.

The second special issue of Le Corbusier's *L'Architecture d'aujourd'hui* is published; he determines the content and layout himself.

Accompanied by Le Corbusier, René Zuber photographs and films the construction site of the Unité d'Habitation in Marseille (1948–49).

1949

Urban planning concepts for Bogotá.

Collaborations with photographer Lucien Hervé begin in December. In addition to documenting Le Corbusier's buildings for the *Oeuvre complète*, he takes dramatic portraits of the architect himself.

1950

Chapel of Notre-Dame-du-Haut in Ronchamp (1950–55).

Appointed Government Architectural Adviser for the construction of Chandigarh as the new capital of the Indian state Punjab. Development of a master plan for the city (1950–51) in collaboration with Pierre Jeanneret, Jane Drew and Maxwell Fry. Primary layout of the city in sectors with the government district (Capitol) on the northern edge.

Publishes *Poésie sur Alger* and *Le Modulor*.

Publishes *L'Unité d'habitation de Marseille* (special edition by *Le Point*).

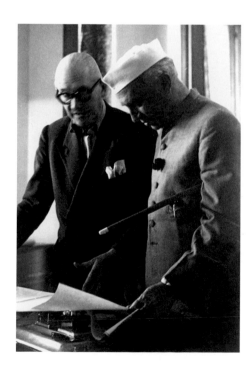

Mural in the director's office of the textile factory Claude et Duval in Saint-Dié-des-Vosges finished in 1950. Le Corbusier combines fragments of a photographic reproduction of a Purist oil painting with textured monochromatic areas of colour.

First photographs of his buildings by René Burri. The Swiss photographer would eventually shoot around 3,000 pictures of both the architect and his works.

Frédéric Pottecher's radio report about the prototype apartment in the Unité d'Habitation in Marseille.

Nicole Védrès's film *La Vie commence demain* is released.

1951

His plans for the UNESCO building in Paris are rejected, but he is a member of the five-person committee overseeing the project. The other members are Walter Gropius, Lucio Costa, Sven Markelius and Ernesto Rogers.

First trip to India, accompanied by Pierre Jeanneret.

High Court (1951–55), Secretariat (1951–58), and Legislative Assembly (1951–64) as part of Chandigarh's Capitol.

Projects for the Governor's Palace (1951–54) and a museum as part of Chandigarh's Capitol.

Symbolic monuments on the grounds of the Capitol in Chandigarh: *Main ouverte* monument (completed 1985), Martyrs' Memorial, Tower of Shadows, Pyramid.

Building for the Mill Owners' Association (1951–54), Villa Shodhan (1951–56) and Villa Sarabhai (1951–56), all in Ahmedabad.

Wooden cabin (Cabanon) in Roquebrune-Cap-Martin, southern France (1951–52).

Jaoul Houses in Neuilly-sur-Seine (1951–55).

1952

Appointed Commandeur de la Légion d'honneur.

Beginning of construction in Chandigarh.

Project for five residential vacation units (Rob) in Roquebrune-Cap-Martin, southern France (1952–55; by 1957 five 'unités de camping' are built next to Roberto Rebutato's restaurant, L'Etoile de Mer, according to Le Corbusier's plans).

Ceremonial dedication of the Unité d'Habitation in Marseille by Eugène Claudius-Petit.

1953

Awarded the Gold Medal of the Royal Institute of British Architects (RIBA).

Exhibits paintings and sculptures at the Musée National d'Art Moderne in Paris and at the Institute of Contemporary Arts in London.

Pavillon du Brésil at the Cité Universitaire in Paris, designed with Lucio Costa (1953–59).

Dominican Monastery Sainte-Marie de la Tourette (La Tourette) in Eveux-sur-Arbresle (1953–60).

Construction begins on the Unite d'Habitation in Rezé-lès-Nantes.

First of three trips to India for the Swiss photographer Ernst Scheidegger. He takes many photographs of Le Corbusier's construction sites and completed buildings as well as a reportage of life in India.

Jean Sacha's film *La Cité radieuse* is released.

1954

Solo exhibitions in Berne and Como.

Completion of the building for the Mill Owners' Association in Ahmedabad.

Publishes *Une Petite maison*. The book includes photographs and drawings from 1945–51 as a visual journey through Villa Le Lac (Petite Maison) from 1923–24. Le Corbusier's search for its final form includes six comprehensive layout prototypes.

1955

Awarded an honorary doctoral degree from the Swiss Federal Institute of Technology (ETH) in Zurich.

Completion of the chapel Notre-Dame-du-Haut in Ronchamp.

Completion of the Jaoul Houses in Neuilly-sur-Seine.

Inauguration of the High Court in Chandigarh by Indian Prime Minister Jawaharlal Nehru.

Completion of the Unité d'Habitation in Rezé-lès-Nantes.

Maison de la Culture (1955–65) and Stadium (1955–68) in Firminy.

Publishes *Architecture du bonheur*; *Le Poème de l'angle droit*; and *Modulor 2*.

René Burri takes photographs of the chapel Notre-Dame-du-Haut's inauguration.

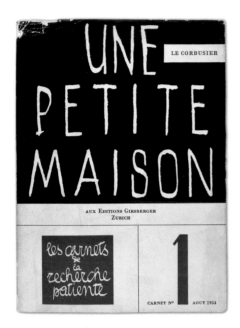

Lucien Hervé accompanies Le Corbusier on one of his trips to India and photographs his buildings in Chandigarh und Ahmedabad.

1956

Lectures in Baghdad and Paris.

Exhibition in Lyon.

Completion of the Villa Shodhan and the Villa Sarabhai in Ahmedabad.

Unité d'Habitation in Berlin-Charlottenburg (1956–58).

Unité d'Habitation in Briey-en-Forêt (1956–63).

Beginning of construction on the Dominican Monastery Sainte-Marie de La Tourette in Eveux-sur-l'Arbresle.

Publishes *Les Plans de Paris 1956–1922* with the plans he made over the years for the redevelopment of Paris.

Publishes *Les Maternelles vous parlent / Kinder der strahlenden Stadt*.

Publishes *Chapelle Notre Dame du Haut, Ronchamp*, with Jean Petit.

Ernst Scheidegger plans a publication series about Chandigarh with the Zurich publisher Hans Girsberger. He designs a maquette for the first volume, *Chandigarh 1956*. The project is never implemented.

1957

Yvonne Le Corbusier dies on 5 October.

Opening of a major travelling exhibition, organized by Willy Boesiger, at the Zurich Kunsthaus (further venues include Berlin, Munich, Vienna, Frankfurt, The Hague and Paris).

Exhibition 'Le poème de l'angle droit et 17 tapisseries de Le Corbusier' in La Chaux-de-Fonds.

National Museum of Western Art in Tokyo (1957–59).

Publishes *Ronchamp* and *Von der Poesie des Bauens*.

Pierre Kast's film *Le Corbusier, l'architecte du bonheur* is released.

1958

Completion of the Secretariat in Chandigarh.

Completion of the Unité d'Habitation in Berlin-Charlottenburg.

Philips Pavilion at the World's Fair in Brussels.

Beginning of construction of the Unité d'Habitation in Briey-en-Forêt.

In the Philips Pavilion, staging of the multimedia composition *Poème électronique* in collaboration with the Greek musician, mathematician and architect Iannis Xenakis. Music by Edgar Varèse and Iannis Xenakis.

1959

Guest lecturer at Harvard University in Cambridge, Massachusetts.

Awarded the Order of Merit by H.M. Queen Elizabeth II.

Unité d'Habitation in Firminy (1959–67).

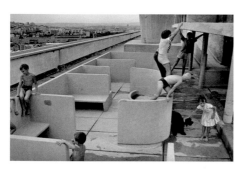

Carpenter Center for the Visual Arts at Harvard University in Cambridge, Massachusetts (1959–62).

Second coloured wallpaper collection for the Salubra company in Basel.

René Burri works on a series of portraits of Le Corbusier and his work (1959–60).

1960

Death of his mother on 15 February in Corseaux, Switzerland, at the age of 100.

Completion of the Dominican Monastery Sainte-Marie de la Tourette in Eveux-sur-l'Arbresle.

Sluice on the Rhine, in Kembs-Nifer, Alsace (1960–62).

Publishes *L'Atelier de la recherche patiente / Textes et planches*. The book is the last work Le Corbusier publishes himself. He selects the texts, photographs and images as well as the typographical layout, all of which makes the publication an impressive personal testimony.

Pierre Joly and Véra Cardot begin to photograph Le Corbusier's work.

1961

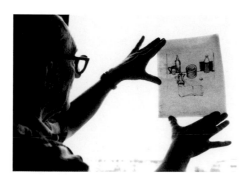

Beginning of construction of the Carpenter Center for the Visual Arts at Harvard University under the direction of Josep Lluís Sert.

Construction begins on the Maison de la Culture in Firminy.

Project for the church of Saint-Pierre in Firminy (realized 2003–6 under the direction of José Oubrerie, one of Le Corbusier's former employees).

Project for a hotel and conference centre on the grounds of the Gare d'Orsay in Paris

Completion of seven wall tapestries for the High Court in Chandigarh.

Publishes *Un Couvent de Le Corbusier* and *Le Livre de Ronchamp*, both with Jean Petit.

Lucien Hervé's second trip to India, where he photographs Le Corbusier's buildings in Chandigarh and Ahmedabad.

1962

Retrospective exhibition at the Musée National d'Art Moderne in Paris.

Completion of the Assembly Building in Chandigarh.

Exhibition pavilion Maison de l'Homme in Zurich, commissioned by the gallerist Heidi Weber (1962–67).

Project for the Olivetti Centre for Electronic Processing in Rho, near Milan (1962–64).

Project for a Congress Centre in Strasbourg (1962–65).

1963

Receives the order Grand officier de la Légion d'honneur.

Retrospective in the Palazzo Strozzi in Venice and award of the Medaglia d'Oro from the city of Florence.

Completion of the Carpenter Center for Visual Arts at Harvard University.

Completion of the Unité d'Habitation in Briey-en-Forêt.

Design for a building for the French Embassy in Brasilia (1963–64).

1964

Inauguration of the Assembly Hall in Chandigarh with the official opening of the monumental enamelled steel door designed by Le Corbusier as a gift from France to the country of India.

Design for a new hospital in Venice (1964–65).

1965

Opening of the Maison de la Culture in Firminy.

Le Corbusier dies from a heart attack on 27 August while swimming in the ocean in Roquebrune-Cap-Martin.

1966

Le Voyage d'Orient is published.

1967

Completion of the exhibition pavilion Maison de l'Homme in Zurich.

Completion of the Unité d'Habitation in Firminy.

1968

Completion of the Stadium in Firminy.

Le Corbusier, Dessins is published under Jean Petit's supervision.

On 24 July, in accordance with Le Corbusier's wishes, the Fondation Le Corbusier is established in Paris as a non-profit organization; it continues to administer his estate to the present day.

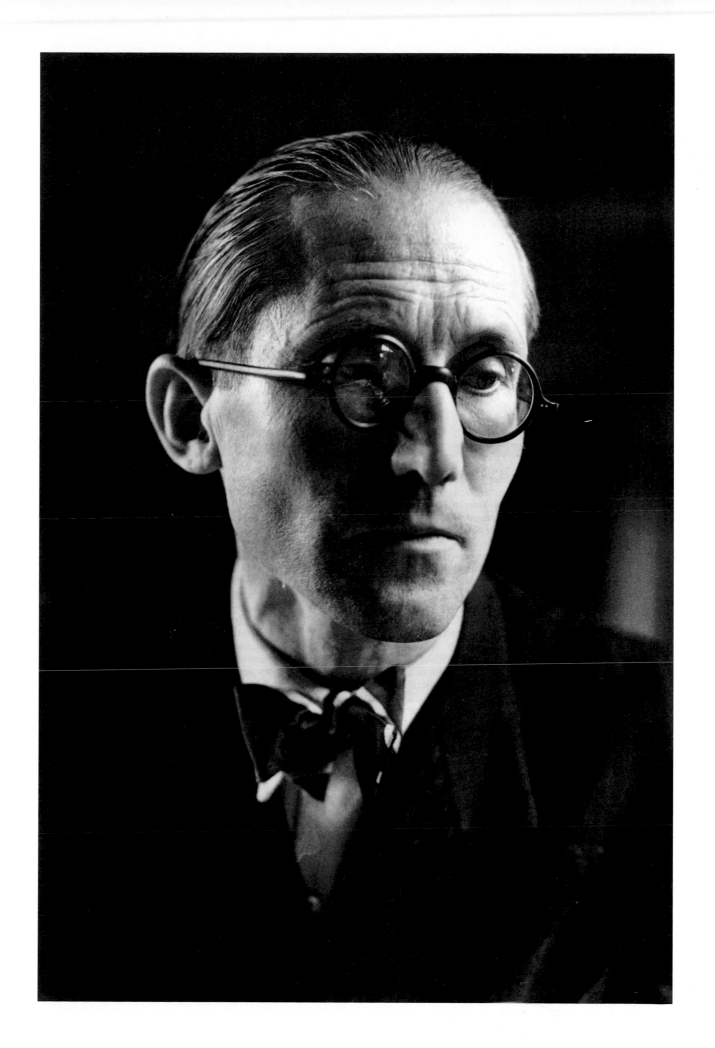

ACKNOWLEDGMENTS

First of all, we would like to thank the authors who have made this publication and the accompanying exhibition possible: Tim Benton, Jean-Christophe Blaser, Veronique Boone, Catherine de Smet, Arthur Rüegg and Klaus Spechtenhauser. Without their active participation, we would not have been able to assemble all the pieces of this extraordinary and complex project and to reveal an unknown side of Le Corbusier's work. We sincerely thank them for their keen insights and expertise on the life and work of this brilliant individual. We are also most grateful to Norman Foster, one of the most distinguished architects at work today, who agreed to write the preface for this book. In his text, he reveals how Le Corbusier came into his life and became a strong influence. Many are those who have been transported in a similar way by Le Corbusier's major body of work .

This book is published on the occasion of the 125th anniversary of Le Corbusier's birth in La Chaux-de-Fonds, a manifestation – on as large a scale as the four Art Nouveau seasons in 2005–6 – that promotes the watchmaking city, awarded World Heritage status by the UNESCO in 2009. We would also like to make a special mention of the executive board: Anouk Hellmann, head of the 'Le Corbusier 2012' project; Jean-Pierre Veya, municipal councillor and director of cultural affairs; Lada Umstätter, chief curator of the Musée des beaux-arts; and Jacques-André Humair, director of the Bibliothèque de la Ville. We extend our profound appreciation to the members of the executive committee: Jacques Bujard, cantonal curator; Denis Clerc, city architect; Xavier Huther, cultural affairs administrator; Ludivine Oberholzer, cultural affairs representative; and Eric Tissot, communication and promotion coordinator.

Our gratitude also goes to the patronage committee, which has supported the 'Le Corbusier 2012' project since its foundation: Alain Berset, federal councillor and head of the Federal Department for Home Affairs; Philippe Gnaegi, member of the Council of State; Martine Rahier, director of the University of Neuchâtel; Patrick Aebischer, president of the Ecole Polytechnique Fédérale de Lausanne; Staffan Ahrenberg, collector and art publisher based in Geneva; Didier Berberat, member of the Council of State; Mario Botta, architect; Nott Caviezel, president of the Commission Fédérale des Monuments Historiques; Jean-Pierre Duport, president of the Fondation Le Corbusier in Paris; Nicolas Mathieu, secretary-general of the Commission Suisse pour l'UNESCO; Eduard Müller, president of ICOMOS Suisse; Marc Petit, president of the Association des Sites Le Corbusier in Firminy; Benno Schubiger, president of the Société d'Histoire de l'Art en Suisse; and Sam Stourzé, director of the Musée de l'Elysée in Lausanne.

Le Corbusier's work is strongly represented in many institutional and private collections. We express our deep thanks first to the Fondation Le Corbusier in Paris, to its director, Michel Richard, to archives exhibitions manager Isabelle Godineau and to their staff. In addition to graciously sharing their tremendous knowledge of Le Corbusier, they assisted us in locating the photographs reproduced here and lent many works to the exhibition, for which we are extremely grateful. We also wish to thank them for organizing the XVIIIth Rencontres de la Fondation Le Corbusier ('Le Corbusier: aventures photographiques'), an international symposium held at Club 44 in La Chaux-de-Fonds on 28–29 September 2012.

We are very grateful for the support of the institutions and individuals who have loaned us pieces from their collections: the Bibliothèque de la Ville de La Chaux-de-Fonds; the Kunsthalle Bielefeld, Mannheim; Musée national d'Art moderne, Centre Georges Pompidou, Paris; Bèr Deuss, Albersen Verhuur BV & Deuss Music; René Burri; the Fraenkel Gallery, San Francisco; Judith Hervé; the archives of the Institut für Geschichte und Theorie der Architektur (gta Archiv), ETH, Zurich; Piet Lelieur, Studieburo, Mouton, Ghent; the Museo Nazionale della Scienza e della Technologia 'Leonardo da Vinci', Milan; Angelo Melcarne, Neuchâtel; the Musée suisse de l'appareil photographique, Vevey; the Musée de l'Elysée, Lausanne; the Museum für Gestaltung, Zurich; the Musée Neuhaus, Biel; the Philips Museum, Eindhoven; Philips Nederland B.V., Eindhoven; the Réunion des Musées Nationaux, Paris; Arthur Rüegg, Zurich; the Stiftung Ernst Scheidegger-Archiv, Zurich; Technomuseum, Mannheim and Björn Teuwsen, Philips Group Innovation, Eindhoven. We also wish to thank the photographers who contributed to our project: Olivo Barbieri, Stéphane Couturier, Cemal Emden, Thomas Flechtner, Matthieu Gafsou, Guido Guidi, Milo Keller, Jean-Michel Landecy, Alexey Naroditsky, Daniel Schwartz and Hiroshi Sugimoto.

Our thanks go to the Musée des beaux-arts in La Chaux-de-Fonds and its entire staff for both producing and hosting the exhibition: Sophie Vantieghem, researcher, coordinator and loans manager; Nicole Hovorka, administrator; and Alexandra Zuccolotto, education co-ordinator. We would also like to thank Thibaud Tissot and his staff at design agency Onlab for creating the exhibition design, as well as Claude-André Moser, president of the Société des Amis du Musée des beaux-arts de La Chaux-de-Fonds, and his committee.

The Bibliothèque de la Ville de La Chaux-de-Fonds and its entire staff have been instrumental in the realization of this project. Our sincere thanks are extended to Jacques-André Humair, director; Katia Willy, administrative assistant; Carlos Lopez, head of research and information; Clara Gregory, head of the audio-visual department; and Hubert Corta, audio-visual technician .

This vast project was made possible by the initiative and the financial support of the city of La Chaux-de-Fonds and the Association des Amis de la Bibliothèque de la Ville de La Chaux-de-Fonds, particularly thanks to its president, Christian Geiser, and his committee. We are also grateful for the generous support received from the Loterie romande, the Ernst Göhner Stiftung, Pro Helvetia and the Bureau de contrôle des métaux précieux in La Chaux-de-Fonds.

The Centre International pour la Ville, l'Architecture et le Paysage (CIVA) in Brussels responded with enthusiasm to our proposal to bring the show to Belgium. We thank its director, Christophe Pourtois, Marcelle Rabinowicz, curator in charge of exhibitions, and their staff.

The publication accompanying the exhibition has been another endeavour requiring prodigious efforts by a large number of people. We are thankful to our publisher, Thames & Hudson, its chairman, Thomas Neurath, Lucas Dietrich, Adélia Sabatini, and its staff in London, as well as Editions Textuel in Paris and Edith Lecherbonnier. Our deepest thanks to Lydia Dorner for her insightful editing of the French text and her contribution to many steps of the production of the book. We are also grateful to Sophie Vantieghem and Gabriel Umstätter for providing ad hoc assistance.

We would also like to express our gratitude to several individuals who have contributed to the realization of this project, both as an exhibition and as a catalogue: Mathias a Marca, Sylvie Béguelin, Christophe Brandt, Cédric Brossard, Edmond Charrière, William A. Ewing, Marianne Gautschi, Evguenia Gerchkovitch, Priska Gutjahr, Rada Landar, Beat Matti, Nadja Maillard, Robin Seiler, Joël Rappan, Niloufar Tajeri and Maria Wahlström. Without every one of these efforts, *Le Corbusier and the Power of Photography* would not have taken on the life that it has.

Anouk Hellmann
Head of the 'Le Corbusier 2012' project
City of La Chaux-de-Fonds

Nathalie Herschdorfer
Editorial director

Lada Umstätter
Chief curator of the Musée des beaux-arts,
La Chaux-de-Fonds
Exhibition curator

ABOUT THE CONTRIBUTORS

Tim Benton is a professor of art history (Open University, United Kingdom) and has been Visiting Professor at the Bard Graduate Center, Columbia University and Williams College. He has curated several important exhibitions, including 'Art and Power' (Hayward Gallery, 1995), 'Art Deco 1910–1939' (Victoria and Albert Museum, 2003) and 'Modernism: Designing a New World 1918–1939' (Victoria and Albert Museum, 2006). He currently teaches at the EPFL (Ecole Polytechnique Fédérale de Lausanne, Switzerland). He has published extensively on the history of modern architecture and especially Le Corbusier. His book *Les villas de Le Corbusier et Pierre Jeanneret, 1920-1930* has been published in English, French and Italian. His latest book, *Le Corbusier conférencier*, published in English and French, received the Prix du livre d'architecture (Académie d'Architecture). He is a member of the board of directors of the Fondation Le Corbusier.

Jean-Christophe Blaser is a curator at the Musée de l'Elysée in Lausanne, Switzerland. As an art historian and critic, he regularly publishes essays in the press and in catalogues for museums and art centres. He is also an independent curator of contemporary art exhibitions.

Veronique Boone is an engineer and architect (Ghent University, Belgium). She teaches at La Cambre-Horta, the Faculty of Architecture at ULB (Université Libre de Bruxelles), where she is affiliated to the CLARA's (Centre des Laboratoires Associés pour la Recherche en Architecture) Hortence research centre. Her research focuses on the representation, communication and promotion of architecture through photography and film, particularly the work of Le Corbusier. She is also a regular contributor to Belgian and international architecture journals on contemporary architecture.

Catherine de Smet has a doctorate in art history and teaches at the Université de Paris VIII, Vincennes-Saint Denis and the EnsAD (Ecole nationale supérieure des Arts Décoratifs, Paris). Her book *Le Corbusier. Architect of Books* accompanied the eponymous exhibition, which she curated (Centro per l'arte contemporanea, Prato; Museo d'Arte moderna e contemporanea, Trento-Rovereto; Musée d'Art moderne et contemporain, Strasbourg). She also published *Vers une architecture du livre. Le Corbusier : édition et mise en pages, 1912-1965* and is the author of numerous articles on contemporary graphic design. Her recent publications include *Pour une critique du design graphique. Dix-huit essais.*

Nathalie Herschdorfer is an art historian and independent curator specializing in photography. She is director of the Swiss office of the Foundation for the Exhibition of Photography (FEP) and of the Swiss photography festival Alt. +1000. She was also a curator at the Musée de l'Elysée, Lausanne, for twelve years, where she worked on major international exhibitions, including 'reGeneration: Tomorrow's Photographers Today', 'About Face: Photography and the Death of the Portrait', and retrospectives of Edward Steichen, Leonard Freed and Valérie Belin, among others. She is the author of *Afterwards: Contemporary Photography Confronting the Past*. Her recent projects include *Coming into Fashion: A Century of Photography at Condé Nast*

Arthur Rüegg, architect, studied under Bernhard Hoesli and Alfred Roth at ETH Zurich (Eidgenössische Technische Hochschule Zurich) from 1961 to 1972. He has worked in Zurich, Paris and Boston and has been a practising architect in Zurich since 1971. He was full professor at ETH Zurich from 1991 to 2007 and publishes extensively on construction, colour and design in the Modern Movement. His books include *Swiss Furniture and Interiors in the 20th Century*; *Le Corbusier: Polychromie architecturale*; *Pour Le Corbusier, René Burri, June 1962*; and *Le Corbusier: Meubles Et Interieurs 1905-1965*. He also co-curated the exhibitions 'Le Corbusier Before Le Corbusier' and 'Le Corbusier – The Art of Architecture'.

Klaus Spechtenhauser studied art history and Slavic languages. He was assistant to Professor Arthur Rüegg in the Department of Architecture at ETH Zurich (Eidgenössische Technische Hochschule Zurich), scientific collaborator and project leader at ETH Wohnforum – ETH CASE (Centre for Research on Architecture, Society and the Built Environment), and worked for the cantonal department of heritage conservation of Grisons, Switzerland. Since 2011, he has been science editor for the cantonal department of conservation of Basel-Stadt, Switzerland. He also writes regularly on 20th-century architecture and cultural history.

Lada Umstätter is chief curator at the Musée des beaux-arts in La Chaux-de-Fonds. She studied art history at the University of Moscow Lomonosov and the Hebrew University of Jerusalem. She completed her doctoral thesis, *L'art religieux en France dans les années 1920-1950. Méthodes d'approche. L'église Notre-Dame de Toute Grâce d'Assy*, at the State Institute for Research on the history of art in Moscow. She has worked variously as a museum assistant, independent curator, art history lecturer, researcher, and television show host across Russia, Switzerland and the United States. She specializes in Swiss and French art of the 20th and 21st centuries, religious art of the 20th century, and Russian and Soviet art and culture of the 20th century.

PICTURE CREDITS

INDEX

Page numbers in *italic* refer to illustrations

On the jacket (front): Le Corbusier, 1955. Photograph by Franz Hubmann. © Franz Hubmann; (back): Jean-Michel Landecy, Unité d'Habitation, Marseille, 2007. © Jean-Michel Landecy

Le Corbusier and the Power of Photography
Copyright © 2012 Thames & Hudson Ltd, London

Texts Copyright © 2012 their respective authors

Photographs and artworks Copyright © 2012 Fondation Le Corbusier/2012, ProLitteris, Zurich, unless otherwise stated

Edited by Nathalie Herschdorfer & Lada Umstätter

Design by SMITH (Justine Schuster, Sarah Newitt, Ana Rocha; www.smith-design.com)

Translations:
EnergyTranslations (English-French-German)
Steven Lindberg (German-English)
Martine Passelaigue (German-French)

First published in the United Kingdom in 2012 by Thames & Hudson Ltd, 181A High Holborn, London WC1V 7QX
www.thamesandhudson.com

First published in 2013 in hardcover in the United States of America by Thames & Hudson Inc., 500 Fifth Avenue, New York, New York 10110
thamesandhudsonusa.com

British Library Cataloguing-in-Publication Data
A catalogue record for this book is available from the British Library

ISBN 978-0-500-54422-8

Library of Congress Catalog Card Number 2012939685

Printed and bound in China by C & C Offset Printing Co. Ltd

This book was published on the occasion of the exhibition 'The Constructed Image: Le Corbusier and Photography' and the 125th anniversary of the birth of Le Corbusier, Freeman of the city of La Chaux-de-Fonds, Switzerland.

Musée des beaux-arts de La Chaux-de-Fonds
30 September 2012 – 13 January 2013

Centre International pour la Ville, l'Architecture et le Paysage (CIVA), Brussels
26 April – 6 October 2013

Captions to images pp. 1–7 and pp. 24–29: p. 1: Bodé, Le Corbusier in Zurich, 1938; p. 2: Le Corbusier in New York, 1959; p. 3: René Burri, Le Corbusier's studio at 35 rue de Sèvres, Paris, c. 1959–60; p. 4: Stéphane Couturier, Secretariat no. 3, from the series *Chandigarh Replay*, 2006–7; p. 5: Le Corbusier in front of the Plan Voisin, 1925; p. 6: Le Corbusier in front of the plans for the Ville radieuse (Radiant City), c. 1933–35; p. 7: Stéphane Couturier, High Court of Justice no. 1, from the series *Chandigarh Replay*, 2006–7; p. 24: René Burri, Le Corbusier at the construction site of the Dominican monastery La Tourette, 1959; p. 25: Le Corbusier, preparatory sketch for the painting *Léa*, 1932; p. 26: Thomas Flechtner, Stairs in the Secretariat, Sector 1, Chandigarh, 1990; p. 27: René Burri, Le Corbusier in a restaurant in Zurich, 1960; p. 28: Robert Doisneau, Le Corbusier in front of the model of the skyscraper 'Brise-soleil', 1950s; p. 29: Guido Guidi, Villa La Roche, Paris, 2003.